EAST GERMAN CINEMA

East German Cinema

DEFA and Film History

Sebastian Heiduschke

EAST GERMAN CINEMA

Copyright © Sebastian Heiduschke, 2013.

First published in 2013 by
PALGRAVE MACMILLAN®
in the United States—a division of St. Martin's Press LLC,
175 Fifth Avenue, New York, NY 10010.

Where this book is distributed in the UK, Europe and the rest of the world,
this is by Palgrave Macmillan, a division of Macmillan Publishers Limited,
registered in England, company number 785998, of Houndmills,
Basingstoke, Hampshire RG21 6XS.

Palgrave Macmillan is the global academic imprint of the above companies
and has companies and representatives throughout the world.

Palgrave® and Macmillan® are registered trademarks in the United States,
the United Kingdom, Europe and other countries.

ISBN: 978–1–137–32230–2 (hc)
ISBN: 978–1–137–32231–9 (pbk)

Library of Congress Cataloging-in-Publication Data

Heiduschke, Sebastian, 1974–
 East German cinema : DEFA and film history / Sebastian Heiduschke.
 pages cm
 Includes bibliographical references.
 ISBN 978–1–137–32230–2 (alk. paper)—ISBN 978–1–137–32231–9
(alk. paper)
 1. DEFA—History. 2. Motion picture industry—Germany (East)—
History. 3. Motion pictures—Germany (East)—History. I. Title.

PN1999.D4H45 2013
384'.8'09431—dc23 2013018109

A catalogue record of the book is available from the British Library.

Design by Newgen Knowledge Works (P) Ltd., Chennai, India.

First edition: October 2013

10 9 8 7 6 5 4 3 2 1

Contents

FIGURES

ACKNOWLEDGMENTS

Writing this book was by no means a solitary endeavor. Granted, putting my prose on paper took place mostly at my desk, but even at those times I was accompanied by two loyal Chihuahuas making sure I stayed on task while I was overlooking the Oregon fauna (aka deer) eating the Oregon flora (tulips and other plants) in our front yard.

I also do have to extend sincere thanks to many members of the human species who all contributed to this book in one way or another.

For feedback on drafts at various stages of completion I thank the members of my writing group at Oregon State University, Rebecca Olson, Kara Ritzheimer, and Bradley Boovy, as well as my online writing group and its members April Eisman and Thomas Maulucci. For engaging discussions about East German cinema and probing questions at a variety of conferences and film institutes I thank Seán Allan, Benita Blessing, Skyler Arndt-Briggs, Barton Byg, Victoria Lenshyn, Hiltrud Schulz, Evan Torner, and many more. I also need to thank the two reviewers who commented on the original manuscript. Your remarks made this book better.

For her diligent and stellar editing work fixing my prose over the past years I would like to thank Melissa Weintraub. If there was a reason not to recommend her it would be the fact that she may not have time anymore to un-Germanize my grammar, fix my citations, and polish up my manuscripts. She has done an outstanding job.

Working with Robyn Curtis and her editorial assistants at Palgrave was a pleasure from the very beginning. I enjoyed the quick turnaround and the professionalism all along. I could not have asked for a better publishing venue for my first book.

Money matters. Research and writing for this book was made possible by grants from the Oregon State University Valley Library, the Center for the Humanities at Oregon State University, and the Faculty Research Office at Oregon State University. The DEFA-Stiftung in Berlin supplied the cover art for this book free of charge. Thank you very much.

A book about film would not be possible without the actual films. For recording literally hundreds of DEFA films broadcast on German television and mailing them to me, I would like to thank my father, Bernd Heiduschke; and my mother, Marianne Heiduschke, for providing me with a quiet place to work, babysitting while in Germany, and allowing me to block the digital video recorder for endless hours.

My students over the past years have had to listen to me talk about East German cinema probably more than they ever expected. I am sure that they were hoping more than once that DEFA had never existed. Their discussions and questions, however, were valuable guides in the writing process.

There is nothing like a good mentor for a junior faculty member. I believe I had one of the best. Thanks, Jon Lewis, for helping me navigate the waters of the publication process, for talking with me about films (and soccer), and for being an inspiration in the way you do your scholarship.

I certainly could not have even attempted to write a book without the support of the two most important people in my life, Victoria and Max. While Max did not always understand why I occupied my time with DEFA instead of dedicating it to our shared passion LEGO, he accepted the fact that his father watches movies for a living and then writes about them. Or something similar to that. Victoria, I am sure, will be happy to see me more often again than in the past year, when the four letters of DEFA pushed the other, more important four letters in our life out of the way. Saying thank you would not nearly be enough for your patience, the time you took out of your day to run errands, to be the parent-taxi and the volunteer at school, and to pick up the films and books that had come in for me at the library. I will do it anyway—and I am ready to load the dishwasher again.

INTRODUCTION

I am not prone to playing extensively with my brain chemistry anymore (except by watching esoteric Asian and East German cinema).
—Paul Turner, Darkside Cinema

If you are a novice to East German cinema, this book is for you. For some years, I have been teaching courses on German (and German language) film, covering virtually all periods and genres, from the silent film of the expressionist era to the films of the Berlin School. I introduced Westerns, comedies, dramas, documentaries, newsreels, animated pieces, short films, mainstream, and independent productions—you name it. I taught master-pieces and obscure films, and each time, I had no trouble finding appro-priate texts to provide a first introduction, a theoretical framework, or an in-depth study of the films I would show my students. Not quite each time, however. Whenever I put the period between 1945 and 1990 on my teach-ing agenda, I ran into the problem that I suddenly would have not one, but essentially two national cinemas to teach. After Germany had lost World War II, it split into two separate countries, East Germany and West Germany, and each developed its own national film industry. For my film courses cov-ering both halves of the divided screen, finding appropriate texts has become easier and easier over the years.[1] However, when I taught courses on my research specialty—East German cinema—I was often dissatisfied with the selection of books, but not for a lack of outstanding and well-researched texts focusing on numerous fascinating topics and intricate details, I should point out.[2] Yet whenever I shared my field of research expertise with friends, colleagues, students, and other film scholars who knew nothing about East German cinema, I found it vexing that there was no introductory-length text I could recommend to help them understand my passion for this period of German film.

The problem with such a project, I realized quickly, was that someone would have to cast a wide net to explain East German cinema, a term I use to describe films produced by DEFA (short for Deutsche Filmaktiengesellschaft or the German Film Stock Corporation, even though there was no stock market in communist East Germany) in the Soviet occupation zone from 1946 to 1949, in East Germany (or, correctly, in the German Democratic Republic) from 1949 to 1990, and in post-unification Germany from 1990 to 1992. In order to understand East German cinema, I realized, you needed to be aware of East German history, culture, society, and its domestic and

international politics. You had to lay out DEFA's history, and you should also have an understanding of the way politics and cinema were inextricably linked with each other to get an idea of the issues filmmakers faced in their daily work. DEFA made more than seven hundred feature films, so an author also had to be able to come up with a canon of films that should be seen. Since East Germany ceased to exist in 1990, you also had to learn what happened to the films since unification with West Germany to make sense of their significance in contemporary Germany. As an introductory volume intended to be accessible to both students and film scholars, but ideally to anyone interested in learning about East German cinema, the text had to be concise and accessible but still informative and stimulating enough to encourage further exploration. Most of all, it had to remain affordable—how ironic would it be if a book about the cinema of a communist country were out of financial reach for some of its intended audience? All of these considerations motivated me to write this book.

Yet why should you care about East German cinema? Wasn't filmmaking in a communist country only a bunch of propaganda films, hoping to convince the population of the supremacy of the dominant ideology? How could films made between 20 and almost 70 years ago be captivating to present-day audiences? Even more, what is the purpose of knowing about these films from an obscure country that no longer exists? In short, wouldn't it be wise to simply forget about it?

Similar arguments were used during the Cold War and later as ways to excuse ignorance or mask embarrassment about being unable to name even one East German film title. For many years, film courses about European cinema after 1945 covered the West German New German Cinema but left out a number of equally progressive films, an East German New Wave that caused so much trouble in East Germany that most of the feature film production in 1965 was banned until 1990. Skipping over the East German rubble films from 1946 to 1950 means leaving out a genre of German cinema that continued the traditions of German expressionism and paralleled Italian neorealism. Many courses on Westerns include the West German *Winnetou* films, but what about the East German "red westerns" that were filmed in the same locations as their West German counterparts? They attracted millions to European movie theaters to see stories of the Wild West told from the perspective of the Native Americans—and even started a star cult in a country that officially did not have any stars. How about the East German science fiction films that not only featured a multinational and multiracial cast years before the *Star Trek* series, but one of which also ended up on the US television comedy show *Mystery Science Theater 3000* without the producers knowing they were screening an East German film? And we should not forget the fairy tale films that became classics worldwide, in part because DEFA allotted the same amount of money to their children's productions, as it did to other features. Nor should we forget the antifascist films such as Frank Beyer's *Jakob der Lügner* (*Jacob the Liar*, 1974), nominated for an Oscar and remade in 1999 with Robin Williams in the lead, or the fact that

DEFA star Armin Mueller-Stahl has been active in Hollywood for decades. In short, East German cinema is much more important than many may have realized—aside from the fact that without it, one half of German cinema between 1946 and 1990 would be missing, though now we have easy access to the films.

Needless to say, a concise treatment of East German cinema as is this book, cannot cover everything there is to know about DEFA. In fact, generalizations abound and there are quite a few gaps that need to be filled—but not here. Obviously, it is neither possible nor even desirable to strive for complete coverage in an introductory book. To reiterate, the idea of this volume is to provide an overview—a taste—of East German cinema. I do hope, however, that you will "catch the DEFA bug" as well, and will seek to learn more about DEFA, the films, the studio, its stars and directors, the reception of the films, and so on. For those, I suggest you begin with the works I mention in my annotations and continue from there. You'll be amazed to learn how many people have studied East German cinema—and each year more and more works are published. These texts fill the gaps I left in this book.

Each of the following 15 chapters addresses discrete aspects of East German cinema; at the same time, these aspects are tied together by the idea of approaching East German cinema not as cinematic manifestations of supporting communism, but as the film history of a country. In my eyes, DEFA films are works of art, made by people who played with the conventions of cinema. Some DEFA filmmakers applied the rules of a film genre, movement, or "school," whereas others tested its limits, broke the standards, and redefined them. They were humans who invested their creative potential to conceive of films and to realize them in accordance with certain standards and external factors imposed on them: economical (How many people are going to see the film? How much does the production cost? Who is going to finance and distribute the film?), cultural (Is the topic of the film ordinary or unusual? Does it address a taboo topic? How will audiences relate to the subject matter?), and societal (Is the film mainstream or art house? How does the film intersect with reality? What are the consequences of this film?). At the same time, history influences cinema. Thus, ignoring the influence of the political, economical, and cultural framework of a film may produce interesting interpretations but cannot explain the reasons of a film's characteristics. In chapter 1, I therefore explain how the history of DEFA cinema links up with the peculiarities of East Germany at certain key points in its political and cultural history. I explore how DEFA was a film monopoly originated in reaction to fascism and German defeat in World War II and how the internal studio structure represented the centralized structure of a socialist country led by one ruling party. Further, I inquire how political decisions and major historical events affected the creative process and determined the modes of production, distribution, and even reception. With DEFA as a state-run institution, filmmaking in East Germany adhered to other parameters than did free market economies. Nonetheless, DEFA was a

film studio, and as such, it functioned as part of East Germany's entertainment industry—the topic of the second chapter.

There, I break down how DEFA linked up with other players in the audiovisual realm, both within the borders of East Germany and abroad, by highlighting the relationship of East German cinema to the medium of television, the permanent dialogue with West German cinema, and the cooperation with other socialist national cinemas in Eastern Europe. One factor in particular, the star cult, distinguishes and unites DEFA with other, non-centralized national cinemas and indicates that despite official parlance that refuted the existence of a star system by calling its eminent figures "audience darlings," East German cinema still relied on audience recognition of familiar faces when casting new productions. I round up the chapter on DEFA as part of the East German entertainment industry by deliberating this star cult and by testing the extent to which one can locate traces of an auteur cinema in DEFA. In the third chapter, I expand the analysis of DEFA as the cinema of East Germany in order to illustrate the role DEFA films play in contemporary Germany. Instead of the now-defunct DEFA studio, a public foundation in charge of the large corpus of films manages the legacy of East German cinema by way of licensing the distribution rights to subsidiaries. I extrapolate the current landscape of DEFA films, looking at the various institutions, the marketing conditions, and the reception of the films to conjoin the films' past with the present. Understanding the function of East German films in a contemporary German environment offers an explanation for the resurgence of films relating to the East German past in contemporary German cinema. The contemporary viewer, I conclude, benefits from previous exposure to DEFA films by being equipped with a basic understanding of cultural background knowledge that allows a more comprehensive reading of contemporary German cinema.

Using the information of the first three chapters in part I as foundational framework, in part II I undertake the reading of 12 films ranging from the beginnings in 1946 to some of the last films produced by an already privatized studio in unified Germany in 1990. This mini-canon has the twofold purpose of providing detailed background information on each film, considering them as exemplary representations of periods in DEFA's film history linked to historic developments in East Germany, and situating the films in a larger cinematic context by analyzing their aesthetic value and affinity to genre traditions or international movements.

There are a number of issues I could have discussed in addition to those mentioned. For example, you will not find any documentary films in this book, although DEFA had its own studio for this genre.[3] I believe, however, that this genre is much too complex for an introduction and warrants its own treatment. For one, DEFA produced thousands of newsreels, short and long documentaries for agitprop purposes domestically and for the presentation of East Germany abroad. Documentaries were so important that there was even a second film studio, the independent H&S studio, directly administered by the propaganda section of East Germany's communist party.[4] Films

by Jürgen Böttcher, Winfried Junge, Volker Koepp, Helke Misselwitz, and
Dieter Schumann, as well as Kurt Maetzig, Karl Gass, Richard Groschopp,
Gerhard Klein, and the H&S directors Walter Heynowski and Gerhard
Scheumann, would be necessary for a canon of DEFA documentaries to
capture even remotely its vast corpus of roughly six thousand films.[5] Another
genre that would have deserved to be investigated is the animated film. With
over 820 productions, DEFA released more animated films than full-length
features. DEFA was known for its stop-motion technique, but it also pro-
duced numerous cartoons, plasticine animation films, puppet films, and cut-
out animation that often set new standards all over Europe.[6] Much like the
fairy tales and DEFA children's films, the animated films were not intended
only for children but contained both political and sociocritical comments
that would not have been possible otherwise.[7] Finally, a look at the dubbing
done by another part of DEFA would have shown how DEFA worked to
bring more than seven thousand features from the Soviet Union, Eastern
Europe, Cuba, and Western Europe to East Germany. By dubbing the films
into German, it was no longer possible for spectators to determine a film's
nation of origin. Films from other socialist nations often followed a simi-
lar political and cultural premise as DEFA cinema—the development of
socialism—and therefore extended the quantity of films available to East
German audiences. Yet again, the sheer number of films and genres makes it
impossible to select one as a representation. Much as with the genres docu-
mentary film and animated film, including a discussion of the dubbed film
would have exceeded the scope of this book. After all, I intended this book
as an introduction to, not an encyclopedia of, East German cinema.

Despite its introductory conceptualization, I nevertheless believe that
the book will also be useful to DEFA experts, film veterans, and readers
already well versed in (East) German cinema. As I already pointed out, the
book obviously has to generalize, leave out details, and compress ideas some
may deem essential to understanding certain aspects or for deciphering the
"codes" of East German cinema. I am aware that these gaps are going to
irk some readers; at the same time, I invite you to see this as a chance to
fill in the missing parts. In your teaching, you may find it useful (as I did)
to use the book as foundation for the topic of each lesson and to have the
dynamics of each meeting determine the focus of the discussion. For your
own research, too, this book might come in handy as a reference or quick
refresher on some aspects of East German cinema. I surely hope that you
will agree with most parts, yet I welcome your criticism and look forward to
learning facets about East Germany and its cinema I am unaware of. I trust
that this book, despite all its generalizations, simplifications, and omissions,
will be useful. Perhaps it will help students understand what you and I have
in common—an interest in and a passion for East German cinema.

Will DEFA films alter your brain chemistry and take you to a different
state of perception, as one of my friends (and the owner of a movie theater)
remarked tongue-in-cheek about their esoteric qualities as asserted in his
epigraph above? By all means: They will expand your horizon about German

film history, they will teach you to think differently about film genres, they will challenge your view on "propaganda" films, and sometimes they will make you crave more of them—be it for their cinematography, their message, their camp value, or something as yet unknown to me. But be warned: Eventually you might become part of a community of film enthusiasts who blog about East German cinema, who get their favorite DEFA star tattooed on their skin, who seek out and share even the most obscure films, who proudly wear T-shirts advertising the latest release of a newly subtitled DVD, or who raise money to rent movie theaters and show DEFA films on the big screen. The story of these DEFA fans, however, is that of another book.

Part I

EAST GERMAN CINEMA

1

EAST GERMAN CINEMA AS STATE INSTITUTION

The history of East German cinema is convoluted and complicated, full of paradoxes and contradictions, fascinating and sobering at the same time. It begins in 1946, before East Germany even existed, and ends in 1992, two years after East Germany's demise. To be more precise, these dates mark the beginning and end of the film company Deutsche Filmaktiengesellschaft (DEFA). This DEFA, however, has become the countenance of East German "national cinema"—and rightly so, as the political entity East Germany was inextricably linked with the company. Politics influenced East Germany's film production throughout its entire existence, so that the key dates of East German film history closely relate to dates in East Germany's political history. This should not be surprising, as East German cinema was born as a reaction to address the legacy of national socialism by way of making films conveying messages of peace, democracy, and antifascist ideals. The onset of the Cold War and the influence of the Soviet Union then shaped DEFA into a socialist film company and East Germany's film monopoly, a role it would play until July 1, 1990, when the restructuring of East Germany's economy became necessary to prepare it for unification on October 3 of the same year.

East Germany technically did not exist until October 7, 1949, when the Soviet occupation zone became an "independent" nation called German Democratic Republic (GDR) ("East Germany" to English speakers, a convention I will follow from hereon) to distinguish it from the Federal Republic of Germany ("West Germany"), which was a merger of 11 states created from of the British, French, and American zones that took place on May 23, 1949. The history of East German cinema, however, had already begun during the final days of World War II, on April 28, 1945, the day some movie theaters in already-liberated parts of Berlin started screening Soviet films that had been dubbed into German.[1] After the collapse of Nazi Germany in 1945 and Germany's division into four occupation zones (and its capital Berlin's division into four sectors), the allied forces took control of the film industry. Each zone followed the political lead of its occupying military governments respectively, and because each occupying power followed slightly

different politics, the reconstruction of cultural life differed from zone to zone. Common to all zones was the refusal of the occupiers to allow an immediate restart of German filmmaking. For one, the occupying powers were looking to eradicate traces of Nazi Germany. Since cinema in Hitler's regime had been centralized and over time had turned into a political tool to promote the Nazi philosophy of anti-Semitism, it seemed necessary to put a complete stop not only to the production but also the distribution and screening of German films. The occupying powers had a second reason to ban German cinema. In order to fill the movie screens, each zone (and sector) now used films from its own national cinemas to appease the hunger of Germans for entertainment and distraction from dismal reality. For a while, postwar Germany turned into another lucrative market for the film industries of the allied nations.

In the Soviet zone, German productions returned to cinemas rather quickly in the form of newsreels, assisted and approved by the leadership of the Soviet colonel Sergei Tulpanov and Major Alexander Dymschitz, who deemed them useful denazification and reeducation tools. These newsreels were the work of the Filmaktiv, a group of formerly exiled communist filmmakers who founded the group in October 1945 with the goal to revive German cinema. Joined by artists interested in making film—including Gerhard Lamprecht, Wolfgang Staudte, and Peter Pewas—the Filmaktiv proposed a new form of critical cinema in order to aid the reeducation efforts. Officially deemed a cinema to "promote a sense of respect for other people and other nations," the Soviet Military Administration in Germany (SMAD) likely approved this group because of their amicable disposition toward communist ideals.[2] With the approval of SMAD, members of the Filmaktiv began shooting in the rubble of Berlin on January 1, 1946: Wolfgang Staudte filmed in a railway tunnel for the never-completed film *Kolonne Strupp* (*The Strupp Convoy*), and Kurt Maetzig started producing the first newsreel, *Der Augenzeuge* (*The Eyewitness*), in the middle of January. The newsreels became a monthly institution in movie theaters located in the Soviet zone and usually opened the screening of Soviet films. With film production already underway, the Filmaktiv applied for a license to officially produce German films. The SMAD agreed, and on May 17, 1946, Tulpanov officially licensed DEFA as film production company with the mandate to "restore democracy in Germany and to remove all traces of fascist and militaristic ideology from the minds of every German, the struggle to re-educate the German people— especially the young—to a true understanding of genuine democracy and humanism, and in doing so to promote a sense of respect for other people and other nations."[3] A few months later, on August 13, 1946, DEFA was officially registered as a stock company in Berlin (with parts of the stock held by the SMAD), a rather curious choice of company structure in a country without a stock market that indicated how DEFA was perceived as company created in reference to the pre–World War II structures of a German free market economy. By the end of the year, it had produced numerous newsreels and completed three feature films, Staudte's *Die Mörder sind unter uns* (*The*

Murderers Are among Us) on October 15, Milo Harbich's *Freies Land* (*A Free Country*) on October 18, and Gerhard Lamprecht's *Irgendwo in Berlin* (*Somewhere in Berlin*) on December 18.[4]

At that time, it had become obvious that despite its structure as stock company DEFA was by no means going to be a film company like others before the war. Not only did the SMAD not license other film companies it also took measures to link DEFA with a newly created political party, the Socialist Unity Party (SED), formed in April 1946 from the fusion of the Social Democratic Party and the Communist Party in the Soviet occupation zone, copying the Soviet system of leadership by the communist party only. One of the measures on the path to such a one-party system was the alignment of the mass media with the party goals.[5] For that reason, the SED provided the film company with start-up money in the amount of 21,000 Reichsmarks and purchased stocks in DEFA via a holding company called Zentrag.[6] In November 1947, the SED created a film commission—internally known as "DEFA Commission"—to regulate the film production and staffing choices within the studio. Gradually, the upper ranks at DEFA filled with loyal party members interested in aligning the goals of the company with those of SED. Similar situations happened in the infrastructure in the Soviet occupation zone. The SMAD initially retained ownership of the production facilities via their company Linsa and only leased these facilities to DEFA. The distribution rights to films in the Soviet occupation zone remained with other Soviet companies, first Sojusintorgkino and later Sovexport, to assure compliance of DEFA with the political goals. After the Soviet occupation zone had become East Germany, the SMAD relinquished power, and then DEFA was entirely in the hands of the SED—via stock held by Zentrag and other SED-related institutions.[7] In 1952, the SED reorganized the cinema and created five separate studios that would remain until 1990: DEFA Feature Film Studio (DEFA-Studio für Spielfilme), DEFA Studio for Animation (DEFA-Studio für Trickfilme), DEFA Studio for Popular Scientific Films (DEFA-Studio für populärwissenschaftliche Filme), DEFA Studio for Newsreel and Documentary Films (DEFA-Studio für Wochenschau und Dokumentarfilme), and DEFA Studio for Film Dubbing (DEFA-Studio für Synchronisation). They also created a duplication factory (DEFA Kopierwerke) and a company for the distribution of films internationally (DEFA Außenhandel). In 1952, Sovexport handed over its domestic distribution to Progress Filmverleih (which, like DEFA, had been a joint Soviet-German company), and on January 1, 1953, DEFA was nationalized, turning from a stock company into a *Volkseigener Betrieb* (people-owned company).[8]

Soon after the conversion of DEFA in 1953, politics began to truly impact reality at the studio. First, the studio no longer renewed contracts with employees, directors, and actors who resided in West Germany as a way of sending a signal that filmmaking at DEFA now also required political persuasion in addition to professional expertise.[9] This shift toward an East German cinema serving the ideals of socialism had already been in the

making: In the years before, more and more productions had already integrated the ideas of socialist realist filmmaking and shifted the focus of DEFA from entertainment films shot in the style of the prewar years toward more political subject matters. By 1953, the East German film industry had developed into a hierarchically structured monopoly largely under SED control, with the politics of the day determining the productions within the studio.[10] And indeed, any change of the political path in East Germany required DEFA to adapt its direction as well. Many films were banned for falling out of lockstep with the current artistic guidelines set by the SED, and for some artists, opposition was costly, ending their careers in East German cinema for good. Being blacklisted with the monopoly studio DEFA often meant unemployment—or the hope to receive a one-way visa to West Germany.[11] At this point, DEFA had already seen its first film ban for ideological reasons. Soviet General Igor Tschekin, an advisor to DEFA, campaigned against Falk Harnack's film *Das Beil von Wandsbek* (*The Axe of Wandsbek*, 1951), a story about a butcher who moonlights as executioner for the Nazis, noting "the film will have a detrimental effect on East Germany's population, as it does not create hatred against fascism, but pity for the murderers."[12] Despite the initial success of the film when it played for a month and attracted about 800 thousand viewers, Tschekin's pressure on the SED caused the party to order the ban of the film. It would take DEFA until 1962 to allow an edited version (20 minutes shorter) to be played in movie theaters; only in 1981 the ban was lifted and the entire film restored.[13]

This case of censorship by the Soviet Union was not the first and by no means the last. To safeguard compliance with the political guidelines at DEFA, the SED instituted an elaborate system that allowed the party to exert control from the inception of a film all the way to its distribution in all of East Germany's 5,700 movie theaters, film clubs, and even travelling cinemas on trucks and in train cars.[14] Thus, from the very beginning, DEFA had to find ways to accommodate the requests of the occupying power. Already Wolfgang Staudte, the director of the first DEFA film, *Die Mörder sind unter uns*, learned he would only be granted a license to film if he rewrote the ending to feature the hero killing a former Nazi commander; this, then, illustrates the pressure for compliance DEFA cinema was exposed to from the beginning. Throughout the years, political events in East Germany began to affect more than just single films. On June 11, 1953, a couple of years after the ban of *Das Beil von Wandsbek*, the death of the Soviet dictator Joseph Stalin caused the SED Central Committee to ratify a plan for a "New Course," intended to slow down the development of communism. Their New Course did not address the workers' demands for higher salaries and better working conditions and led to the June 17 national strikes that were stopped by Soviet tanks, killing hundreds of workers in the process.

What followed in DEFA cinema was a rather interesting reaction to the strikes. While the studio gradually terminated contracts with its West German employees, it increased the involvement of guest actors and directors from West Berlin, West Germany, and Austria, and also aimed for more

coproductions with studios from West Germany and France.[15] Simultaneously, though, DEFA continued its development of political antifascist films that contradicted the coproductions with the West in a paradoxical manner. For that reason, DEFA cinema in the 1950s consisted of a smorgasbord of film genres that, put side by side, shows a breadth in styles ranging from productions like Kurt Maetzig's communist biopics *Ernst Thälmann-Sohn seiner Klasse* (*Ernst Thälmann—Son of His Class*, 1954) and *Ernst Thälmann-Führer seiner Klasse* (*Ernst Thälmann—Leader of His Class*, 1955) to the other extreme, Ernesto Remani's *Die Schönste* (*The Most Beautiful*, 1957), a drama intended for the export to Western countries.

Meanwhile, the SED decided at its 1957 cultural conference that East German art was to nurture and promote socialism even more than previously. In reaction to uprisings in Poland and Czechoslovakia in 1956 and to the youth riots in West Berlin and West Germany, the short period of "thaw" (a time when film censorship was handled more loosely, and filmmakers were granted more freedom to voice criticism in their films) that embraced liberalism and promoted diversity ended; this cultural conference and a July 1958 film conference turned back the clock and started a new period of a cultural "freeze," (strict censorship and usually film bans to demonstrate the change).[16] Konrad Schwalbe, a staunch SED member, replaced the more liberal DEFA head dramaturge, Rudolf Böhm, and socialist realism, a style of filmmaking that demanded proximity to and realistic depiction of life in a socialist society, was to become the leading idea in film production—at least for the time.[17] As a consequence of the conference, films that were too Western were either completely banned, such as *Die Schönste*, or were only released in a black-and-white version, such as *Die Spielbank-Affäre* (*The Casino-Affair*, Arthur Pohl, 1957) to distort the colorful cinematography.[18] DEFA also fired their directors Remani and Pohl, not coincidentally two of the last remaining non-East German directors at the studio. Another film, Konrad Wolf's *Sonnensucher* (*Sun Seekers*, 1972) was also banned. After initial editing required for being it too critical about the SED in a first version, the Soviet embassy requested the film be shelved for its treatment of uranium mining in East Germany.[19] DEFA complied eventually, even though the studio head had already released the film. As the political regulations tightened, DEFA films turned into increasingly uninspired, schematic constructions, causing the average film attendance to drop by almost half within a year, from 1.5 million in 1959 to a little over 800 thousand in 1960.[20] With the exception of antifascist films such as Frank Beyer's *Fünf Patronenhülsen* (*Five Cartridges*, 1960), a story about the Spanish civil war, and Gerhard Klein's *Der Fall Gleiwitz* (*The Gleiwitz Affair*, 1961) about the Nazi attack on the radio station Gleiwitz that had served as justification for the beginning of WWII, DEFA films otherwise hit a low mark. This would change in August 1961 when the erection of the Berlin Wall caused the popularity of East German cinema to soar again.

The closure of East Germany's borders put an end to East Berliners crossing into the western sectors to see movies. Accordingly, East German

cinemas, instead of the border cinemas, became the hotspots for teenagers and young adults.[21] Along with this, the influx of imported films from the West slowed down, while progressive films by Eastern European directors such as Mikhail Romm, Andrei Tarkovsky, Andrzej Wajda, and Milos Forman inspired DEFA directors. In 1961, the SED still reacted sensitively about films that addressed the Wall critically, so that a film that mocked it, the satirical fairy tale *Das Kleid* (*The Dress*, Konrad Petzold, 1961) was banned, whereas movies such as *Und deine Liebe auch* (*And Your Love Too*; Frank Vogel, 1962) and *Der geteilte Himmel* (*The Divided Heaven*, Konrad Wolf, 1964) that illustrated commitment to East Germany were shown, even if it meant that East Germans had to make personal sacrifices. In the years to follow, one can actually observe how DEFA gained a certain amount of autonomy from the politics of the day. Backed by the knowledge that the Berlin Wall was indeed strengthening East Germany internally, the studio allowed its directors to embark on more critical projects. DEFA even decentralized its structure, forming a number of artistic work groups (KAGs) that were to act independent of each other, like mini-studios under a DEFA umbrella company.[22] Although only short lived in their autonomy, these KAGs were responsible for films that were reminiscent of the French new wave cinema, and for a brief time, DEFA operated fairly free from SED control.

Yet, once again, a political event curtailed this freedom, curbed artistic development, and had the SED reinstating even tighter controls over East German cinema than ever before. The party's Eleventh Plenum, regular political conferences of the communist party in East Germany to determine political strategies and revise or adapt the centralized planning, met in 1965 in order to discuss and address a new economic system's severe shortcomings. In order to avoid discussion of the failure of the new system, the gathering turned into a fundamental debate of the role of art in socialism.[23] After two of the upcoming DEFA feature films of that year, *Das Kaninchen bin ich* (*The Rabbit Is Me*, Kurt Maetzig, 1965) and *Denk bloß nicht, ich heule* (*Just Don't Think I'll Cry*, Frank Vogel, 1965), had been screened during the meeting, the participants of the Plenum pointed to these films as exemplary reasons for the failure of socialist art. They were described as having irrelevant storylines, promoting nihilist worldviews, and doing a disservice to the goal of promoting the development of socialism.

After emotional debates, DEFA's entire feature film production from 1965 was banned by the Plenum: Some films were removed from movie theaters, others were stopped at various stages of the production process. In all 12 films were blacklisted: *Das Kaninchen bin ich, Denk bloß nicht, ich heule, Berlin um die Ecke* (*Berlin Around the Corner*, Gerhard Klein, 1965), *Karla* (*Carla*, Hermann Zschoche, 1965/66), *Jahrgang 45* (*Born in '45*, Jürgen Böttcher, 1966), *Wenn du groß bist, lieber Adam* (*When You're Older, Adam*, Egon Günther, 1965), *Spur der Steine* (*Trace of Stones*, Frank Beyer, 1966), *Ritter des Regens* (*Rainbow Knights*, Egon Schlegel and Dieter Roth, 1965), *Fräulein Schmetterling* (*Miss Butterfly*, Kurt Barthel, 1965), *Hände hoch, oder ich schieße* (*Hands Up, or I'll Shoot*, Hans-Joachim Kasprzik, 1966),

Der verlorene Engel (*The Lost Angel*, Ralf Kirsten, 1966), and *Der Frühling braucht Zeit* (*Spring Takes Its Time*, Günter Stahnke, 1965). Some film careers ended completely as a result of the bans, and a number of directors did not receive new contracts or were sent to direct television productions instead. And even though only some of the forbidden films contained politically sensitive topics, the fallout of the Plenum affected the future of East German cinema. After the termination of a movement by SED that, in retrospect, represented East German avant-garde cinema, the studio and its directors shifted the focus to less controversial topics found in the genre films of Westerns, science fiction films, and occasional musicals.[24] The ban of Heiner Carow's *Die Russen kommen* (*The Russians Are Coming*, 1968) when the Soviet Union invaded Prague to prevent a democratic revolution in their satellite state, Czechoslovakia, showed once more how closely the SED controlled the cinema. In fact, Carow's tale of a teenage Nazi fighter that challenged the myth of the Red Army as longed-for liberators was not simply shelved like the 1965 productions, but destroyed instead.[25]

DEFA cinema never recovered from the Eleventh Plenum. Many directors were now unwilling to take any risks, fearing another wave of film bans that might endanger their jobs. In addition to the official modes of censorship, this "inner censor" now affected East German cinema perhaps even more seriously. Before embarking on a production, filmmakers now consistently weighed the potential film project against the current political mindset and the degree of artistic freedom to determine the level of individual freedom expected. Self-censorship certainly prevented politically controversial films; at the same time it also stopped the artistic renewal. Audiences returned to theaters to see the new products of DEFA's genre cinema and enjoyed the growing East German stardom that saw the introduction and rise of nonpolitical public personas as DEFA stars.[26] The Plenum, however, had confirmed two things: one, the SED had truly tightened its political influence on East German cinema even more than before, and two, despite the building of the Berlin Wall, DEFA films could not complement official narratives as alternative voices or offer additional interpretations of East German socialism after 1965.

It took a change in SED leadership to ring in the next period of thaw for DEFA cinema. Along with East Germany entering into cooperative agreements with West Germany—a result of an eastern policy by the West German government to forego their previous claim of sole representation of the German nation—the SED overthrew their leader Walter Ulbricht and replaced him with Erich Honecker. A few weeks after his appointment in 1971, the Eighth Party Congress declared East Germany a fully developed socialist nation. At the same congress, a change for the arts also unfolded when Honecker announced the end of taboos on artistic expression. DEFA filmmakers were now urged to specifically address matters of everyday life in socialism, point out deficiencies, and come up with narratives about the intersection of the private and the public spheres. This shift in topics granted more freedom to directors to pursue critical narratives, yet it also steered them

away from tackling political topics that exceeded the scope of individual stories to avoid general criticism. Indeed, even controversial films, such as *Die Legende von Paul und Paula* (*The Legend of Paul and Paula*, Heiner Carow, 1973), *Die Schlüssel* (*The Keys,* Egon Günther, 1974), *Das zweite Leben des Friedrich Wilhelm Georg Platow* (*The Second Life of Friedrich Wilhelm Georg Platow*, Siegfried Kühn, 1973), and *Der nackte Mann auf dem Sportplatz* (*The Naked Man in the Stadium*, Konrad Wolf, 1974), were debated in the studio but were eventually released to the public. Nonetheless, one film, Iris Gusner's debut *Die Taube auf dem Dach* (*The Dove on the Roof,* 1973) was censored by DEFA for its critical message and believed to be destroyed in the following—even though the director had complied with the requests for multiple changes. Thus, while it looked as if the SED was loosening its grip on cinema, it retained control instead by sidetracking the attention to proclaim that now, films were not being released due to their poor quality instead of a critical message.

As DEFA directors and actors noticed how the penultimate crisis the proclaimed new freedoms of 1971 dwindled, they voiced their frustration in a protest of writer and singer Wolf Biermann's forced expatriation in 1976. Biermann had been stripped of his East German citizenship while touring West Germany singing songs critical of the SED government. Twelve of his writer colleagues, supported also by a number of DEFA directors and actors, sent a letter of protest to the SED. When these protesters refused to retract their signatures, they became targets of the system. Manfred Krug, one of the most popular DEFA stars, no longer received new film roles and even had to see the finished DEFA film *Feuer unter Deck* (*Fire Below Deck*, Hermann Zschoche, 1977), in which he starred, withdrawn from distribution. Eventually Krug emigrated to West Germany along with many other colleagues such as Armin Mueller-Stahl, Jutta Hoffmann, Egon Günter, Hilmar Thate, Angelica Domröse, and Winfried Glatzeder, who had also protested the expatriation.

The exodus of so many stars had a severe impact on DEFA cinema—to the point that, after the loss of huge artistic potential and of some of the most prominent faces—East German film took a dive in the 1980s.[27] After Honecker's policies had allowed an increase in Western film imports, those attracted more viewers by far than DEFA films, which rarely sold even one million tickets.[28] And while other eastern European cinemas in Poland, Czechoslovakia, and Hungary reflected the new Soviet politics of *glasnost* (transparency) and *perestroika* (restructuring) that was beginning to change their political structures, both the SED and DEFA were adamant about conserving the status quo in terms of allowing cinema to address political issues. Instead of politics, films about the role of the individual in East German society became frequent topics. Additionally, keeping young directors at bay by not issuing them contracts or providing them with ways to make their films within the system, as was still the case in 1988 when a group of young directors requested changes in the studio, reaffirmed how politics still exerted its power over DEFA cinema until the very end. Ironically speaking,

one of the few advantages of the unwritten but still-enforced embargo on overtly political topics, as the ban of the films *Jadup und Boel* (*Japup and Boel*, Rainer Simon, 1980) and *Schnauzer* (Maxim Dessau, 1984) attests to, was the rise of both women directors and of the genre of the women's film; additionally, toward the end of East Germany, even the one film addressing overtly the topic of homosexuality, *Coming Out* (Heiner Carow, 1989), was released.[29]

Film production remained under control of the SED until the fall of the Berlin Wall on November 9, 1989. Along with the removal of the one-party political system in East Germany, the influence at DEFA ended, too. In December 1989, a task force formed to develop future models for the company as part of a democratic, independent East Germany. However, with the unification between East and West Germany, DEFA, like all other people-owned East German companies, was privatized and placed under control of the holding company Treuhand, which sold the companies to the highest bidders.[30] In the short time of an independent DEFA Studio für Spielfilme GmbH (Limited Liability Corporation [LLC]) in 1990, a number of unregulated and uncensored films called *Wendefilme* (films of change) were produced.[31] These films allowed at least a glimpse into a parallel DEFA universe dominated by creativity and democratic structures to hint at the breadth and depth of films that might have been created by DEFA without the permanent SED influence on the production process.

With tight control of the SED over East German cinema, one wonders how it was possible for film directors to put their individual stamp on film projects. How were they able to express their personal opinions at all about contentious subject matters, and why did they not merely manufacture films according to guidelines given to them by the SED? And, as a consequence of the party influence, why weren't all films loaded with propaganda? Obviously, as the brief chronology of DEFA has shown, either the Soviet Union or the SED ensured that East German cinema complied with the larger ideals. Yet, particularly during the brief thaws, film directors were quick to produce films addressing critical topics and did not shy away from films that encouraged discussion. Even during stricter times, one can often find dialogues and passages in films that can be (and certainly were) read in more than one way. In fact, East German audiences took pleasure in decoding these spells of defiance that appeared to have gone unnoticed by censors—even if DEFA filmmakers had been allowed by the various control instances to create the illusion of a democratic cinema.[32]

It would also be a mistake to perceive DEFA directors as a group of anti-communist filmmakers who had been coerced into directing films for East Germany. In fact, many filmmakers working for DEFA were convinced socialists hoping to contribute to a peaceful, antifascist, and communist society that at times did not agree with the structure handed to them by East German politics. As a trade-off, since the films had been prefinanced by the country's economy, these directors did not have the pressure to succeed at the box office, or the fear that their projects would be canceled in

mid-production for lack of money. In that respect, the control of DEFA by the SED had its advantages—and without it, DEFA's children's films and fairy tales would not have been nearly as well made.[33] DEFA was state-controlled and integrated in East German economy and society like other companies in this centralized system. If or how it would have survived as privatized company among competitors in a united Germany remains an open question. One thing, however, is sure: Its films would have been different from those it produced between 1946 and 1990 as East Germany's monopoly.

2

Reciprocities and Tensions: DEFA and the East German Entertainment Industry

DEFA as monopoly film industry occupied a privileged position in East Germany. Compared to its West German counterparts operating in a competitive market economy, the studio appeared to work under ideal conditions. There were no domestic contenders due to the centralized structure of East Germany, and DEFA never had to compete for film funding. In fact, film financing for approved productions was not a problem, and its productions did not have to break even, let alone make profit at the box office. Yet, although it was a state-owned enterprise in a centrally governed socialist political system, DEFA compares to many other global film industries.

The studio showed many components found in these other film industries. DEFA had a studio CEO (called studio head), a number of film stars, and many famous, auteur-like directors. At the same time, DEFA was different, since it did not have any domestic competition, but was a monopoly studio in a socialist society. Party politics influenced the development of films by implementing a rigorous hierarchical system intended to prevent overly critical material. To open new markets and export its films DEFA engaged in coproductions with Eastern European countries—by necessity, since the West German market often remained off-limits. And like other nations, the advent of television struck the East German movie industry severely, when audiences preferred the comfort of staying home over going out to the movies. In East Germany, the additional temptation of being able to taste the "forbidden fruit" of West German television complicated the situation for DEFA even further.

It is often surprising to learn about the parallels between DEFA's structures and those of film industries in Western capitalist societies in, for instance, the way they competed against the rise of television or how they created star systems to lure audiences to movie theaters. In addition, DEFA's dialogue with West German cinema is noteworthy: From the beginning of postwar German filmmaking in 1946 through the end of DEFA (and even beyond), the cinemas of East and West Germany perpetually cross-fertilized

each other. Examples of this exchange can be located in the exchange of personnel over film trades between the countries, in coproductions between DEFA and West German companies, and also in similar thematic and structural developments regarding the genre films of both nations. DEFA also occupied the crossroads between East and West; it was not only interacting with West German cinema but was firmly embedded into the traditions of the Eastern European Cinemas, borrowing from and contributing to the traditions of film genres situated in communist and socialist countries. As a hybrid entertainment industry bridging Western and Eastern European traditions and structures, DEFA may perhaps be the only truly pan-European film company of the Cold War period.

One would think of the film industries of East and West Germany to be in constant competition with each other, mirroring the overall tense political atmosphere during the Cold War. Indeed, during much of the time of the "divided screen," DEFA cinema stood in permanent competition with films produced in West Germany and elsewhere. From 1946 to 1961, it was particularly difficult for DEFA to convince East German audiences of the superiority of its film production, since entertaining films from behind the Iron Curtain were within easy reach for many East Germans. Before the building of the Berlin Wall in 1961, travel between East and West Germany was possible and especially uncomplicated in Berlin, where many citizens crossed the borders regularly to watch movies not playing in the eastern sector. Twenty-six thousand East Berliners took advantage daily of those movie houses in close proximity to the sector border, often accounting for more than 90 percent of the audiences.[1] Even DEFA directors regularly frequented the cinemas of West Berlin to watch films in these border theaters, catching up on new releases of western European cinemas and the latest Hollywood films.[2] Due to this direct competition, DEFA (and East Germany's ruling party, SED) had to find ways to bring audiences to the screening of DEFA productions.

In many instances, ensuring decent attendance numbers required creative thinking. Particularly, the ideologically tainted productions that aimed to indoctrinate East Germany's population with the objectives of socialism by means of film had trouble competing with the entertaining genre films of the West. In an attempt to expose as many East Germans as possible to DEFA films, movie theaters offered fairly inexpensive tickets to DEFA movies. Another form of state subsidy was the organized trip of entire schools and units of factory workers to (occasionally free) screenings of films depicting the struggle of the proletariat, showing the victory of communism over fascism, or promoting other socialist ideals. Later on, movie theaters bundled the screenings of imported films from the West with a DEFA film opening the double feature, requiring spectators to be in their seats for the first film and not allowing late seating. One statistic from 1963, for example, contrasts the attendance figures of these Western imports with those of DEFA and other socialist countries. The numbers reveal that 41 percent of the audience attended Western productions, even though only 21 percent of the

films shown originated there.[3] In 1983, the quota was even more lopsided: of about 72.5 million total tickets sold that year, almost 40 million people saw films from the West.[4] Regardless of the number of viewers, East German statistics of DEFA film attendance did not necessarily depict interest in these films. Press releases often celebrated the huge success of DEFA films based on impressive attendance figures, yet news like this glossed over the fact that many East Germans did not see the films by their own accord but were required to do so.[5] If one takes into account the bundling of imported movies with DEFA films and the practice of canceling import films in the 1960s that had become too successful, one can rather easily see how audiences preferred the Western imports over DEFA productions.[6]

Given such a bleak situation on the domestic market, it might seem surprising that DEFA films did find a following outside East Germany; some even turned into cult hits in West Germany and the UK. But how did DEFA films get to these countries, and why would East Germany even want to engage in trade relations with their Cold War enemies? For one, introducing DEFA films to other countries increased the visibility of East Germany internationally; film export was therefore a highly political effort. As the country was consistently measuring itself and being measured against the achievements of West Germany, DEFA films represented not only East Germany's national cinema but also served as a litmus test of international recognition. At the time when the Hallstein doctrine—an element of West German foreign policy threatening to terminate diplomatic relations with countries that recognized a sovereign East Germany—prevented formal relationships of East Germany with many nations, the cultural exchange, also via DEFA films, served as ambassadors of goodwill between the countries. However, trading with West Germany was always an important pillar for East Germany's economic success, especially as West Germany's booming economy during the economic miracle of the 1950s appealed as an attractive market for DEFA films. Due to their common language, selling DEFA films to West German distributors offered a relatively uncomplicated way to bring in much-needed "hard" currency to boost the domestic economy. All revenue generated by these sales did not belong to the studio or its trading arm DEFA Außenhandel (DEFA Foreign Trading Company), but to East Germany. While official parlance may have justified the sales as tools for the political education of West Germans, it is safe to assume that the need to sell films in order to raise capital trumped the desire to convince the West German population of East Germany's ideological superiority.

Because East Germany considered West Germany a foreign nation, film export and import to West Germany was carried out by the monopoly trader DEFA Außenhandel since its founding in 1952.[7] Yet, this film exchange turned out to be rather complicated. Marred by Cold War politics, the import of each DEFA movie into West Germany had to undergo an extremely elaborate sanctioning process by the West German Interministerial Cinema Committee (Interministerieller Ausschuss für Filmfragen), which often demanded censorship of passages with political context deemed unacceptable

for West Germany.[8] Because DEFA's fairytales (*Märchenfilme*) lacked the propagandistic tone of many other DEFA productions and did not criticize West German politics, they could be imported quite smoothly. These films, based on the stories of Wilhelm Hauff, the Grimm brothers, and others were received very well in the West, and they became staples both on West German television and, later, on video cassette.[9] Compared to West German productions that often looked cheap, DEFA's fairytales were treated in East Germany like any other production. They therefore had budgets comparable to other DEFA feature films and were directed by accomplished directors, making these films stand out as well-made. Their success was not limited to West Germany; even outside the German-speaking countries, some of the fairytale films achieved cult status, such as *Das singende, klingende Bäumchen* (*The Singing, Ringing Tree*, Francesco Stefani, 1957) in the UK.[10]

Since consistent access to the ever-lucrative West German market was vital, DEFA had to find ways to circumvent the Interministerial Cinema Committee for exports to West Germany. One example of an ingenious strategy that allowed not only the export of DEFA products but also coproductions between East and West Germany was the utilization of so-called dummy companies.[11] In order to avoid conflicts with the committee, West German producer Erich Mehl created a Swedish film production company, Pandora Film, which acted as a coproducer for DEFA films when West German companies were involved. Essentially a phantom company, Pandora not only coproduced but also distributed over 150 DEFA films in West Germany at a time political restrictions would have made such an endeavor nearly impossible.[12] Importing films directly from DEFA would not have been allowed, but getting the films from a Swedish producer, on the other hand, was fine in West Germany.

While DEFA was able to regulate and therefore limit the number of Western film imports to its movie theaters, it was more difficult, if not impossible, to find ways to compete against a new medium—television. Initially, television did not pose a threat to DEFA cinema. When East Germany launched its own initiative to develop television in reaction to West German television test broadcasts in 1950 and constructed a television center in the Berlin locality Adlershof, there was not yet any official programming taking place. Merely two years later, East German Sender Berlin began its first broadcast of news and political documentaries—four days before the West German television channel Nordwestdeutscher Rundfunk launched on Christmas Day 1952—making use of the new medium primarily for educational and propagandistic purposes.[13] The East German station soon added feature films from the Soviet Union. However, broadcasting very limited offerings only a few hours per day along with the fact that only 75 television sets existed in 1952 (all of them in East Berlin) did not pose a substantial threat for DEFA productions.[14] Even once the official East German Broadcasting Agency Deutscher Fernsehfunk (DFF) commenced its work in January 1956, replacing Sender Berlin, most of the program hours on television consisted of satirical shows alternating mostly with feature films from the Soviet

Union and Czechoslovakia.[15] An early cooperation agreement between East German television and DEFA allowed Sender Berlin and later DFF to select an occasional DEFA feature film for television broadcast. But watching DEFA films in the cinema provided audiences with better value for their money: The first East German televisions cost more than an annual salary, featured monochrome screens smaller than a modern-day iPad, produced pictures with static in inclement weather, and had antenna problems or other technical issues.[16] In contrast, more and more DEFA productions shown on the big screens of movie theaters were shot in Agfacolor, a type of negative known for its rich colors, and remained unaffected by transmission problems or static interference. With only one East German television channel broadcasting on average three to four hours per day in the initial years and the majority of programming being news and documentaries, television replaced radio but not movie theaters' variety of features and better quality.[17]

As more East Germans purchased television sets, attendance at the movie theaters dropped, which created tension between DEFA and DFF. The two entities continued the agreement to have occasional DEFA features shown on the DFF channel, probably because two political entities, the State Committee for Film Affairs (Staatliches Komitee für Filmwesen) and the State Committee for Radio Broadcasting (Staatliches Komitee für Rundfunk), had initiated this contract to rerun popular DEFA movies.[18] When DFF complained about the allegedly high fees DEFA was charging for these films, the television studio started producing its own films. Suddenly, DEFA had a competitor who was contending for scriptwriters, directors, highly qualified technical personnel—and, increasingly, audiences.[19] The situation exacerbated for DEFA as television technology evolved. Television screens grew, the sets became more affordable, programming hours increased, and eventually DFF added a second channel and started broadcasting in color. With an expanded lineup that now consisted of established programs, live sporting events, and films produced exclusively for television, the convenience of audiovisual entertainment at home caused many viewers to choose television over movie theaters, despite the low cost of the theaters—one East German mark, the equivalent of a handful of pennies in Western currencies.[20] Television gradually overtook going to the movie theater as most popular entertainment method.

The biggest blow to DEFA cinema was probably East Germans' access to West German television on their sets at home. While austere censorship and political subtexts permeated many DEFA films, transformed entertaining storylines into vehicles of party propaganda, East Germans "voted with their feet" and stayed at home, watching the feature films and shows broadcast on West German television. At that time, television signals could be received over in-home antennas attached to individual television sets or via communal antennas mounted to the roofs of buildings. West Germany had strategically placed a number of strong broadcasting towers along the border to East Germany and was transmitting television signals deep into East German territory. Only the eastern part of East Germany's coastline of the Baltic Sea

and an area of Saxony, mockingly called *Tal der Ahnungslosen* (Valley of the Innocent), remained outside the range of these towers.

Thus, receiving West German television channels for all other East Germans required only minor technical modifications to their television sets. Additionally, many purchased freely available decoders to add the West German PAL system (Phase Alternating Line) to the originally French SECAM technology (Séquentiel couleur à mémoire) of the Soviet Union, which was also used by the DFF, to retrofit their televisions, although it was initially illegal and later frowned upon to watch West German television (and to introduce politics-free entertainment and Hollywood cinema in their living rooms). After the new SED general secretary Erich Honecker introduced a turn in cultural policies in 1971, users of the PAL converters were no longer persecuted by the government, and absurd activities such as the nightly government-initiated turning of antennas on the rooftops of East Germany to point away from the West German towers stopped. As shown, the rise of television in East Germany affected DEFA tremendously, and ticket sales continued to drop sharply, further compounding the already troubled situation for DEFA films.[21]

However, DEFA cinema was helped by its connection to Eastern Europe. Positioned not only geographically but also artistically between the filmmaking of Eastern and Western Europe, DEFA film occupied an interesting role as both a bridge and a border of film culture between the political hemispheres. As arguably the only truly pan-European cinema in the Cold War, DEFA connected with the film industries on both sides of the Iron Curtain. The relationship with the West German media industry existed in a rather complicated setup of collaboration and oppositional practices. Even when coproductions did not take place between DEFA and West German studios, the filmic output of West Germany still influenced DEFA projects and vice versa; a "contrasted dialogue" between the two film industries shaped the output of the two German states.[22] For instance, genre films, such as the West German westerns of the 1960s, triggered responses in DEFA cinema that resulted in the creation of the "red westerns," a few years later.[23] This influence worked also from East to West; The films of director Wolfgang Staudte, for instance, showed how he continued his style of filmmaking in West Germany after having left DEFA.[24] Because of the many parallels before the building of the Berlin Wall ended the cultural exchange, many scholars have suggested that a single German national cinema existed during the period from 1946 to 1961, regardless of any political or ideological division.[25]

At the same time, with East Germany as a satellite state of the Soviet Union and its filmmaking rather firmly embedded into the ideological cinematic superstructure of the Eastern Bloc, it is important to also look eastward and to read DEFA as a cinema that moved German film into Eastern Europe.[26] How did DEFA function within parameters delineated by its comrades in Eastern Europe? For one, many of the DEFA productions followed Soviet cinema or other national Eastern European cinema in their topic

choice, their cinematic language, and their political framework.[27] A uniting factor for all of these industries in socialist societies was the lack of financial pressure. Production cost, ticket sales, and other market considerations were not pressing issues of the centralized economies in communist countries and their state-owned film industries. Both within their domestic economies and the communist bloc, the film exchange did not generate much revenue but rather served as affirmation of international solidarity. Transnational collaboration between Eastern European studios and DEFA was ubiquitous, taking place on multiple levels of the production process. For example, Konrad Wolf used Bulgarian scriptwriter Angel Vagenshtain for his film *Sterne* (*Stars*, 1959) and later again for *Goya*; Serbian actor Gojko Mitic became a star in DEFA cinema for his role as a native American in the DEFA series of red westerns from the 1960s and 1970s; and the music compositions of Polish composer Andrzej Markowski would have caused the German-Polish coproduced sci-fi film *Der schweigende Stern* (*Silent Star*, Kurt Maetzig, 1960) to have lost much of its appeal. Many aspiring DEFA directors also had to serve on international coproductions as codirectors before being put in charge of individual directing projects—an exercise in international solidarity, but also a rejuvenating experience.[28] Those DEFA directors who studied filmmaking or worked outside East Germany were introduced to vibrant avant-garde scenes that developed—despite similarly restrictive political systems—and they often developed new techniques. Since East Germany was sometimes considered even more dogmatic than the Soviet Union, working in these other film industries turned out to be beneficial.

The cinematic exchange with other friendly Eastern European nations also worked on the level of film supply. Due to the restricted and restrictive import of film productions from the West, DEFA relied much more on its Eastern European partners to supplement their domestic production. With an annual feature film production of only 12 to 15 DEFA films, it was necessary to import films and fill East Germany's screens with productions from Eastern European comrades. Entering into film trade agreements with studios from Poland, Bulgaria, Hungary, and Czechoslovakia was fairly uncomplicated, and films from many of these countries attracted more viewers to East German cinemas—especially when these films turned out to be more radical, innovative, and progressive than DEFA productions. Unlike DEFA cinema that stuck to traditional storylines and curbed attempts to develop an avant-garde, Eastern European cinemas undertook considerable experimentation and quickly developed a style different from that of DEFA.[29] In some instances, these films ended up being screened only to a limited audience in East German film clubs due to their provocative content or, sometimes, their high artistic quality.[30] In exchange, DEFA exported its films to these other nations, which guaranteed sales of the film even at time when Western nations refused to purchase DEFA films for political reasons.

Creating a film exchange also helped manifest the political strategies of the Eastern Bloc; watching and comparing the everyday realities in Poland, Czechoslovakia, and Bulgaria to that of East Germany also illustrated the

larger, collaborative, political goal of a global communist community. Even though DEFA only engaged in a small number of coproductions with other Eastern European studios— a total of 3 in the 1950s, 11 in the 1960s, and 18 in the 1980s out of an annual production of about 12 to 15 DEFA films— these movies were indispensable in formulating a common ideological line across national boundaries as "ideologically charged co-productions."[31] A film such as the Oscar-nominated *Jakob der Lügner* (*Jacob the Liar*, Frank Beyer, 1974), coproduced with Poland, illustrates how antifascism was an overarching topic among united Eastern European nations affected by Nazi Germany. But even more pragmatic considerations played a role in the decision to coproduce films across borders. Collaborating on big-budget productions of the sci-fi and western films allowed studios to share the cost by pooling resources and personnel, opening multiple markets in the Eastern Bloc with their casting of multinational stars, and access to a variety of exotic filming locations.[32] By producing authentic-looking pictures, DEFA created a virtual travel space for its East German viewers who, despite travel restrictions, were now able to at least "travel in their minds." The collaboration with Eastern European studios thus globalized DEFA, at least within the confines of the socialist realm.

Film production at DEFA resembled that of other studios, both in Eastern Europe and in western studios. Nevertheless, some considerable differences existed due to the studio's monopoly position in East Germany's centralized, socialist society. The centralized structure of film production meant that there was no domestic competition to the studio. Therefore, anyone interested in an occupation related to the production of movies in East Germany either worked for DEFA or for East German television. For large feature film productions, DEFA was the only choice, so directors and actors had to comply with the official guidelines set for production. A look, then, at the "human" components of the studio reveals how the dynamics of film production differed from those at western studios.

Notwithstanding that the studio held the monopoly of feature film production, DEFA was still an entertainment industry. One major difference in the studio structure was the lack of a producer required to obtain financing and keep the production on track. DEFA itself acted as its own producer of every East German feature film released between 1946 and 1990.[33] The details of the production responsibilities changed throughout the years, but for most of the time, DEFA first created an annual production plan that had to be ratified by the Film Department in the East German Ministry of Culture (Hauptverwaltung Film).[34] DEFA's head of the studio then accepted the screenplay and commissioned the production of the film with a director of production. This director of production and the director of the film then determined the organizational structure of the production, such as the hiring of the main personnel, the casting of the lead actors, and the establishment the production deadlines. For the day-to-day oversight of an ongoing film production on the set, the director of production selected a head of production who then worked with a production collective consisting

of the film director and a dramaturge on the development of a screenplay; the head of production also organized the equipment and set construction, supervised the shooting process, and participated in the final editing. After completion of the film, the head of the DEFA studio received the film for a final approval within the studio before the Film Department endorsed the production for distribution.

The collaboration within the production collective of artistic work groups seemed to signal the participation of many people in the production process, giving them agency over their film.[35] In reality, it allowed SED to exert political influence at all times during the production of a film by having party members be their voice on the set.[36] Thus, film directors never had complete autonomy over their films. The director of production regulated most of the film's genesis, the dramaturge was the "artistic consultant and ideological midwife,"[37] and, with the exception of a brief period of relative freedom before the advent of the New Economic System in 1964 placed them directly under the supervision of the studio director, the directors were never as much at liberty to realize their own visions as those in western cinemas.

Because of this relationship of dependency that required compliance, East German cinema never truly developed an auteur cinema the way Western nations did.[38] Still, audiences returned to movie theaters when a new film by a well-known director was released, suggesting that DEFA directors were able to express their individual styles despite the restrictive system. Nevertheless, despite their prominent position in the production process, film directors still relied on the studio's goodwill; directors who fell into disgrace with the studio leadership faced demotion to assistant director, relegation to television productions, or even complete dismissal. In the last case, being amenable was essential because there was no other studio to accommodate them.[39] As one consequence of this structure of control and dependency, the power into a studio hierarchy stifled artistic freedom, slowed the creative process, and resulted in the over-politicization of many DEFA productions.[40]

Much like the director, DEFA's film stars found themselves in a constant predicament, as well. Stars did not exist in East Germany; in official parlance, they were called "audience darlings," suggesting that the East German people selected these actors over their peers to be in the limelight. Such a choice in words also implied how the popularity of DEFA actors was organically grown, unlike the artificially constructed images of Hollywood stars invented to create personality cults with the goal to sell more tickets at the box office.[41] Since DEFA did not depend on box office revenue to remain in business and actors' salaries were modest compared to their Western counterparts, creating a star system to ensure the studio's success was not as crucial as for nations with competition. Only the top DEFA stars earned about five times the salary of other actors, with monthly wages topping out at 1000 East German marks already in the 1960s, for shooting one, sometimes two movies a year.[42] Actors and directors were permanently employed by DEFA—different from studios in other Western countries—but like in

competitive markets, they earned more for successful films—sometimes an additional premium of up to 35,000 marks (enough for buying three cars at a time).[43] Most actors, though, earned significantly less than actors on the DEFA A-list—and getting on this list by no means depended solely on audiences or fans but as much on the needs of East German politics.

Even though DEFA initially hesitated to create a star system modeled after the cinemas of capitalist Western nations, it became obvious that audiences were looking for faces they would recognize and identify with. The approach to create a unique system of DEFA stars in the early 1960s—not coincidentally at the time East Germany closed itself off from West German influences—combined the conception of star personalities with a politicized approach to ensure that it was clear how those stars were part of East German society.[44] Aided by the erection of the Berlin Wall that slowed the exposure of audiences to stars from West Germany and Hollywood, it was now possible to fabricate a uniquely East German stardom with domestic stars.[45] A concerted effort between the studio and the nation's print media helped to establish a number of actors as the "faces" of DEFA cinema.[46] By 1954, the East German film magazine *Filmspiegel* had already been reviewing new and upcoming releases of domestic movies and international films along with news about actors, even including "pin-up type images" of them.[47] Now, in the 1960s, in a focused and orchestrated push toward the establishment of domestic DEFA stars, postcards with film stars (also already distributed in the 1950s) more frequently had East German actors adorning the picture side.[48] An annual poll in the youth magazine *Neues Leben* determined the most popular (DEFA) film star, showing how DEFA utilized various age groups to promote its films.[49] And instead of using the method of western companies who hired film stars to sell their products, DEFA actors modeled East German brands and appeared in magazines to bolster their star appeal and did not promote items made by people-owned companies in the planned economy.[50]

The modeling and promoting brands also had a second purpose. In order to stress the ordinariness of its stars, DEFA regularly sent actors to factories to mingle with the workers and even encouraged artists to "adopt" factory brigades to foster ties between them and the workers. Based on the notion of East Germany as the state of workers and peasants, the "East German star discourse clearly pursued a cultivation of the ordinary in the sense that the myth of a working-class background and of remaining within such a background were reinforced."[51] Many DEFA roles required the portrayal not only of antifascist heroes, communists, and resistance fighters, but also of workers building the new, socialist East German society. As an additional bonus, artists thus were able to observe the working conditions of those they had to play on-screen. One of the biggest DEFA stars, Manfred Krug, did not require this object-lesson on location: Before playing in live theater and starring in DEFA films, he had worked as an apprentice in an East German steel plant, making him a paradigm of this work-star relationship.

Once established as audience darling—the exclusive designation used for DEFA stars—Krug (and other DEFA stars) often were typecast to draw

audiences by raising expectations of character acting. For instance, as Krug "had earned a reputation for nonconformity and outspokenness," the "Krug persona remained present in the imaginations [...] as something larger than any one role, charging films with latent ironies and double meanings."[52] When he declared his decision to leave East Germany and was allowed to emigrate in 1978, East Germany lost a big star to West Germany. Similarly, Armin Mueller-Stahl who, like Krug, decided to draw the consequences after their friend and colleague Wolf Biermann had been expatriated. Mueller-Stahl, also a huge audience darling, left, first to West Germany and later became a well-known actor in Hollywood. In DEFA films, Mueller-Stahl regularly played the antifascist, socialist hero, whose on-screen actions supported the procedures of East Germany's political system.[53] His roles and performance style of "understated and restrained acting, small gestures and fixed gazes instead of verbal expressions [...] were open to different interpretations and ambiguity," allowing viewers who disagreed with East German politics to nevertheless relate to the characters played by Mueller-Stahl.[54] If attracting viewers was DEFA's main goal, the construction of such star personas that allowed multiple (and even subversive) readings of a film was an appropriate scheme.

The case of beloved DEFA star Erwin Geschonneck confirms that audiences identified with actors who played "believable" characters instead of being presented with whitewashed, idealized, socialist heroes. Geschonneck became a film star precisely because he refused to have his past as communist, actual resistance fighter, and prisoner of a Nazi concentration camp mythologized and translated into his film roles.[55] Instead, his film characters were often disruptive and unwilling to comply with the rules of society, skeptical and probing, and therefore carried an aura of authenticity spectators looked for in vain in other DEFA films. It would probably go too far to claim that DEFA built a double entendre of both challenging the official political discourse while complying with the parameters set by the SED on purpose. Still, many films allowed for multiple readings, and much of the more provocative interpretations in regard to challenging official politics were the result of certain types of film stars such as Geschonneck, Mueller-Stahl, and Krug.

Not all DEFA stars were subtly subversive or even allowed controversial interpretations of their on-screen personas. Günther Simon, the lead in the *Thälmann* films and later in *Der schweigende Stern*, was the epitome of a model star whose roles generally helped the cause of East German socialism.[56] Other non-German actors, in particular Serbian Gojko Mitic and American Dean Reed, were interesting for DEFA because of their ethnic origins. Reed left the United States of America and relocated to East Germany in 1972. He was cast quickly for DEFA films, even though his German was not good and his dialogue had to be dubbed. Reed nevertheless rose quickly into the group of best-paid film stars for ideological reasons: DEFA (and SED) capitalized more on the fact that he left the United States of America for East Germany rather than his acting abilities. Known as the

"Red Elvis" all throughout Eastern Europe, Reed's claim to fame were his songs.[57] Casting him in DEFA films brought two advantages: first, to have an Eastern European pop star appear in East German films legitimized DEFA productions as potential blockbusters, attracting audiences interested in seeing the pop star on-screen. Second, the fact that Reed was American added an ideological subtext to films that were ostensibly apolitical, suggesting that domestic film production by DEFA had become so significant that American actors were relocating to East Germany.

A somewhat different ethnic significance was the reason that the Serbian Gojko Mitic was cast to play the lead role in one of the new genre films of DEFA, the "red western" *Söhne der Großen Bärin* (*Sons of the Great Mother Bear*, Joseph Mach, 1966).[58] As a citizen of Yugoslavia—a country with somewhat of a special status in the Eastern Bloc because it was a bit more open toward the West than other socialist nations—Mitic first played small roles in the successful West German westerns of the 1960s. When the West German producers took notice of his well-built body, he was cast into more important roles. And as DEFA was looking to produce its own westerns, they went not only to the same locations the West German studios had used, but they also cast some of the Yugoslavian ethnic actors—among them Gojko Mitic in the lead role "as a physically more impressive counterpart to Winnetou."[59] Because his exotic physiognomy was unusual for DEFA productions, Mitic turned into an audience darling. From this point onward, DEFA benefitted from his status and continued to offer him further roles in the red westerns. Essentially, this self-perpetuating star status contributed to the tremendous success of the film genre of East Germany's red western.

Was DEFA a different film studio? Yes—and no. In many instances, DEFA compared to studios in Western nations, minus certain aspects that had little room in a socialist society. It helps to think of DEFA as a company operating on similar conditions than Western counterparts. The studio still needed to be competitive, even though it had no domestic competition in East Germany and a regulated market to guarantee distribution of the films. Despite of this beneficial setup, DEFA faced stiff competition in films imported to East Germany, in the growing market share of DFF, and in the easily available West German television channels. The involvement of politics into the day-to-day production process impinged upon creativity—but at the same time it ensured the production of films that would not have found financing in capitalist economies. Towards the end DEFA employed more than 2,500 people in its feature film studio alone, and even directors and actors who may have only participated in one or two productions per year received monthly salaries, making the studio a subsidy enterprise, as many other institutions in a planned economy such as East Germany's.[60] As these subsidies ensured continuous and regular funding, DEFA maintained a fixed annual production of 15 to 20 films. And like any other film studio, some of the films were bad—and others very good.

3

A CULTURAL LEGACY: DEFA'S AFTERLIFE

In December 1992, production of DEFA films ended for good when the French real estate firm Compagnie Immobilière Phénix (CIP) bought the DEFA feature film studio for 130 million German marks; renamed it Studio Babelsberg; hired Volker Schlöndorff, a renowned (West) German filmmaker as CEO; and began dividing the studio premises.[1] The trademark DEFA was dropped from the German trade register in 1994 when nobody claimed it. Further, without any organization actively promoting DEFA films, a complicated legal situation preventing large-scale commercial film distribution in the area of the old West Germany,[2] and no new films coming on the market with the DEFA logo, DEFA cinema appeared to die a quick death. Meanwhile, all East German movie theaters had been privatized and catered to the desires of a general public who were ignorant and indifferent about East German cinema or who preferred Hollywood productions to films they associated with their East German past. DEFA cinema disappeared from the public realm in post-unification Germany with the exception of the occasional late-night television broadcast or as a film retrospective. Hardly anyone seemed to miss DEFA films.

Now, more than 20 years later, the tide has turned completely. Since 1999, DEFA cinema has staged a comeback of unforeseen dimensions: the films have become hot commodities and are bestsellers on DVD and Blu-ray. Many retrospectives and film festivals play DEFA films frequently; a plethora of television channels broadcasts them; and an on-demand streaming platform, Icestorm TV, was launched in 2012 to deliver an ever-growing number of films to audiences. Even a DEFA fan culture established itself to celebrate East Germany's cinematic legacy with numerous, multifaceted activities such as fan writing, conventions, reenactments, and much more. DEFA's popularity has shifted within only a decade, and if one believes the number of films available for viewing across different media, appears to be growing each year. This resurgence did not come accidentally, of course. A series of purposefully conceptualized marketing strategies contributed to this turn in popularity, and even though no new films have been produced in a DEFA studio for more than 20 years, the name DEFA is now firmly established in the cultural life of post-unification Germany.

A snapshot of the current situation of DEFA film in Germany brings forward a number of institutions that have shaped DEFA's "afterlife," managing

the films as East Germany's cultural legacy by creating a well-functioning infrastructure to make them accessible to the public and by aggressively promoting active reception. The same institutions, most importantly the DEFA-Stiftung along with its longtime partner companies, the film distributor Progress Filmverleih and the home entertainment corporation Icestorm Entertainment, turned DEFA cinema into a figurehead of a relatively recent emergence of an eastern German regionalism. In a way, they "reinvented" DEFA films as a tradition of this region.[3] This development is even more remarkable given the fact that the last DEFA film appeared in 1994, Herwig Kipping's *Novalis-Die blaue Blume* (Novalis—The Blue Flower)—a curiosity in itself, since the DEFA studio no longer existed at that point. Now, DEFA lives on in its films. Otherwise, though, only a few traces remain in locations that used to be dominated by it.

Even on the former DEFA studio premises, there are hardly any remnants of DEFA. A large portion of the space was turned into a "media city" (*Medienstadt Babelsberg*), with studios for television stations, postproduction facilities, and soundstages for the DEFA successor Studio Babelsberg and a number of other smaller film companies, and converted office space for the German Radio Archive. But nothing on the premises still used for film production indicates that the space was occupied by DEFA for more than four decades. Only in one area, the theme park Filmpark Babelsberg, is a small portion of East German film history is still present.[4] In this theme park that is reminiscent of a German version of Hollywood's amusement parks and studio tours, visitors can stroll through the reconstructed set of DEFA's most successful film ever, Wolfgang Staudte's *Die Geschichte des Kleinen Muck (The Story of Little Mook*, 1953), called "The Gardens of Little Mook" (Die Gärten des Kleinen Muck).[5] Filmpark Babelsberg has undergone many changes to its setup and structure of the exhibits since the opening in 1991. The Gardens have been a staple from the beginning and are still an audience magnet 20 years later, suggesting that the popularity of the gardens is at least in part evidence of DEFA remaining present in the memories of East Germans. The Gardens thus serve as memorial of East German film history and link the DEFA past to contemporary filmmaking at Studio Babelsberg.

Another memorial to DEFA cinema, the Filmmuseum Potsdam, located only few miles away from the former DEFA film studio, has carried on the legacy in a different way. Since 1981, the former film museum of East Germany (Filmmuseum der DDR) has held exhibits about topics related to film. After unification and its rebranding as Filmmuseum Potsdam, the museum morphed into a (unofficial) DEFA museum, with most of its exhibition space dedicated to filmmaking between 1946 and 1990.[6] Here, original costumes, film scripts, set pieces, posters, props, and other objects used in connection with DEFA films give visitors a picture of the variety of East German cinema. The exhibit was changed and modernized in 1994, 2004, and 2011, yet even the current permanent exhibition, "The Dream Factory—100 Years of Film in Babelsberg," emphasizes filmmaking during the DEFA years.[7]

Aside from the Filmmuseum and the Gardens of Mook, no other tangible locations exist in post-unification Germany that convey the history of DEFA. In fact, it appears that following unification, DEFA had disappeared for good, along with the majority of its films. Very few movie theaters continued to book DEFA films, television stations broadcasted the films only in late-night slots (if at all), and viewers seeking DEFA films on videocassette looked in vain, as these films had never been released as home entertainment in East Germany.[8] In the 1990s, when eastern Germans began to recall their East German heritage, this lack of availability created a demand that could not be fulfilled at that point. This shortage of DEFA films in post-unification Germany was probably the most important factor that led to the renaissance of the films.

Soon after the sale of DEFA to CIP had been completed, another portion of East German cinema went up for sale—the former East German monopoly film distributor Progress Filmverleih. The German Tellux group purchased Progress in 1997 with a licensing package that granted Progress exclusive worldwide distribution rights to DEFA films until the year 2012.[9] In 1998, a confusing legal situation regarding ownership of DEFA films was finally resolved so that on January 1, 1999, the newly created non-profit foundation DEFA-Stiftung became the legal successor to DEFA and took possession of the entire DEFA film stock. Since then, DEFA-Stiftung has been in charge of commercializing the films and making them accessible to the public. The foundation has fulfilled its mission to preserve East Germany's cinematic legacy by cooperating with Progress as its distributor, using the German Federal Film Archive (*Bundesarchiv-Filmarchiv*) as a storage facility for the film negatives and production agency for film prints, and with the small start-up company Icestorm Entertainment as the exclusive distributor of DEFA films for the private home entertainment market.[10] In 1999, the infrastructure was ready for the reintegration of DEFA cinema into German visual culture. This may have happened on a small scale, marketing DEFA films for a niche audience interested in film classics, yet when their initial release on videotape coincided with a nostalgia wave for things from East Germany (termed *Ostalgie,* a compound of the German words for East and nostalgia), they turned into symbols of the East German past. The cooperation with Icestorm thus became the inaugural moment of DEFA's phoenix-like afterlife.

It is ironic only at first glance that a commercial agreement between a home video distributor and the successor institution to a communist film studio would aid in the resurgence of East German cinema. In fact, all over Eastern Europe, the former communist studios took a necessary turn toward commercialization to survive in the new market economies.[11] In Germany, the rights to DEFA films were even compared with "black gold" in 1995—although such a statement seemed rather optimistic given the otherwise bleak situation.[12] West German Gerhard Sieber took a chance on capitalizing on the potential of this huge, well-preserved DEFA film stock and launched his company, Icestorm Entertainment, in 1997. In his previous

position working for another home video distributor, Eurovideo, Sieber had encountered DEFA fairytale films frequently. When he learned that most DEFA films were not available on home video, he founded Icestorm with the intent to fill the market niche. As soon as the DEFA-Stiftung had begun its work in 1999, it awarded Sieber's company the exclusive rights to the films on home video. Icestorm came prepared, and within only one year released more than 80 titles on videocassette for purchase. The success story of DEFA films (and of Icestorm) had begun.

Icestorm approached the release of DEFA films methodically, assuming that eastern German audiences were longing to reencounter them as testaments of their personal past histories. Aiding in the dissemination of the movies was the situation that most eastern German households had acquired VCRs, often as their first purchase after the fall of the Wall to celebrate their newly gained freedoms with a product that had been unavailable in East Germany.[13] By the beginning of 1999, more than 75 percent of the households owned a device. The disappearance of DEFA films from other media such as television and movie theaters pushed eastern Germans look for the motion pictures on videocassette—unsuccessfully for the most part, as only few of the DEFA films exported by the East German film export company DEFA Außenhandel had been picked up by western distributors to be sold on video. Thus, the shortage of DEFA films on videocassettes coupled with the lack of general availability of DEFA movies revealed a gap in Germany's market economy. Yet filling this void and targeting primarily eastern Germans required prudence and the willingness to accept lower profit margins, as high unemployment was rampant in former East Germany; those with jobs earned substantially less than their colleagues in similar positions in western German regions—sometimes salaries were only at 70 percent of the value for the same work. Icestorm showed solidarity and priced the DEFA films with these audiences in mind, charging also only about 70 percent of the price for a film compared to the average market price of other videocassettes. This move suggested the films were meant to be affordable for everyone—ironically reminiscent of government subsidies for food and housing prevalent in East Germany. Even after the switch from videocassette to DVD a few years later, Icestorm kept prices lower than average, and even came up with another subsidy model that allowed them to almost give away their films by partnering with the eastern German tabloid *SuperIllu*. Marking the sixtieth anniversary of DEFA in 2006, a newly forged cooperation with *SuperIllu* allowed the dissemination of DEFA films in previously unexpected quantities. Since the September 2006 edition, *SuperIllu* has released monthly special issues containing a DEFA DVD supplement for nominal fee of €2 per disc, something still continuing in 2013. This high-volume agreement obviously does not yield high revenue, but the promotional aspect stands in the foreground. The magazine reaches approximately 3.7 million readers weekly, making the DVD insert a lucrative means of advertising DEFA films to a large circle of viewers and potential customers. The strategy is paying off: The Icestorm catalog is continuously expanding and currently offers

more than five hundred titles on DVD and Blu-Ray discs, and since the end of 2012, also has a growing selection of films via its own video-on-demand platform, Icestorm TV.

The low price of the films unquestionably helped to market them to an already keen audience waiting to see many movies they knew well and that triggered pleasant memories. In the first year, Icestorm chose features that promised to become immediate bestsellers. Almost all of the rabbit films (*Kaninchenfilme*) of 1965—a group of films that were banned after the Eleventh Plenary Meeting of the East German communist party—but also many of the DEFA fairytales that had motivated Sieber to found Icestorm, and also the westerns (*Indianerfilme*) starring DEFA star Gojko Mitic were among the first films to come out.[14] This first wave was a tremendous success. The banned films were particularly attractive, since they had been taken off the blacklist and had premiered in movie theaters only shortly before unification in 1990. Now that those films were available on videocassette, audiences appreciated the experience of critical DEFA films they had been deprived of for over 30 years. Some customers contacted Icestorm directly to thank them and to make requests for further releases. This audience feedback and possibly the revenue generated by the sales of these first films warranted the video production of both a number of antifascist films—another classic genre of East German cinema—and the well-known literary adaptions of classic German literature by Johann Wolfgang Goethe and Friedrich Schiller. By 2002, Icestorm offered over two hundred DEFA films for the home video enthusiast and had established itself to tackle the more controversial movies promoting ideological topics. For instance, audiences requested the two-part biopic *Ernst Thälmann-Sohn seiner Klasse* (*Ernst Thälmann—Son of His Class*, 1954) and *Ernst Thälmann-Führer seiner Klasse* (*Ernst Thälmann—Leader of His Class*, 1955) by Kurt Maetzig, examples of a propagandistic filmmaking many East Germans despised but had been mandated to watch.[15] Icestorm released a small number of copies in 2000 to cater to customer feedback—and to fulfill the mandate of DEFA-Stiftung to make the films accessible to the public, regardless of their content. However, it is doubtful if that release would have taken place without the previous success of the more popular films.

The timing for the release of these politically "loaded" films coincided with the success of contemporary films such as *Sonnenallee* (*Sun Alley*, Leander Haußmann, 1999) and *Good Bye, Lenin!* (Wolfgang Becker, 2003) and television shows such as *Die DDR Show* (*The East Germany Show*) that called attention to the East German past. The celebration of "authentic" East German products such as the Spreewald Pickle and Trabant cars in the media offered the opportunity to capitalize on the popularization by selling the films as representations of East Germany. Much of this *Ostalgie* retro cult was also embraced in Germany's western federal states, though DEFA films did not nearly become as popular as other commodities. For one, western German audiences generally were unable to decode much of the cultural information or identify with the stories. Recognition of the films

was crucial in their marketing, something western Germans lacked, as most of the films either had never been screened in the West or only to very limited audiences. In eastern Germany, on the other hand, interest perpetually grew among audiences of all ages, genders, and social statuses when older viewers reencountered the films from their East German past and shared these with their children. That younger generation with only a distant or no knowledge at all of life in East Germany had been swayed by the pop cultural phenomenon *Ostalgie* and approached the films from other angles: first, the style of DEFA cinema was unusual in pace, acting, humor, sound, and more, and differed substantially from the films they usually watched. Some of the films, such as *Heißer Sommer* and *Die Legende von Paul und Paula* had an immediate impact, often evoking a camp aesthetic, and therefore turned into cult films for this new generation.[16] Second, to a young generation of eastern Germans, growing up in a unified, democratic, and capitalist Germany with individual freedom was the norm. As their experience differed radically from that of their parents, who had spent their lives in an opposite system of which only traces had survived unification, DEFA films acted as testimonies of such an existence that allowed intergenerational communication. In those films, the lives of their parents and grandparents in a totalitarian German society came to life and challenged the picture of everyday life they had experienced in new *Ostalgie* films such as *Sonnenallee* (*Sun Alley*, Leander Haußmann, 1999), *Good-Bye, Lenin!* (Wolfgang Becker, 2004), and television shows. DEFA films had developed into significant testaments of a past East German history that was gradually pushing back, demanding its place in German history.

However, the popularity of DEFA cinema is a post-unification occurrence that for the most part did not have any representation in East Germany, where the films often had trouble attracting audiences. It required an elaborate marketing process to establish DEFA pictures as "products" of East Germany, using the past to turn the films into surrogates of history. As Eric Hobsbawm observed, "Inventing traditions [...] is essentially a process of formalization and ritualization, characterized by reference to the past."[17] The resurgence of DEFA cinema is then not merely the result of an organic development of nostalgia for the East German past; it also rests on the prerequisite of putting to use this past to create a demand for the films. At the same time, continuous innovation has become necessary to sustain interest in them now that the *Ostalgie* wave has passed. The DEFA-Stiftung accomplished this by restoring and releasing a number of never-before-seen, banned films. Between 2002 and 2010, four formerly banned films were completed and premiered successfully in Germany, celebrated as the recovery of "lost" films. The series started with the complicated reconstruction of the 1958 film *Die Schönste*, which was banned in 1959 and never released because the film no longer existed in its original form. Based on screenplays and other documentation, the restoration team discovered not one, but two versions of the film made by two directors, Ernesto Remani in 1958 and Walter Beck in 1959. DEFA had hired Beck to take over the project when Remani's version

was not approved because of ideological problems. Yet even Beck's edits did not change the mind of the censors, and all of the material was archived in its unfinished state until the restoration process 40 years later. After the time-consuming restoration, a two-DVD set containing both films and extensive bonus features documenting both the censoring and the reconstruction process was released, making *Die Schönste* the first "new" DEFA film to be released in a decade—and the first DEFA movie that premiered under the authority of the DEFA-Stiftung. A reconstruction of another banned film, *Fräulein Schmetterling*, followed in 2005; this time, however, its release was only to the big screen as a version that retained the character of a censored film; dialogue passages that could not be reconstructed were replaced with subtitles, and each screening of the film was accompanied by an introduction explaining the banning and reconstruction of the film. In 2010, the two most recent feature film reconstructions, the crime comedy *Hände hoch, oder ich schieße*, originally produced in 1965 and also forbidden after the Eleventh Plenum, and the 1973 drama *Die Taube auf dem Dach* premiered within a short amount of time of each other in theaters and then on DVD. Within only eight years, audiences had gained access to a total of five DEFA films never before been screened.

By releasing "new" films, DEFA cinema entered yet another stage of its afterlife. Even though the movies were technically not new productions but reconstructions of previously unfinished or unreleased films, their allure was based on the fascination of audiences with a cinema of a past culture they could relate to that continued to reveal its treasures over time. Furthermore, contemporary audiences validated the work of the DEFA-Stiftung by coming to screenings of the films. For instance, *Hände hoch, oder ich schieße* drew 16,500 people to cinemas through mid-2011, and it sold more than 3,600 DVD copies by the end of 2010—numbers that would have been idealistic for a West German film from the same year.[18] Overall, DEFA-Stiftung, Progress, and Icestorm facilitated access to DEFA films to fuel the demand for visual documents of the past. Along with the sales figures of DVDs, Progress distributed 540 films to television, and more than 100 thousand people attended public screenings in 2009 alone, a number that is bound to increase with the new releases that have since taken place.[19]

Perhaps even more remarkable than the completion and release of previously damaged films by the DEFA-Stiftung was how audiences proceeded beyond a passive reception of the films to form a network of DEFA film enthusiasts. In a complete reversal of preunification times when the films were ignored in favor of western film imports and even despised as products representing the political status quo, the contemporary interest for East German cinema is based on individuals' interests and choices, not official doctrine. DEFA fandom is grassroots-driven and works independently, operated individually or as groups of fans sharing a common interest in either specific DEFA productions or DEFA cinema in general. As there is no umbrella DEFA fan club or comparable organization to coordinate fan activities, host, and organize events, or to provide an infrastructure on the

web, fans of DEFA cinema often do not necessarily know each other. Here, Bendedict Anderson's idea of an imagined community comes to mind, as the members of such a community "will never know most of their fellow-members, meet them, or even hear of them, yet in the minds of each lives the image of their communion."[20] What unites many DEFA fans is a desire to revisit their past; others seek out the films to retrace East German history and culture in the narratives of the movies, and some embrace them not as reminders of anything historical, but for their stories, camp value, or other cinematic characteristics not related to their East German past at all. A lively fan culture has developed—arguably the best evidence to demonstrate the popularity of DEFA.

Since the 1990s, one can trace activities of DEFA fans that commemorate and celebrate the films by, for example, setting up websites and blogs, publishing books, and even by organizing small-scale fan conventions. They lobby for new editions of films on Blu-ray or with more extensive bonus material, and they request film soundtracks on CD or for MP3 players. Some are inspired by the films to produce their own artwork, such as jewelry, paintings, music, and photography. There is even an active network of fans that share (illegally) DEFA films via peer-to-peer networking. Although DEFA-Stiftung, Icestorm, and Progress would certainly not be pleased to learn about these activities that infringe on their copyright, it shows the excitement that exists about the films.

The most frequent fan activities consist of creating and maintaining websites. Most renowned are www.defa-fan.de, a website celebrating the fandom of site owner Jens Rübner, along with a brief introduction to the best-known genres and film periods of DEFA cinema; and DEFA Sternstunden (www.defa-sternstunden.de), an online DEFA encyclopedia run by sisters Katrin and Uta Zutz that also informs readers when the films will be broadcast on television. Rübner has also self-published a number of books about DEFA, and Team Zutz, as the sisters call themselves, offer an online guestbook and forum for the exchange of information among DEFA fans. Information found on their websites preceded the web presence of the DEFA-Stiftung and may have served as model for the "official" DEFA websites.

Other fans engaged more creatively with DEFA films by doing mash-ups and reappropriating them to create their own art. In a "poaching" of the DEFA musical *Heißer Sommer* in 2010, YouTube user "frischbeton" uploaded a video response to the well-known Matthias Fritsch video *Technoviking* (2000).[21] "Frischbeton" combined a techno-beat with the title theme of the DEFA film to have the technoviking dance in step with his musical variation to create a rather amusing piece for those familiar with the dancing scenes in the East German film.[22] Another example of a flourishing fandom of East German cinema is one of the most active and varied fan group among DEFA fans that was founded to celebrate the DEFA fairytale *Drei Haselnüsse für Aschenbrödel* (*Three Nuts for Cinderella*). Abbreviated by the acronym 3HfA, the fandom unites a large variety of activities centered on the film, ranging from jewelry copied from the necklaces worn by the actors, music

and songs inspired by the film, a cellphone ringtone, Barbie dolls, coffee mugs, and even pralines. Two annual conventions allow fans to dress up in fairytale garb, reenact their favorite scenes with other fans, and keep up-to-date with most recent developments.[23] In all, contemporary DEFA fandom exhibits all customs and traits of a lively film culture serving a wide array of fans, some who celebrate one film only and others who enjoy a much larger corpus of DEFA movies.

The growing popularity and increased presence of DEFA movies since the 1990s inspired references to them in film, music, and art. For viewers of Leander Haußmann's *Sonnenallee* who were familiar with the DEFA film *Die Legende von Paul und Paula*, a cameo appearance of Paul (played by Winfried Glatzeder) and a doorbell nameplate reading "Paul und Paula" was more meaningful than for others without knowledge of the film. Familiarity with the DEFA story also explains the choice of music and certain lines in the dialogue, but even more, allowed eastern Germans to read *Sonnenallee* as a partial spoof on the DEFA film. Already a cult movie in East Germany, *Die Legende von Paul und Paula* also inspired a remake into an opera that debuted in 2004.[24] Even German pop artists could not resist the legendary love story of Paul and Paula: the band Rosenstolz paid homage to the film in their 2008 song "Ich bin mein Haus" ("I Am My House").

Internationally, DEFA films have had significant impact, too. In the past years, DEFA-Stiftung organized retrospectives of films in Brazil, Japan, Israel, the UK, and the United States of America. In fact, the founding of an East German film archive, the DEFA Film Library, by Barton Byg at the University of Massachusetts at Amherst in the early 1990s has since allowed numerous scholars to study East German cinema without having to travel to Germany. In addition to a research collection of many DEFA films for rent and more than one hundred films in subtitled versions available on DVD, the DEFA Film Library also stores a number of original film prints in a former NATO bunker located in the hills around Amherst, and sends them out for public screenings. Biannual summer film institutes open to researchers of East German cinema, DEFA directors lecturing at US and Canadian universities, and a growing number of public screenings of DEFA films in movie theaters attest to the fascination with the films that for a long time were inaccessible behind the Iron Curtain. In 2005, the Museum of Modern Art in New York City even curated the retrospective "Rebels with a Cause: The Cinema of East Germany" to display for the active afterlife of DEFA cinema.

Obviously, it is impossible to predict how DEFA cinema will develop in the future. Current developments indicate that the commercialization will continue beyond the feature films to preserve and make accessible documentaries, newsreels, and other genres (not included in this book). If one takes the competition for the distribution rights in 2012 as an indicator, a bright future lies ahead for East German cinema. More and more, the field of film studies appears to discover the films and to acknowledge not only their contribution to German film history but also their position in international film.

East German cinema will act as link between the understudied cinemas of eastern European countries and those of western European nations, allowing the discovery of parallels, cooperation, and coproduction agreements between them even during the Cold War, to name but one example of future possibilities. Increasingly over time, DEFA films will lose their sometimes still-tainted images as propaganda products and become "normal" films. All the important structures are in place—now it is up to audiences to discover.

Part II

Freezes and Thaws: Canonizing DEFA

The study of East German cinema has one big advantage over many other national cinemas: it is a closed field. As a result of German unification in October 1990, the national cinema of East Germany ceased to exist, and not much later, in 1992, DEFA folded operations when it was sold and renamed. Once the funds to finance the last productions had dried up, the last chapter of DEFA as a film producer had been written. East German cinema lasted from 1946 to 1992.

However, in these 46 years, DEFA produced almost nine thousand films overall, of which almost eight hundred were feature films. In the 2001 printed lexicon of DEFA feature films by Frank-Burkhard Habel, a synopsis and a brief analysis of each film covers 758 pages.[1] These numbers alone indicate that it takes a substantial amount of time to at least read about, if not view, these films. Without guidance, one would be lost in this film jungle, not knowing where to begin watching. If required to restrict oneself to a limited number of films, how can one still get a relatively accurate impression of DEFA film?

As such a first impression will be a lasting impression, it is important to select carefully and choose films that make the viewer long for more. At the same time, it is important to select those productions that left the most impact at the time of their release or those that are still watched by many viewers. Finally, in the case of East Germany, such a canon of films must take into account the political circumstances and influences accompanying each production coming out of the centralized film monopoly. With few exceptions, DEFA cinema equals the cinema of East Germany, and the dozen films that make up the canon of this book are influenced by the day-to-day politics of that socialist nation.

If there is one DEFA film that belongs in every canon, it is the very first feature film, Wolfgang Staudte's *Die Mörder sind unter uns* (*The Murderers Are among Us*, 1946). It is, one could say, a bookend to the rest of the films. It opens the short-lived genre of the predominantly East German rubble films, shot in the remnants of Germany's bombed-out cities. These rubble films tell tales of loss and hope, coping with the Nazi past, and rebuilding the nation—at this time, though, divided into four occupation zones and the four sectors of Berlin. Almost equally uncontested is the second

feature, *Die Geschichte vom Kleinen Muck* (*The Story of Little Mook*, Wolfgang Staudte, 1953). As East Germany's most successful film ever, with over 13 million viewers, it is another film by Wolfgang Staudte, one of DEFA's eminent directors of the "first hour"; it is also the best example of a transnational director who also worked for West German companies and left DEFA at a time when politics were taking over. Released in 1953, a year of major strikes, unrest, and violent riots in East Germany, the fairytale film barely reflects the beginning of a series of alternating "freezes" and "thaws" in East German cinema; the former were periods in which DEFA filmmakers had to follow strict guidelines for filmmaking, set by politics, and to endure harder censorship than during the periods of "thaw." *Mook* also represents a large batch of fairytale films and films produced for children that became one of DEFA's hallmarks in the years to come, and a genre that many other nations admired East German cinema.

The film *Berlin—Ecke Schönhauser* (*Berlin Schönhauser Corner*, Gerhard Klein, 1957) stands for the group of Berlin films that address the topic of the divided city from an East German perspective, trying to translate ideological borders into film. While DEFA produced a number of these films, *Berlin—Ecke Schönhauser* allows an easy comparison with films about teenage rebellion from other nations in Europe and overseas. Similar comparisons may also come to mind with DEFA's first sci-fi film, *Der schweigende Stern* (*Silent Star*, Kurt Maetzig, 1960). No DEFA canon would be complete without a science fiction film, and this one in particular, as it marks the birth of East German genre film. Director Kurt Maetzig, another founding member and perhaps the most eminent person of DEFA, also directed the film *Das Kaninchen bin ich* (*The Rabbit Is Me*, 1965). This film was among the first to fall victim to another period of ideological freezes, and became the eponym to the group of the 1965 East German feature films often known as "rabbit films," which were all banned as result of a political turn. While other films, such as *Spur der Steine* (*Trace of Stones*, Frank Beyer, 1966), would have been good alternatives, Maetzig's film allows better insight into the parallels of East German cinema and other European new waves.

The selection of *Heißer Sommer* (*Hot Summer*, Joachim Hasler, 1968) is again easy to justify because it belongs to the genre of the musical film and allows insight into the lighter side of DEFA cinema like few other films. At the same time, its eminent status due to its immense popularity raises the question of the role of entertainment cinema in a socialist society, and in particular makes us wonder why the musical film was merely DEFA's stepchild if it was so enjoyed by audiences.

Choosing a film from DEFA's most beloved genre, the "Red Western," proves to be much more random: most of them featured one star, Gojko Mitic, who was then typecast into the role as Native American. The selection of *Apachen* (*Apaches*, Gottfried Kolditz, 1973) hinged upon the fact that it is one of the three subtitled East German "Westerns with a Twist."[2] In the same year, benefitting from a new "thaw" period that had started in 1971, another one of DEFA's eternal blockbusters, *Die Legende von Paul*

und Paula (*The Legend of Paul and Paula*, Heiner Carow, 1973), came out. As this film set new standards in the depiction of gender imbalance in East Germany—and dared to show sex scenes on-screen—challenged the liberties of artistic freedom. It is as much a landmark of DEFA as the 1974 antifascist film *Jakob der Lügner* (*Jacob the Liar*, Frank Beyer, 1974). This film is unique because it belonged to one of DEFA's largest and longest-lasting genres, was East Germany's only nomination for an Academy Award, and had the questionable honor of being "remade" in Hollywood.

Solo Sunny (Konrad Wolf, 1980), on the other hand, represents a much smaller group of films that could be subsumed under the umbrella term "women's film." Once more, this film stands out against others because of its director, Konrad Wolf. Instrumental in East German cinema as part of another generation following the foundational members, Wolf's oeuvre influenced much of DEFA's filmmaking for many years; however, *Solo Sunny* remains a very special film because it differs from his other movies and was his last film before his death. DEFA's last film *Die Architekten* (*The Architects*, Peter Kahane, 1990), the other bookend (to the first film *Die Mörder sind unter uns*), is also a special film that deserves, if not requires, to be studied as a historical document in two ways: one, as a document of an East Germany in dissolution (Kahane was frantically trying to capture authentic images while the opening of the Berlin Wall made his film superfluous), and two, as a testimony that in fact concludes the history of DEFA as East Germany's national cinema. However, including *Letztes aus der Da-Da-eR* (*Latest from the Da-Da-eR*, Jörg Foth, 1990) shows how the end of socialist East Germany meant a coda for DEFA in a democratic East Germany that allowed a final glimpse at the potential of cinema that had it not been influenced, regulated, and manipulated by East German politics. Like no other of the films of the political turn, Foth's film represents the angst of giving up the past, which, although not great, was familiar, and offered the chance to turn East Germany into a democratic society, whereas unification with West Germany would turn it into an appendix. It turned out that Foth was right, and in retrospect, *Letztes* anticipated the problems of East Germany's missing legacy in united Germany.

4

The Rubble Film, Wolfgang Staudte, and Postwar German Cinema: *Die Mörder sind unter uns* (*The Murderers Are among Us*, Wolfgang Staudte, 1946)

In 1946, German film director Wolfgang Staudte knocked on the doors of the commanders in charge of occupied Berlin to receive a license for a film entitled *Der Mann den ich töten werde* (The Man I Am Going to Kill). His idea was rejected in the three Western sectors; in the Soviet sector, however, he was granted the license to shoot what became the first German feature film made after World War II. When it premiered under the title *Die Mörder sind unter uns* (*The Murderers Are among Us*) on October 15, 1946, it represented the first feature film by the newly founded Deutsche Filmaktiengesellschaft (DEFA). *Die Mörder* became an instant success—and a timeless classic of German cinema, as its selection as sixth-most important film of German cinema attests to.[1] The film continues to fascinate audiences, from the 1975 Berlin International Film Festival to moviegoers of the 2006 retrospective of DEFA cinema at the New York Museum of Modern Art. Many factors contributed to making this story set in postwar Berlin not only a milestone of DEFA but also of German cinema.

When the young woman Susanne Wallner (played by future German star Hildegard Knef in one of her first roles) returns to her former apartment in the rubble of 1945 Berlin, she finds it occupied by Hans Mertens, a medical doctor who no longer practices his profession due to Post-traumatic stress disorder after serving in World War II. Mertens, who had been assigned to a troop of the German Wehrmacht in Poland as military surgeon, deals with his memories of wartime by drowning his guilt in alcohol in Berlin's variety shows night after night. Wallner was liberated from a Nazi concentration camp where she was imprisoned for political reasons—presumably because her father was either a communist, an active resistance fighter, or both—moves back into the apartment.[2] Over time, the roommates become friends and then lovers. Although their love is marred by Mertens' frequent returns home only in the morning hours after nights of heavy drinking, it prevents an act of vigilant justice on Christmas Eve, 1945. Mertens is about to shoot

his former Wehrmacht captain Ferdinand Brückner to avenge an order from Brückner three years before. On December 24, 1942, the captain had ordered his troops to shoot 36 men, 54 women, and 31 children after occupying a Polish town—and then celebrated Christmas, an event that Mertens was unable to cope with afterward. As he gets ready to pull the trigger, Wallner steps in, and pleads with Mertens to leave justice to the authorities. In the final scene, Brückner is shown in a prison cell, waiting to be tried for his war crimes. The protagonists of the story and its subplots are allegories of parts of German society. Susanne Wallner stands in as the imprisoned communist returning from the concentration camp, Hans Mertens is the collaborator tortured by his guilty conscience who needs a cathartic experience (saving a child's life in the ruins of postwar Berlin) to find closure, and Captain Brückner exemplifies the thousands of former Nazis who either escaped the trials "whitewashed" or avoided them altogether and returned to public life as if nothing had ever happened.[3]

In Staudte's original script, Mertens kills the former Nazi captain, not only to take revenge for the more than a hundred Polish civilians but as settlement of a universal debt of crimes against humanity. The final series of superimposed images suggests these crimes: The picture of a family, consisting of a father, a mother, and their child fades into that of two soldiers, who fade into the final series of shots depicting a large gravesite marked with crosses, to represent the millions of casualties World War II had claimed. At the same time, this abundance of crosses becomes problematic, since they associate Christianity as religion for the victims, even though six million Jews were killed during the Nazi terror in Europe. Additionally, the depiction of Susanne as political prisoner and not as a Jewish inmate of a concentration camp in the first German film after the war at least raises the question of accountability and responsibility of Germans for the Holocaust. *Die Mörder* falls short of addressing the fate of Jews by remaining ambiguous about the recent past. For instance, the film stresses the suppression of the Holocaust in postwar Germany, such as in the scene we see Brückner enjoy coffee and eating a sandwich wrapped in a newspaper bearing the headline, "Two million Jews gassed"; he appears unaffected by the unimaginable dimension of this crime against humanity. At the same time, *Die Mörder* still alludes to the fact that some Jews survived the Holocaust. Signified in a typical Jewish name Mondschein, the optician awaits news about his son, whose letter from the United States of America only arrives after Mondschein dies. We never learn if the optician is indeed Jewish, if the son successfully escaped the Nazi concentration camps, and what happened to the rest of his family, but the film prompts reading Mondschein as Jewish survivor who is ready to forget the atrocities, according to his conversation with Susanne Wallner about being able to move on after the war. Taken altogether, *Die Mörder* treats the Holocaust as a side note of history to create a general, antifascist narrative about the psychology of survivors and perpetrators alike.

Given the production conditions of the film, the focus on antifascism instead of the Holocaust is not surprising. In retrospect, Staudte seemed like

the ideal candidate for a film supported by the SMAD. He had started to work on the script for *Die Mörder* while the Nazis were still in power, risking his life as he had already been banned from the theater stage in 1933 for political reasons.[4] Committed to antifascist ideals, Staudte had found employment after the war, dubbing Russian films into German. These films were then screened in the Soviet-occupied sector of Berlin as part of a reeducation program for the German population that had been implemented by the Allied Forces in their respective sectors.[5] Staudte was affiliated with the group Filmaktiv, DEFA's predecessor, and participated in a November 1945 meeting that ended with a proposal to the SMAD for the creation of a new, critical German cinema.[6] When the proposal was approved, it was Staudte who filmed his first footage for the Filmaktiv in January 1946—a fortnight before Filmaktiv cofounder and iconic director Kurt Maetzig began his work on the newsreel *Der Augenzeuge* (*The Eyewitness*). Staudte's active participation in the fledgling film culture located in the Soviet sector of Berlin may have been one of the reasons why his original script to *Die Mörder* was turned down by all three Western Allied powers. After being sent away by the British in his "home sector" and rejected by the French and the Americans (whose cultural officer Peter van Eyck even told him no German would make a new film for the next 20 years),[7] Soviet cultural officer Major Alexander Dymschitz invited Staudte back, granting him the rights to the film on May 4, 1946—nine days before DEFA's official inauguration.[8] However, Dymschitz requested that Staudte change the ending of his film to eliminate the murder scene. Regardless of its well-meant intention, this request marked the first instance of censorship—even before the first DEFA film had even been started.[9] Thus, *Die Mörder*, the first DEFA film, was already dependent on the politics of the day to the end of reeducating and removing fascist ideology from the minds of Germans.[10] In the following decades, antifascism remained one of the fundamental narratives of DEFA.[11]

The film was an instant success, and more than 6.5 million tickets were sold in Berlin and the Soviet occupation zone.[12] Audiences, however, often left screenings with mixed emotions. To them, going to the movies meant to escape reality for a while, but *Die Mörder* touched on difficult subjects like life in the rubble, coming to terms with the recent Nazi past, negotiating personal guilt, concentration camps and the Holocaust, and the fact that a complete new beginning—a "zero hour" for Germany—was not possible. Being reminded of the daily tribulations instead of escaping into the glamorous world presented by the films from Hollywood, France, and the UK that played elsewhere proved trying for German audiences. Yet Staudte believed that reflecting thoroughly on Germany's recent past was essential to a new beginning to avoid the errors of the past.[13] *Die Mörder* thus represents a necessary milestone in the overcoming of both National Socialism and Nazi cinema, as well. For Staudte, it was also a personal matter, since he and other members of this team were involved with the film industry of the Third Reich: Staudte had directed features and shorts and played numerous roles, even in the infamous Nazi propaganda film *Jud Süß* (*Jew Suss*, Veit Harlan,

1940). Ernst Wilhelm Borchert, playing Hans Mertens, was even arrested by American forces when it was discovered that he had misrepresented his involvement with National Socialism on an official questionnaire—supposedly the reason why he was not on the posters advertising the film.[14] Even Hildegard Knef had learned her trade in the Nazi-controlled film school and played minor film roles. They all confronted Germany's dark era by working on this film to help German audiences reflect on the immediate past, shoulder responsibility, and commit to antifascist ideals by identifying war criminals as one way to repent.

Early on in the film, *Die Mörder* introduces the ubiquitous rubble that would become the eponym for an entire genre, the rubble film. Eventually produced in all occupied zones and sectors between 1946 and 1949, these rubble films were reminiscent of Italian Neorealism. Both types of films zero in on common themes and motifs: returning soldiers struggling with reintegration in society, people trying to cope with their fascist past, and survivors searching for idols and ideals—motifs that portrayed reality instead of illusion and encouraged identification instead of escapism.[15] Some audiences disliked *Die Mörder*, the first film in this genre, for the realism evoked by shooting the outdoor scenes in the actual rubble of Berlin. Extended sequences depict the drab reality of bombed-out buildings, streets barely cleared of the remnants of destroyed houses and lined with piles of rocks, bricks, burned-out tanks and cars, and even makeshift graves with wooden crosses and helmets. The film begins with a sequence depicting life in the rubble of the bombed-out city, setting the film in a contemporary environment all too familiar to audiences. In the first few scenes, the camera is set in the middle of the rubble, capturing a long street of destroyed apartment buildings that look uninhabitable at first glance. The camera then slowly pans to the left and captures a group of young children running around and playing in the rubble, as well as smoke, perhaps from a stove, billowing out of one of the ruins, suggesting that people do reside in the debris. Eventually, the camera stops and tilts up to rest on a sign that advertises a cabaret with "dance–good mood–humor," further reinforcing that life goes on in the rubble. The picture dissolves into a series of shots featuring a steam train overflowing with people, some of whom even hang off the engine and hold on to the outside—a sequence taken from footage shot and used by DEFA for their newsreel program *Der Augenzeuge*, and therefore likely recognized as authentic by audiences. The camera cuts to a different location, mounted on top of the train engine, to allow the view of the rubble left and right, before it cuts back to a location at the entrance to the covered train station. Set there, behind a steel beam that obstructs our view partially as it follows the train into the station, the position of the camera takes full advantage of the rubble that dominates the city horizontally and vertically. Because extended sequences like these reflected the bleak landscape and reiterated subject matters many Germans sought to escape by going to the movies; one can easily imagine the resentment of audiences toward a film that was probably perceived as overly moralizing and overly psychological, exploring such issues as guilt.

If *Die Mörder* was simply a moralizing story, it is unlikely that so many spectators would have come to see the film, no matter how well-heated the movie theaters or the need to be among others. Wolfgang Staudte used a number of cinematic techniques, however, to turn a didactic story about the Germans' need to repent their war crimes into a visually remarkable piece in the tradition of German expressionism. *Die Mörder* probes the mental condition of Germans after the war, and with canted camera angles, the distinctive use of light and shadow, and unsettling scenery of the landscape, calls to mind a mise-en-scene prevalent in German cinema when expressionist filmmakers explored the human psyche through their films in the 1920s. In fact, if we follow how Staudte makes use of canted angles and of low- and high-angle shots throughout the film, we realize that these help audiences gauge the level of emotional stability. Canted angles in *Die Mörder* are used in a conventional fashion: they communicate a sense of uneasiness and instability in the German psyche. The film opens with a number of them; for example, when we follow Mertens through the rubble and when a confused Susanne arrives at the train station, we immediately relate to their disorientation in a world in turmoil. The same angles reappear in other cases, such as when setbacks happen in the interpersonal relationship between Susanne and Hans (for instance, when he does not come home after a night of drinking at the bar) and in the séance by Mr. Timm and the optician Mondschein, who is trying to get news from his missing son by way of having Timm augur his whereabouts. The canted angle accentuates the gloomy mood conveyed by the plot further, much as it did in the silent films of German expressionism, and often, the addition of either high-angle shots (as in the case of a drunk Mertens chatting with the girls at the bar) or low-angle shots (as with Mertens and Brückner walking through the rubble together) bolster the emotions further. Even buildings and objects take on the asymmetrical shape known from German expressionism. The partially destroyed buildings and the rubble create a surreal landscape dominated by oblique lines, the broken windows and the cracked walls in the apartment of Susanne and Hans remind of the haunted buildings in German silent films, and the equally crooked poster of Germany and bar sign clearly show the disarray of the world the protagonists live in. In comparison, when the camera shoots at eye level and lacks the canted angle, periods of calm and harmony prevail in the lives of the protagonists (see figure 4.1), also allowing audiences a reprieve from the tense mood.

As with the oblique angles, Staudte makes recurring use of another distinguishing mark of expressionism—the interplay of light and dark—to literally bring to light the psychological condition of the protagonists. As the central figures are representations to sketch the various German characters after the war and their roles during the Nazi regime (the victim, the perpetrator, the bystander), *Die Mörder* takes great care to indicate their disposition by the way they are illuminated. Susanne, for example, is usually well-lit to suggest her innocence, her pure character, and her unabated sense of justice. Many scenes feature her in a chiaroscuro effect with the dark background

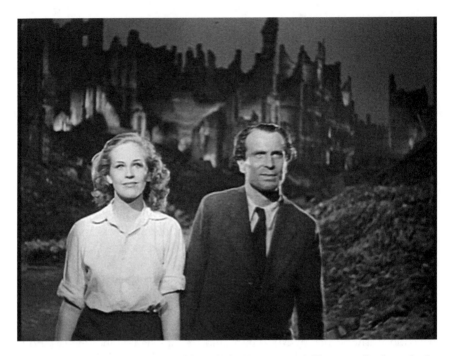

Figure 4.1 The well-dressed, well-lit couple, Susanne and Hans, strolls through the "expressionist" background of the destroyed city, captured by a camera positioned at eye level. DVD screen capture, *Die Mörder sind unter uns.*

as way to underscore her aura. Hans Mertens, on the other hand, alternates between scenes of low-key lighting casting shadows across his face when he is affected by a negative mood and lighting similar to Susanne's in moments of happiness. One of the most powerful moments of the film, the "face-off" between Mertens and Brückner in the closing sequence is dominated by Merten's large shadow that begins to overlay and eventually encases Brückner completely. Here, Staudte borrows from expressionist films such as *Das Cabinett des Dr. Caligari* (*The Cabinet of Dr. Caligari.* Robert Wiene, 1920) and *Nosferatu* (Friedrich Wilhelm Murnau, 1922), in which shadows on walls signal life-threatening events; however in *Die Mörder*, Susanne arrives in time to prevent the killing of Brückner.

By employing the patterns of light and darkness familiar to audiences from filmmaking in Weimar Germany, Staudte positions his film in the tradition of these "golden years" of German cinema and clearly sets it apart from Nazi films. He establishes the antifascist narrative in a DEFA film not only in the story but perhaps even more convincingly in a visual style that links the cinemas of Weimar with that of a postwar Germany. As he constantly illuminates Susanne Wallner throughout the film with three-point lighting to indicate her moral superiority and purity, Staudte creates her as the archetype of a new German. It is therefore no coincidence that Susanne

returns from the concentration camp not as a Jewish survivor but as a communist, ready and capable of starting the creation of an antifascist German nation based on the values of justice and mutual understanding. Much like her, Hans Mertens also represents hope by showing how the new Germany needs to look forward by referring to democratic structures for the persecution of war crimes. With this consideration in mind, it is no longer puzzling why the couple appears well-dressed and well-nourished. *Die Mörder* is as much a romance to help audiences retain a positive outlook on the future as it is a reminder not to forget the recent past.

Die Mörder was not only Germany's first postwar feature film production, it also became one standard for DEFA cinema addressing the recent German past. DEFA produced lighter entertainment fare that catered to the escapist needs of the German population after the war, as well. Films were produced with the intention to show them first in the other sectors and zones, and after the founding of the new countries, in West Germany, too. Some directors, such as Wolfgang Staudte, shot films for both DEFA and West German companies at the same time, making them border-crossing commuters (*Grenzgänger*).[16] No matter which side of the Iron Curtain Staudte worked, his films remained critical of state-sanctioned authority, causing the West German magazine *Der Spiegel* to call him politically immature.[17] Staudte left DEFA for good in 1955 when his film *Mutter Courage und ihre Kinder* (*Mother Courage and Her Children*) was abandoned because of differences of opinions between the original playwright Bertolt Brecht, the DEFA studio, and the SED.[18] In any case, the period of the rubble film had come to an end in the late 1940s, when films in the tradition of socialist realism oriented their narratives away from coping toward the building of East Germany as a socialist nation.

5

Fairy Tales and Children's Films as Eternal Blockbusters: *Die Geschichte vom Kleinen Muck* (*The Story of Little Mook*, Wolfgang Staudte, 1953)

The story of the production of DEFA's fairy tale *Die Geschichte vom Kleinen Muck* (*The Story of Little Mook*, Wolfgang Staudte, 1953) sounds like a fairy tale in itself. What began as a production to occupy the director and to fill the studio space due to the cancellation of the film *Mutter Courage* became East Germany's most successful production ever. It sold almost 13 million tickets in East Germany alone, was exported to more than 60 countries, and turned out to be so popular that West German television stations circumvented the ban of DEFA productions to show this film year after year.[1] *Muck* set the standards at DEFA in set design and overall commitment to produce high-quality films for children. Few (if any) other East German genres ever reached the consistent level of quality and excellence that DEFA committed to its fairy tales and children's films; to this day, these films guarantee high audience ratings on television and good sales figures. *Muck* is the epitome of East German cinema, to be read beyond the constraints of political filmmaking due to its production by renowned director Wolfgang Staudte, a budget comparable to a film geared toward an adult audience, and being only the second fairy tale produced at DEFA.[2]

The film opens with a scene set in an oriental town. Mook, an old man with a hunchback, works in a pottery shop. When he leaves the store to run errands, children tease him for his looks, chase him through the streets, and taunt him by pelting him with vegetables and splashing water in his face. One day, Mook manages to lock the children in his shop and tells them he won't let them out before they have listened to a story about "the wicked man"—his own life story, he informs the children. The film then shows Mook's story as a young child, When his father dies, greedy relatives divide his father's possessions and kick Mook out of the house. Mook decides to leave the town and head into the desert to search for a merchant said to sell good fortune. On his travels, he gets to a house occupied by a woman who locks him up and takes away his shoes so he cannot leave the

home anymore. When the woman leaves the house for a while, one of her cats knocks over a vase and shatters it. Among the shards is a pair of slippers and a stick; Mook grabs the two items, and now that he is in possession of shoes again, decides to run away. Once he puts on the shoes, they turn out to be magic racing slippers that enable him to outrun any man or animal. The slippers come in handy when Mook is caught at the sultan's palace and has to compete against the sultan's best runner to have his life spared. When he wins the race, he is appointed as the court's runner-in-chief. Sometime later, he becomes the sultan's treasurer when the stick shows its magic attribute and points Mook to the location of a hidden treasure, put there by the sultan's son and some of the sultan's ministers who had been stealing money and buried it, Since they are afraid the sultan will find out, they throw Mook first into the dungeon and eventually chase him away from the palace. When he lies down at a river, he discovers two fig trees—one that makes a person grow donkey ears and the other one to make them disappear again. With the help of these figs, Mook gets back his slippers and stick and starts to do good among people: he returns to the palace, and helps the sultan's daughter marry a prince her father had disapproved of and he gives money to the poor in town, finding good fortune by doing good. As the story wraps up, old Mook now finds new friends in the children who enjoyed his tale and who have learned that not gold nor personal wealth but benevolence brings happiness in life.

Although some people have thought that DEFA latched onto fairy tales' morals as a way of usurping of the genre for socialist agitation, this idea is fallacious. In fact, from the beginning of film production, children's stories and fairy tales have been a favorite subject matter of cinema. As early as 1899, George Méliès produced the picture *Cendrillon* (*Cinderella*), and other Brothers Grimm fairy tales followed. Over time, these films added optical and mechanical special effects, and in the 1920s even turned from using just actors to "animation, hand puppets, marionettes, silhouettes, and cutouts."[3] These films were not, however, aimed at children particularly but at the general public because they were entertaining and could showcase the medium of film and its trick effects. At that time, fairy-tale films were often shown in afternoons and evenings and appealed to mixed audiences of children and adults. After a number of changes, interventions, and censorship during the 1920s, studios created films tailored to children, most of them based on Grimm folktales.[4] During the time of National Socialist rule, fairy-tale productions were paused when stories of heroism and military targeting the teenage population were filmed instead. But when film production resumed after World War II, a large portion of films for children was once again based on fairy tales. In West Germany, an average of almost 50 percent of all children's films broadcast on television in the 1950s—the medium that replaced the movie theaters for children entertainment—was comprised of fairy tales.[5] In East Germany, the production of fairy tales started in early 1950, with the cinema production of *Das kalte Herz* (*Heart of Stone*, Paul Verhoeven).

In general, fairy tales have always been a welcome medium for cinematic adaptation: they offer familiar storylines and have the additional advantage of providing a pedagogical message at the end that aids in children having well-rounded personalities. The idea of education is precisely where the goals of fairy tales intersected with East Germany's founding objective of being an antifascist German nation—and using the arts to do so. Fairy tales offered evidence of how universal humanistic values coincided with the values promoted by socialism, and much like the happy endings of fairy tales, communism would supply the same as socialism peaked and concluded. In this respect, employing fairy tales set an overall tone that would associate DEFA with a style of cinema that was much different from the neorealist films of the 1940s. Fairy tales did not reflect the realities of everyday life, but they promoted, or at least heralded, utopian models that in the future would reward the hardworking people, who were still deprived of luxury and personal wealth. East German cinema was not unique in this respect, as Soviet cinema and the national cinemas of other socialist eastern European nations all employed their local lore for fairy-tale productions; in fact, the Soviet film *Kamennyy tsvetok* (*The Stone Flower*, Aleksandr Ptushko, 1946) is credited as being an inspiration and motivation for *Das kalte Herz*.[6] In some instances, the DEFA adaptations of German fairy tales had to modify the characters in the original stories to achieve the intended message: now, intelligent or dimwitted characters appeared instead of some that were good and evil.[7] This variation allowed audiences (and censors) to view not only the fairy tales but also to find a political subtext in the films when the common people outsmarted kings or when a peasant hero saved the day (and often put a compassionate leader back into power).

Because of this twofold way of interpreting these adaptations and the possibility of viewing them politically but free from the agitating undertones that characterized other DEFA films of that time, the fairy tales became valuable assets to be nurtured. One obvious reason was their exportability beyond the ideological borders to West Germany—even during the Cold War. A year before *Muck* was released, East Germany had created its film import and export company, DEFA Außenhandel, to manage film exports. In its trades with West Germany, the company could not simply arrange for purchases or sales with individual West German film companies but had to go through the West German Interministerial Cinema Committee. This federal agency had been created to allow oversight and compliance with the political regulations of a West Germany that did not acknowledge the existence of East Germany as sovereign nation at this time.[8] Even though political restrictions in West Germany generally prevented the import of DEFA films, fairy tales were treated more leniently, and several copies of *Muck* came to West German screens in 1955 (compared to not being released at all, as was the case for many DEFA films).[9]

At least three reasons made *Muck* and other DEFA fairy tales excel against productions from other countries (including West Germany) and may have helped to accelerate the approval process by the Interministerial Cinema

Committee—or even circumvent it. First, plots that lacked elements antagonistic to West German politics and that it did not contain overt or implied socialist ideals made it easier to make a case for these films. Indeed, whenever *Muck* or other DEFA fairy tales were screened on West German television during Christmastime (as they still are), printed program guides that usually informed viewers of a film's country of origin never did for these films.

Second, expensive sets, such as the sultan's palace complete with reflecting pools, and exotic props, such as live lions, were unusual for children's films. These splendid arrangements would seem to point to a West German studio instead of an East German one; at that time, the Economic Miracle had turned West Germany into a prosperous nation, while East Germany still felt the consequences of the war and suffering everywhere. Even the opening credits referenced the origin of the film by showing the DEFA logo only briefly; in the plot following, however, there is no indication that *Muck* was an East German production.

Finally, the personnel hired to make this film were prominent and well-known for their quality work. As in the first fairy tale, *Das kalte Herz*, when DEFA had hired the established Paul Verhoeven as director, the studio now approached Wolfgang Staudte, another first-tier director, for its second fairy-tale film.[10] Staudte, who had been under contract to make another film—*Mutter Courage*, which was cancelled due to confrontations with the playwright, Bertolt Brecht—suddenly became available and agreed to this project, an unusual one for him, as he usually directed acerbic and polemic films.[11]

Along with the director, other illustrious names of German cinema made *Muck* not simply a stopgap project but an almost guaranteed success simply by their participation. For example, Robert Baberske, perhaps the best-known cinematographer at that time, who had already worked with Fritz Lang and Friedrich Wilhelm Murnau, staged the events with a dynamic camera that replicated the mood of an adventure film without sacrificing the overall impression of a fairy tale. The costume designer, Walter Schulze-Mittendorff, was also one of the most experienced in his profession, having designed costumes for 40 films. Equally well established was the film's art director, Artur Günter, who was able to take advantage of a high budget to set new standards for the DEFA children's films with its lavish set design (see figure 5.1). Even though audiences were not necessarily aware of the high-quality personnel Staudte had assembled, the decision by DEFA to finance an expensive fairy tale by allowing the technical personnel to realize their visions suggested the importance of *Muck*.

This success of *Muck* in 1953 surpassed that of the first popular, big-budget DEFA fairy-tale production, *Das kalte Herz*, and signaled to DEFA that excellence in the area of children's films and fairy tales could become its calling card and establish the studio in a leading position in the international markets of Eastern Europe, as well as in the capitalist nations—first and foremost, West Germany. Indeed, DEFA fairy-tale films exported well due to the wide variety of tales adapted for their filming that appealed to different

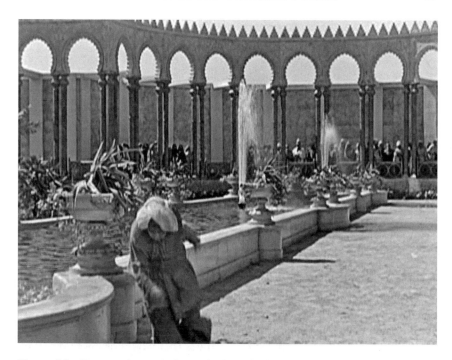

Figure 5.1 Extravagant sets indicate the large budget spent on DEFA fairy tales and children's films. DVD screen capture, *Die Geschichte vom Kleinen Muck.*

age groups and even to different nationalities. Obviously, films based on the literary fairy tales of Wilhelm Hauff (such as *Muck* and *Das kalte Herz*) and on the folktales collected and recorded by the Brothers Grimm appealed particularly to German children and adults alike, who were familiar with the tales and were elated to see the films, which brought back memories. Movies developed from the tales of other nations—such as the stories of Hans-Christian Andersen, the Bohemian tale *Tři oříšky pro Popelku/ Drei Haselnüsse für Aschenbrödel* (*Three Nuts for Cinderella*, Václav Vorlíček , 1973) by Božena Němcová, and tales of geographically more remote locations, such as the DEFA-Mongolian coproduction *Die goldene Jurte* (*The Golden Tent*, Gottfried Kolditz and Rabschaa Dordschpalam, 1961)—were well received with domestic audiences who enjoyed the faraway locations, the magic, and the fantasy as a means of escapism.[12] International audiences saw "their" fairy tales realized in high-quality productions they would have been unable to achieve themselves. Thus for DEFA, the film exchanges with other socialist nations also fulfilled the purpose of attesting to international solidarity and raised their international prestige as a global production company.[13]

Also important was the prospect to excel in the "competition" against West Germany. DEFA obviously deemed distribution of the films in West Germany as almost equally important to its domestic market because of the shared language. The films were ready to be shown without any dubbing,

and due to the multiple interpretations of the films, there was only little danger of the films not being distributed at all. These fairy tales represented a part of Germany's cultural heritage. As East and West Germany were constantly vying to claim the title of the legitimate successor to prewar Germany, producing these films and selling them to West Germany was therefore more than only a means to bring in much-needed revenue to aid East Germany's economy: Exporting the films to West Germany also was tantamount to claiming supremacy in the battle of German cultural legacy.[14] The initial success sparked a wave of more than 20 fairy tales based on the Grimm Brother stories.[15] Many of them became staples of West Germany's television programming with multiple broadcasts.

Regardless of the international appeal, domestic acceptance of the fairy-tale films was of foremost importance. As the target audience of fairy tales and children's films were children—and DEFA aimed to educate postwar generations in an antifascist tradition—the films had to translate this topic into universal messages children could understand, without sacrificing entertainment.[16] Initially, East German political functionaries eyed fairy tales critically.[17] The stories were set in feudal times and often recalled the ideas German romanticism valued—all bones of contention for the ideal socialist world order. In order to make the fairy tales appropriate for Marxist settings, DEFA filmmakers had to implement changes that would promote proletarian values while keeping the general storylines intact.[18] In the case of *Muck*, Staudte's adaptation of the Hauff tale altered the narrative frame significantly to make a case for the benefits of work and life in a collective: In contrast to the written story, Little Mook in the DEFA film is no longer the recluse who lives by himself in the midst of his treasures. Instead he turns into the favorite of the children once they have heard the story of the deprivations of his childhood and when they understand how his experiences of the past lay the groundwork of the comfortable life they are leading. As Mook has given away the treasures of the sultan to the people, he is now a simple worker in a pottery who lives a model lifestyle as part of the group and is respected by his peers in the workplace. This twist on the original brought the fairy tale in line with the political goal of raising awareness for the power of socialist ideals—and taught youngsters in East and West Germany the value of sharing one's possession to find individual happiness.[19] Careful crafting of the underlying political message was of importance, as it turned out later when the fairy tale *Das tapfere Schneiderlein* (*The Brave Little Tailor*, Helmut Spieß, 1956) went too far in its interpretation of class struggle, and East German reviewers criticized the film for overstepping the mark.[20]

Muck contained little controversy itself but was produced during a challenging time in East Germany: the workers' uprising on June 17, 1953. Staudte even had to interrupt shooting the film because of the noise as Soviet tanks rolled past the studio on their way to put down one of many unrests taking place all over East Germany. For audiences of that time, fairy tales were therefore even more important than ever, as they allowed viewers to escape reality for a couple of hours and enter a dream world full of happy endings.

Children's films and fairy tales were audience favorites at other times, as well, offering spaces of freedom not available in feature films for adults; further, "critical double-entendres filled children's and young people's films, seldom remarked upon by censors."[21] The ability to depart from ideological premises and to present risky dialogues without the scrutiny of the censors, along with a substantial budget that allowed the casting of first-tier DEFA actors, made children's films and fairy tales a welcome medium for even renowned directors—and explains how about 20 percent of the entire DEFA feature film production consisted of these genres. Even in the present time, many of the films have not only survived but are still staples of television. In the United Kingdom, generations have grown up with *Das singende, klingende Bäumchen* (*The Singing, Ringing Tree*, Francesco Stefani, 1957), a German fan club celebrates *Drei Haselnüsse für Aschenbrödel* with annual conventions, and US viewers may still be able to watch *Die goldene Gans* (*The Golden Goose*, Siegfried Hartmann, 1964) that was originally imported by K. Gordon Murray.[22] With regular screenings of DEFA fairy tales on German television and in movie theaters each year in December, the popularity of *Muck* as an exemplary film will likely last for a long time.

THE *GEGENWARTSFILM*, WEST BERLIN AS HOSTILE OTHER, AND EAST GERMANY AS HOMELAND: THE REBEL FILM *BERLIN— ECKE SCHÖNHAUSER* (*BERLIN SCHÖNHAUSER CORNER*, GERHARD KLEIN, 1957)

East German filmmaking at DEFA changed significantly following the death of Soviet dictator Joseph Stalin in 1953, proving that a close connection of politics and film in East Germany already existed. Technically, the Soviet Union still owned part of DEFA, and during Stalin's rule, the SED ensured that DEFA films complied with the ideology predetermined by the "big brother" in the east.[1] Many of the productions in the late 1940s and early 1950s therefore followed a style known as "Socialist Realism"—films made to foster the ideals of socialism and communism. After Stalin, the danger of ending in a political prison for disagreeing ceased in East Germany, too, and made way for a new wave of more critical films. More and more, DEFA directors paid attention to contemporary conditions of life in East Germany and observed and criticized the development of the country. They created a genre called *Gegenwartsfilme* (films addressing contemporary life) that expressed the shortcomings of East Germany in a nuanced way that had become possible, even desired, between 1954 and 1961 as a way to help socialism evolve. Only the few productions that either continued the prewar UFA (Universum Film AG) aesthetic (such as *Die Schönste* in 1957) or addressed sensitive domestic issues (for example, Konrad Wolf's *Sonnensucher* [Sun Seekers] in 1958) were banned,[2] and for a few years in the 1950s, DEFA released a good number of films intended to aid the integration of politics into East German society. Often, directors addressed a young generation, showing their significance for the future thriving of the country—not an easy feat as they competed with a West Germany, prospering as result of Allied support. Gerhard Klein's 1957 *Berlin—Ecke Schönhauser* (*Berlin Schönhauser Corner*) stands out as a pivotal film that subsumes the ideals and challenges East Germany was facing at that point in time: seeking an identity as antifascist, peaceful nation and a "better" Germany by juxtaposing it against a hostile West Germany.

In this 1957 youth drama, *Berlin—Ecke Schönhauser*, set and shot at the height of the Cold War, we follow the lives of four teenagers from East Berlin. The friends, Dieter, Kohle, Karl-Heinz, and Angela, live in (East) Berlin's Schönhauser Avenue in dysfunctional families; for example, fifteen-year-old Angela lost her father in the war and lives with her widowed mother, who is having an affair with her married boss. When he comes to visit in the evenings and Angela has to leave the apartment until midnight, she hangs out with other teenagers underneath the suburban train tracks. Dieter, her boyfriend, has lost both parents and shares a room with this brother, a young police officer in East Germany's *Volkspolizei* (People's Police). Dieter works as construction worker, but he is indifferent toward politics and does not want to join the SED or its youth organization, FDJ (Freie Deutsche Jugend [Free German Youth]). A third friend, Kohle, is beaten regularly by his alcoholic stepfather; having dropped out of school, Kohle spends most of his time and money in West Berlin watching the latest Hollywood releases and dreaming of becoming a jet pilot. The fourth friend, Karl-Heinz, does not work either, but he lives with his well-off parents who take advantage of East Germany's subsidized apartments despite owning two houses in West Berlin. Although his family seems perfect, it disrupts East German society because it abuses the ideals of socialism. Along with other disillusioned teenagers, the four friends repeatedly get in trouble with the authorities, a theme Klein knew from American films such as *The Wild One* and *Rebel Without a Cause*. In Klein's East German variation on the Hollywood genre of films about juvenile delinquency, the teenagers look for ways to come to terms with the lack of good—in this context socialist—father figures to guide them. Eventually, all the teenagers pay a price. Kohle dies in a refugee camp when he and Dieter flee to West Berlin; Karl-Heinz turns to criminal action, also in West Berlin, when he helps to rob and kill a wealthy businessman; and Angela gets pregnant after sleeping with Dieter. The film ends with a glimmer of hope, however, and a voice-over as encouragement for a better life in a socialist East Germany if collaboration across generations was going to take place in the future.

Director Gerhard Klein and screenwriter Wolfgang Kohlhaase purposely conceptualized the film after Hollywood's teenage rebel films of the 1950s, but adapted this model to fit East Germany's political ideals.[3] In this (and three other films shot in the 1950s Berlin) we can see how East Germany is not (yet) the ideal society promoted by politicians and propagandistic DEFA films of that time but that everyday reality consists of struggles.[4] *Berlin—Ecke Schönhauser* is also different from films such as Kurt Maetzig's *Ernst Thälmann—Sohn seiner Klasse* (Son of his Class, 1954) and *Ernst Thälmann—Führer seiner Klasse* (Leader of His Class, 1955); those biopics show well their glorification of Communist hero Thälmann, and how politics influenced productions of East German cinema and integrated agitation and propaganda (known as agitprop) as tools to educate East Germans politically. On paper, the Thälmann films may have sold more tickets (see chapter 1), but the Klein's realistic films appealed to an audience familiar

with the Hollywood rebel films starring Marlon Brando and James Dean. Those films were not shown in East Germany not only because of Cold War politics and constant tensions between East and West Germany but also because of the lack of cultural exchange between the USA-led capitalist and the Soviet Union–controlled communist sectors.

Both hemispheres clashed in Berlin, divided into four sectors controlled by the allied forces of France, the UK, the United States of America, and the Soviet Union, and, until the erection of the Berlin Wall on August 13, 1961, it was possible to travel freely between the sectors. For this reason, Dieter can cross easily from the American sector back into East Berlin without a border other than the iconic signs in three languages marking the beginning of the western sectors and two patrolling officers waving cars, trucks, and motorcycles across. Pedestrians are not even checked. The camera pans along with Dieter running and shows him cross into the Eastern sector, or as the sign reads, "Beginning of the Democratic Sector of Greater Berlin" as a reference to the "real" name of East Germany as the German Democratic Republic.

Klein and Kohlhaase processed historical realities and integrated them as necessary backdrop for this story about East German teenage rebels who take advantage of the open border to the western sectors to watch films inaccessible to them in the eastern sector of Berlin.[5] We see how the four teenagers in the film are intimately familiar with Hollywood's rebels: Kohle admits that he has seen more than a hundred movies there, Dieter's dream is to own a motorcycle (presumably to be a bit like James Dean), Karl-Heinz wears a fashionable leather jacket like the rebels, and Angela's dream man has to "look like Marlon Brando"—something we learn when Dieter accompanies her home one night. Yet *Berlin—Ecke Schönhauser* is much more than a copy of a rebel film set in East Berlin, and we can see on numerous occasions how Klein and Kohlhaase use the genre as an appeal to young people to stay in East Germany and help build it as a better Germany.

At the time Klein shot the film, approximately 300 thousand East Germans immigrated to West Germany each year.[6] A substantial number of these emigrants were part of East Germany's intelligentsia, which caused problems at many work places that sometimes lost key people overnight. Building East Germany, Klein and Kohlhaase believed, like others committed to the creation of a socialist and antifascist German nation, would not be possible if young people followed suit, that is, emigrated, because of the temptations of the West. Thus, the rebellious teenagers in *Berlin—Ecke Schönhauser* were intended to paint an accurate picture of East Germany's disillusioned youth without blaming them. Instead, the film delivers the message that socialist society was at fault for not caring enough for its youth. This was the only reason that East Germany's teenagers failed to integrate in society, the film suggests, and it was up to society to correct this shortcoming. Three recurring themes make *Berlin—Ecke Schönhauser* a rebel film intended to both reeducate East Germany's teenage rebels and to allow older generations insight into the mindset of young people: first, establishing East Germany as homeland (*Heimat*); second, the notion of the state as paternal

substitute; and third, the affirmation of socialism as the right path to a better life for everyone.

If East Germany was to become a true homeland for the young generation, it was necessary for them to identify with it as place of belonging and to understand it as a safe haven. Klein and Kohlhaase thus constructed West Germany as the hostile "Other." Multiple scenes juxtapose a peaceful East Berlin with the debauchery of West Berlin. Both societies are set up as antagonists throughout the story, and each move between the "good" and "bad" parts of Berlin is also clearly marked in an interplay of visual signs in the mise-en-scene with lighting choices and both diegetic and non-diegetic sound. Multiple times, the camera frames the large signs announcing the beginning and end of Berlin's "democratic sector"—clearly signaling a turn in the plot. In the beginning of the film, Dieter returns home, having escaped hostile West Berlin; in turn, right after we witness the scene of domestic disturbance at Kohle's home, the picture fades out and then back in on the sign announcing the end of the democratic sector and continues panning to the right to show another sign announcing the beginning of the French sector. Without the ancillary "democratic," the French sector is thus placed in opposition to East Berlin and, if one believes the text of the sign, has overcome Soviet occupation that is part of a free, democratic Germany. The scene recalls the sign of the American sector Dieter crossed earlier in the film, now reinforcing the nondemocratic nature of West Berlin and amplified by the final bars of a dramatic orchestral score as indicator of impeding danger.

In addition to the subliminal message of East Berlin as Berlin's democratic part, the experiences of Kohle, Dieter, and Karl-Heinz in West Berlin reveal the true nature of capitalist society behind the façade of money and glamour. West Berlin turns into a crime-infused place with illegal money and East German ID card trafficking seemingly widespread. In East Berlin, on the other hand, where the only intentional misdeed is Kohle's mischievous breaking of a street lantern with a rock, crimes such as the manslaughter and armed robbery Karl-Heinz participates in in West Berlin are not present at all. When Kohle knocks Karl-Heinz unconscious in the attic of the apartment building they live in, he does so in self-defense as Karl-Heinz threatens Dieter with a pistol. And though the parental generation disapproves of the (Western) dance music and the visits to movie theaters in West Berlin, there is hardly the notion that life in East Berlin is remotely as dangerous as being in the western sectors of the city. The more serious offenses always originate in the West: Karl-Heinz turns into an ID thief to finance a luxurious lifestyle he has become used to in the bourgeois household of his parents; Dieter is tempted to participate in order to purchase a motorcycle; and without Karl-Heinz bringing a pistol from West Berlin, there would have been no need for Kohle to attack Karl-Heinz and then run to the West, where he accidentally dies by poisoning himself after ingesting a fever-inducing method he presumably copied from a Hollywood movie.

A dramatic score and different lighting schemes augment the dichotomy of a good and peaceful East Germany versus a dangerous and hostile West.

In a nod to Italian neorealism of the 1940s and the genre traditions of the melodrama, Klein employs light and shadow to convey the feeling of being safe and sheltered in East Germany. For instance, when Angela walks through the solitary streets of East Berlin alone at night, the natural light cast by the street lamps presents no danger—and allows viewers to pause after the revelation of her pregnancy, suggesting the East German part of Berlin as suitable place to raise a family (see figure 6.1). In contrast, the scene of Dieter and Kohle confronting Karl-Heinz in the attic calls forth the potential dangers and crime brought to peaceful East Berlin from the West: In that scene, low-key lighting repeatedly casts shadows across the faces of the teenagers, conveying their ambivalence about the face-off. Instead of resolving the situation, Dieter and Kohle appear to have committed a crime and run away to West Berlin, prompting viewers to equate this part of the city as harbor of criminals that protects various illegal activities.

We can also discern two other aspects related to the role of police: first, West Berlin appears to have little or no police presence, and despite criminal activity in the train stations and the streets, we do not see any police officers until late when Karl-Heinz is arrested for manslaughter. Second, although East Berlin only has little crime, we notice police officers to be omnipresent at day and night as they patrol the streets, answer emergency calls, and investigate unusual activities. However, East Berlin's police officers

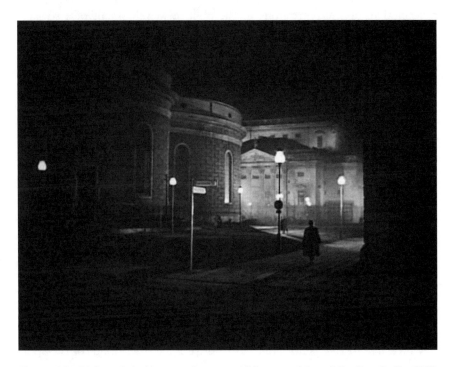

Figure 6.1 Light and shadow as tools to exemplify a peaceful, socialist East Berlin. DVD capture, *Berlin—Ecke Schönhauser.*

are avuncular rather than threatening; they function as paternal substitutes for the teenagers and as role models for a new generation of young socialists. When the officers arraign the teenage rebels and take them to the precinct, the teenagers receive only a brief lecture on the street light incident, after which the police captain talks with them about their future. The display of a benevolent, preventative police reinforces the concept of East Germany as the better German nation, looking out for its citizens and ensuring their well-being, much like a father accepting minor transgressions of his children. In fact, joining the *Volkspolizei* as a junior officer—as Dieter's brother has done—becomes one career path that testifies maturation: In an argument among brothers, Dieter accuses his brother of having smuggled cigarette after the war, which the young police officer shrugs off, saying that these were sins of his youth he has overcome. It is he who finds pregnant Angela, his brother's girlfriend, in the streets of Berlin after she has run away from her mother and he vacates his bedroom so she has a comfortable place to sleep. East Germany's police, Gerhard Klein reminds us again and again, are family, and when the police captain sends Dieter home after the teenager has returned to East Berlin, the captain sums up the responsibility of the police (and therefore of East Germany) with the words, "Where we are not…there are our enemies."

With these words, and the police captain admitting his failure in protecting East Germany's youth, Klein and Kohlhaase hold the government accountable for the regressions in the political development of a socialist nation; however, they do so without lambasting them to the extent that would have required DEFA to demand substantial changes before a release. Even though the Hauptverwaltung Film found fault with the film as being too critical, Klein was allowed to continue. *Berlin—Ecke Schönhauser* hit a nerve with audiences, who rewarded the frank evaluation of problems. In the first three months after its release, more than 1.5 million tickets sold, making this film both commercially and stylistically the "perhaps most important DEFA film about contemporary life in the 1950s."[7] Few other films of this time reflected the tensions, struggles, dreams, and hopes of the first postwar generation of Germans growing up in a still young East German nation, making East Germany, and particularly East Berlin, into a home despite the constant temptations of West Berlin and the still lingering fallout from the nationwide East German uprising on June 17, 1953.[8] As product of the Cold War, the film sketches East Germany as "better" Germany by contrasting it with a West Berlin that is a hostile place, governed by violence, greed, and the remnants of fascism. Not coincidentally, youth riots in West Berlin of those days rattled West German society,[9] while the departure of 70 thousand troops of the Soviet Army at least appeared to signal that East Germany had taken another step toward turning into the peaceful, antifascist nation it envisioned itself to be.

Much like in the use of police as positive force, the modes of transportation chosen by the directors reinforces the antagonism between East and West Germany. In general, cars and motorcycles stand for Western

decadence, whereas bicycles, streetcars, and of course walking show that achieving true equality is only possible in a society undivided by individual luxuries. In fact, the film suggests that the lack of privately owned vehicles is not a shortcoming of East German society, and instead categorically rejecting personal luxury is an essential step on the nation's path toward socialism. Once Dieter rejects the idea of owning a motorcycle, he indicates that he has moved beyond the temptations of the West, has realized the opportunities life in the East offers, and is ready to integrate. It is important that Dieter makes this decision of his own accord, and yet Klein places multiple audiovisual clues to assure film viewers what the right decision must be. Obviously, Dieter's attempts to get the money needed to purchase a motorcycle gets him into trouble. Additionally, Karl-Heinz's accomplices in West Berlin drive a Volkswagen for a number of reasons. They ostensibly accumulated enough wealth with their criminal activity to afford their own car, the make associated with the Nazi legacy as the "people's car." While cars are ubiquitous in the streets of West Berlin—a subconscious reference to the West being permeated by Nazis and crooks—car use in the East is limited to the police. The sector border becomes a magic line that annihilates fascist influence. For example, when the camera signals the sector crossing from the democratic sector (that is, East Berlin) into the French sector (West Berlin), the sound changes immediately from the ringing of a bicycle bell to the honking of a car horn. Other indications include Dieter's contemplation of the streetcar in the film's closing scene, realizing it is preferable to the motorcycle, the bicycles some of the teenage rebels own (as compared to the motorcycles ridden by the Hollywood rebels), and, of course, the numerous scenes with people simply walking.[10] And yet, despite these subconscious signals indicating that East Germany is the better of the two German nations, the country is still depicted realistically, full of flaws and as a work in progress.

As the 1950s came to an end, restrictions at DEFA tightened, and a few years later, Klein would not have been able to make a film such as *Berlin— Ecke Schönhauser*. After a violent uprising of workers in Poland in June 1956 was put down by their government, and Soviet tanks ended the Hungarian revolution in October 1956, a revisionist process took over at DEFA. At a film conference of the East German Ministry of Culture in 1958, its director, Alexander Abusch, declared the change in studio politics that had allowed a short period of progressive filmmaking at DEFA was over. The end of the *Gegenwartsfilm* with its critical realism and influences of Italian neorealism brought back a dogmatism that filmmakers had thought was left behind. Films following the prewar UFA aesthetic did not return either, thus turning DEFA cinema into a political tool as an SED mouthpiece. Ticket sales dropped sharply as a result. The caesura of 1958 marked the first low point in East German cinema.

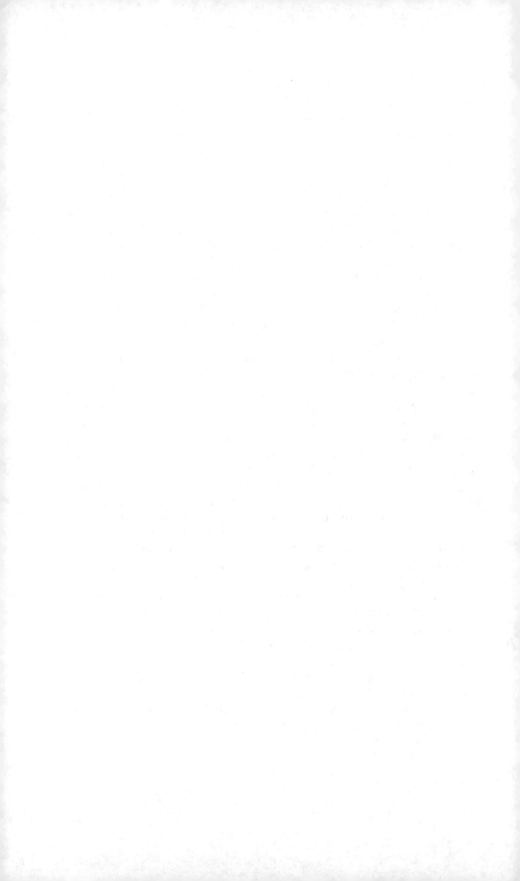

7

THE BIRTH OF DEFA GENRE CINEMA, EAST GERMAN SCI-FI FILMS, NEW TECHNOLOGIES, AND COPRODUCTION WITH EASTERN EUROPE: *DER SCHWEIGENDE STERN* (*SILENT STAR*, KURT MAETZIG, 1960)

The launch of the Soviet satellite Sputnik 1 on October 4, 1957, threw the Western hemisphere into a crisis and put the Cold War space race on another level. The communist world, led by the Soviet Union, had landed a psychological victory, something it would repeat when cosmonaut Yuri Gagarin became the first human in space on April 12, 1961. The moon landing and the first steps taken on the moon by the US astronaut Neil Armstrong on July 20, 1969, helped the western world catch up. This portion of space exploration took place over nearly 15 years, but in science fiction, time is often handled differently. The first East German sci-fi film, *Der schweigende Stern* (*Silent Star*, 1960) illustrates this by taking place in the future—1970—and by following an international team of scientists on an expedition to planet Venus. Studying *Der schweigende Stern* from a variety of angles, as we will see, reveals a fascinating glimpse into East German filmmaking at the end of the 1950s. *Der schweigende Stern* also set a number of records: DEFA's first science fiction film, its first genre film, and the "most expensive DEFA film ever made."[1]

The significance of this space adventure to East German cinema is shown in an anecdote about some of its special effects. According to director Kurt Maetzig, creating the radioactively contaminated sludge on Venus depleted the entire annual output of glue in 1959, making it impossible to find glue anywhere in East Germany.[2] Why was this film so important that Maetzig was allowed to stretch the resources of an entire country for this one production? The central idea of the film suggests why it was imperative to invest so heavily into *Der schweigende Stern*. Based on the science fiction novel *Astronauci* by Stanisław Lem, the film tells the story of an audacious enterprise undertaken by an international team of renowned specialists to solve a secret message; the message, contained in a spool-like object at a

construction site in the Gobi desert in 1970, suggests an imminent attack on Earth.[3] Led by the Soviet commander Arsenyev, the crew, consisting of the cosmonauts Talua from Africa, Chen Yu from China, Robert Brinkmann from Germany, Sikarna from India, the female doctor Sumiko Ogimura from Japan, Soltyk from Poland, and—as the only Western participant—the US American Hawling, travel on the international spacecraft *Kosmokrator* to Venus, the origin of the mysterious object. There, the crew discovers the remnants of a very advanced civilization and learns the fate of the Venusians, who perished when a massive weapon designed to attack Earth malfunctioned and triggered a nuclear chain reaction that devastated the planet's surface and wiped out the entire population. After an accident takes the lives of three crewmembers during expeditions on the surface of Venus, the survivors return to Earth. The film closes with them admonishing the Earth's population to be wary of atomic war and to collaborate more to make Earth advance as a united world.

Clearly, the fear of a nuclear war between the two superpowers United States of America and the Soviet Union was quite tangible at the time the film was conceptualized. In fact, the history behind the development of the screenplay of *Der schweigende Stern* presents a vivid picture of the way the atomic threat guided changes to the script. For example, in an early version, a US American astronaut Higgins was the pilot of the spaceship, constructed as a person "most conspicuous for his libido and off-the-cuff manner."[4] But Higgins would have created a potential conflict for audiences on an interpersonal level instead of the hoped-for ideological level. The replacement of US American character with the scientist Hawling, whose teacher and mentor, Heimann, was responsible for building of the atomic bomb, allowed for more ideological examination. Hawling is advanced enough in the US hierarchy of scientists to confront a US American "consortium" about their development of the atomic bomb in a key scene early in *Der schweigende Stern*. He can, furthermore, request to participate in scientific instead of military work. When Heimann, a mirror image of J. R. Oppenheimer—as DEFA screenwriters Wolfgang Kohlhaase and Günther Rücker stated in their script—enters the scene for an actual meeting, his comments to the consortium about Hiroshima as their "adventure" suggest a plausible danger of a nuclear confrontation between the superpowers in the film. USA politics, the film suggests, are controlled by an oligarchy of economists (this consortium) most interested in earning as much money as possible without worrying much about mankind.

Another example of the nuclear threat triggering changes to the film is that Kohlhaase and Rücker were asked to change the composition of the Venusian society; an earlier version of the screenplay envisioned a political division on Venus into two factions: one is peace loving and the other constructed the atomic bomb found on Venus to destroy Earth. Upon intervention by the minister of culture, the plot line was changed into the current version. In this, the Venusians were warmongers toward Earth but were killed on accident by their own weapon. In order to avoid a demoralizing

effect on the audience the story received the optimistic ending of peaceful coexistence, with the cosmonauts spreading their message of peace and coexistence.[5] The female Japanese doctor Ogimura, whose parents died in the Hiroshima bombing, was also added to bring *Der schweigende Stern* more in line with the reality in the late 1950s. Because of these and other changes that align the film with the historical threat of a nuclear war in 1960, media scholar Michael Grisko has challenged the film's classification as a science fiction film and hints at a possible reading of *Der schweigende Stern* as *Gegenwartsfilm* (a film about contemporary life).[6]

The screenplay also reveals interesting details about DEFA in an international context, working with both West German and Eastern European partners—by choice during the development of the script and out of necessity while shooting.[7] *Der schweigende Stern* is promoted in the opening credits as a coproduction between DEFA and the Polish *Zespol Filmowy*; their cooperation during the height of the Cold War helped the Eastern Bloc convey a level of unity and solidarity only a few years after the 1956 protests in Poland and Hungary strained the relationships with the Soviet Union. Yet, what reads like a picture-perfect story of an international collaboration between socialist nations—something the plot echoes in the composition of the *Kosmokrator* crew as predominantly from socialist countries—was actually a complicated enterprise that revealed the cracks of a forced, fabricated socialist comradeship.[8]

Envisioned and created between 1956 and 1959, the screenplay of *Der schweigende Stern* was rewritten an impressive 11 times, until the twelfth version by the DEFA team Kohlhaase and Rücker was finally approved. Director Maetzig had initially turned down an early script by an experienced team of DEFA screenwriters that was based on a treatment by a Polish team because it had too much humor and romance and not enough ideology.[9] A new, German-Polish script was approved by the Polish producers but rejected by DEFA due to the fact that the Polish cosmonaut supposedly outdid the Soviet commander as being wittier, more resourceful, and more humorous, something that could have been construed as slap in the face of the "big brother." When the German and the Polish producers eventually signed a cooperation agreement two days before the Sputnik launch, it looked like the project *Planet des Todes* (*Planet of Death*, as that version of the script was called) was ready to commence. DEFA, however jeopardized the film: They were ready to bring in a French coproducer, Pathé, and they had also contacted a number of other West European studios in the UK and West Germany to discuss export agreements in exchange for foreign actors playing the roles of the international space crew. During these negotiations, a French scriptwriter provided his input on the screenplay, resulting in another rewrite, but when East German minister of culture Erich Wendt intervened, the project was halted. Despite Maetzig's protests to the SED Central Committee, all contacts with the western partners were stopped, the foreign actors not considered, and Kohlhaase and Rücker were engaged to complete another version of the screenplay—which now the Polish production

company Iluzion refused. Only after the Polish co-scriptwriter was brought back and two more revisions were made to the script, did both studios agree to start shooting.

The prestigious project was completed successfully and premiered in East Germany on February 28, 1960 and in Poland on March 7, 1960.[10] The price tag of the film ended up three times as high as other DEFA films, making *Der schweigende Stern* DEFA's most expensive film.[11] The high budget was one of the contributing factors that stalled the production of further science fiction films for a decade; the next DEFA sci-fi film ‚*Signale—Ein Weltraumabenteuer* (*Signals—A Space Adventure*, Gottfried Kolditz, 1970), allowed the artistic work group defa-futurum to create a tradition of East German sci-fi film. Sci-fi was in vogue in the late 1960s and early 1970s, with films such as the US production *2001: A Space Odyssey* (Stanley Kubrick, 1968) and the Soviet film *Solaris* (Andrei Tarkovsky, 1972); these pushed DEFA to return to the genre with the feature films *Eolomea* (Hermann Zschoche, 1972) and *Im Staub der Sterne* (*In the Dust of the Stars*, Gottfried Kolditz, 1976), and short films by defa-futurum.[12] The fact that DEFA committed to the sci-fi genre at all despite the obstacles during preproduction of *Der schweigende Stern* illustrates that the studio was willing to devote substantial means to the development of attractive and entertaining genre films.[13]

It was obvious to DEFA from the onset of *Der schweigende Stern* that moving into the genre of the utopian adventure film demanded the best technology available for set design, props, and technical gadgets, and for modern equipment and shooting material. The visual results are stunning: for a film shot in the late 1950s, *Der schweigende Stern* features beautiful colors. Maetzig took advantage of the Agfacolor stock available to him by giving the cosmonauts space suits in a variety of colors and putting these in contrast to an eerie Venusian sky of orange and reddish colors (see cover picture). In scenes on Earth, such as the prelaunch press conference, the colors of mountain peaks capped with snow against blue skies stand in contrast to the green grass, and the lush colors of the uniforms worn by mechanics and technicians at the launch pad not only accentuate the scenery, but allude to the significance of space exploration in a socialist society of the near future. Maetzig also used the recently introduced East German Totalvision lens to capture the desolate and vast Venus surface in widescreen format on 35 mm film without having to resort to panning into offscreen space.[14] The widescreen format allowed for the simultaneous view of the spacecraft *Kosmokrator* on the horizon, the futuristic Venus rover in the left third of the frame, the three cosmonauts on the mission on the two right thirds, and the multifunctional robot, "Omega," in the foreground at the feet of one astronauts (see figure 7.1). To East German viewers of the 1960s, both the visual experience of watching the film shot in Agfacolor and widescreen, as well as of the technology with spaceship, rover, and robot featured in the mise-en-scene must have been captivating.

Figure 7.1 Agfacolor, gizmos, expensive props, and special effects in DEFA's first sci-fi film, *Der schweigende Stern*. Screenshot from *Der schweigende Stern* DVD.

What audiences did not know was that much of this technology that contributed to the tremendous cost had to be imported from West Germany. Ironically, the depiction of socialist progress and technological dominance experienced in much of the film only became possible because Western technology had already advanced to a stage that the makers of *Der schweigende Stern* anticipated as futuristic. For instance, the screenplay required a robot to assist the cosmonauts while on Venus, yet East Germany was unable to supply the relays needed to have the remote-controlled machine work. Importing the necessary part from the West German company Siemens turned out to be difficult: Not only did the Ministry of Foreign Trade have to approve all acquisitions from foreign countries, the Foreign Currency Office at the Ministry of Culture had to provide the necessary valuta (West Germany's Deutsche Mark) to pay for the relays needed to make the robot function.[15] In another instance, it was impossible to manufacture a synthetic material for the radiation suits worn by two actors that would have looked convincing enough to actually sustain radiation while still being flexible enough for the actors to move about the set. Turned down by the Ministry of Culture, DEFA had to plead with officials to allow this trade after all.[16] These anecdotes about the deficiencies of the East German economy and a reliance on the technological advances elsewhere also provide a comment on the ways East German politics and DEFA film production were inextricably linked: Controlling the state economy and not only regulating but funnelling all commerce through a centralized East German infrastructure enabled the SED to exert control over even minute details.

Looking at *Der schweigende Stern* from this angle upends the film's dialogue and symbols of socialist supremacy in the near future. The ostensible lead of the Eastern Bloc in the space race at the time DEFA shot the film was represented by the existence of the "socialist moonbase" Luna Three and the long-distance spaceship *Kosmokrator* that could be repurposed to fly to Venus instead of Mars. Yet the persistent political references to this

dominance hint at the film as attempt to counteract East Germany's precarious political situation in 1960. In reality, the bleak economic perspectives and the lack of commodities and individual freedom caused over 2.7 million East Germans to leave between 1949 and 1961.[17] Thus, interweaving enthusiastic progress reports about the Venus expedition by the imagined international socialist television network "Intervision" makes *Der schweigende Stern* a call for perseverance.[18] Along with Brinkmann's audio diary entries documenting life on *Kosmokrator* during the travel to Venus, the television reports point toward a utopian future as an outcome ensuing from socialist politics. By the same token, the success of the Eastern Bloc insinuates the failure of the West in securing a safe future for mankind.

Der schweigende Stern is, therefore, as much an "ideological statement" as it is a sci-fi film.[19] It conceptualizes East Germany as visionary homeland in the larger context of a socialist/ communist world order as a desirable and inevitable end product of all societies.[20] At the same time, it begs to be interpreted as cultural symptom that, in the words of Frederic Jameson, allows viewers to gauge "the temperature of a social system at a particular historical moment."[21] Even though the Eastern Bloc was winning the space race, East Germany was at a moment of crisis in 1960. Relocating socialism to a not-too-distant utopian future was a way to answer the challenges of the time.

Another crucial decision involved personnel. The fact that Kurt Maetzig directed and Günter Simon played one of the lead roles was not lost on East German audiences and helped associate *Der schweigende Stern* with previous German films in the communist tradition. Casting Simon as the German cosmonaut Brinkmann brought a familiar face to the screens of East Germany; after his breakthrough in the lead role of the two biopics about communist leader Ernst Thälmann, the actor was usually typecast in DEFA films as hero of the working class.[22] Simon's reappearance on the screen as (East) German cosmonaut Brinkmann—who dies a heroic death on Venus to save the *Kosmokrator* crew—harks back to the second Thälmann film and Simon's martyrdom. His return "in the future" alludes to the belief of East Germany's central role in developing and promoting communist ideals. Selecting Kurt Maetzig to direct *Der schweigende Stern* inspired a similar connotation, as Maetzig—like no other director—embodies DEFA's history. From his days as a founding member of the Filmaktiv that turned into DEFA, Maetzig helped guide East German cinema, both by way of his administrative and his artistic work. Well-known for his commitment to communism, Maetzig supported the political agenda driven by the SED even if it required compromising or even distorting the truth.[23] He successfully urged for a reconsideration of genre cinema to win back audiences, pursuing to combine what he perceived as goals of DEFA: entertaining and educating.[24] Hence, Maetzig cautioned against turning the first genre film *Der schweigende Stern* into a spectacle and insisted on the film genre being a "realistic-technological utopia"—a signal for a discernable political message as fundament of East German genre cinema.[25]

Was *Der schweigende Stern* therefore "dated from the outset" because of this "inability to transcend the demands of Socialist Realism?"[26] Such a reading is tempting at first, but it would mean dismissing the film's contributions to the genre of sci-fi cinema in the 1960s. DEFA manned a spaceship with an international and interracial crew six years before the *Star Trek* television series. The special effects look period-appropriate, the story is compelling, and more than 200 thousand East German viewers saw the screenings in the first 13 weeks, when a notable 61 copies circulated through East Germany's movie theaters.[27] The film sold well in Eastern Europe and, in a reedited version under the title *First Spaceship on Venus*, in the UK and the United States.[28] This edited version even received one of the highest honors for a science fiction film: In 1990, it became the object of ridicule in an episode of the US comedy television series *Mystery Science Theater 3000* as one of only three German films.[29] More than 50 years old, *Der schweigende Stern* is still considered a "classic" of (East) German sci-fi cinema, "blending outrageous camp and Marxist ideology."[30]

8

FILM CENSORSHIP, THE EAST GERMAN
NOUVELLE VAGUE, AND THE "RABBIT FILMS":
DAS KANINCHEN BIN ICH (THE RABBIT IS ME,
KURT MAETZIG, 1965)

"If one knows about censorship in East German cinema, it is surprising that this film was allowed to be made," director Kurt Maetzig once pointed out in an interview.[1] And yet, unlike in previous cases of films banned in East Germany, it was not primarily the plot of his film *Das Kaninchen bin ich (The Rabbit Is Me,* 1965) that caused the ban, but a change in the social mood.[2] This change resulted in an eradication (*Kahlschlag*) of almost the entire DEFA feature film production of 1965 and turned out to have long-lasting implications for East German cinema. After this event, East German directors no longer attempted to reform DEFA cinema until 1990, when a group of young directors resurrected art house film with their new productions of *Wendeflicks.*[3] By shelving the "rabbit films" (*Kaninchenfilme*)—as the banned films from 1965 have become known—East Germany not only curbed critical voices, but it also put a stop to an artistic movement promising to be an East German Nouvelle Vague that "might well have developed in advance of or in interesting counterpoint to the New German Cinema just getting underway in the Federal Republic" (West Germany).[4] Although such a thesis about potential competition between the banned films in East Germany and the prolific art house cinema in West Germany will always remain guesswork to a certain extent, analyzing *Das Kaninchen* undoubtedly reveals how DEFA's "rabbit films" ought to be understood as the East German "New Wave"—and how film censorship in East Germany destroyed the chance of DEFA films becoming known among Europe's famous art films of the 1960s.[5]

When Kurt Maetzig, a convinced communist and one of DEFA's most respected directors, started to work on *Das Kaninchen bin ich*, the mood in East Germany and in DEFA favored critical films about contemporary society, the so-called *Gegenwartsfilme*. There appeared to be no major hurdles on the way to this film production; in fact, even high-ranking politicians supported Maetzig's plan for a critical film, as East Germany was once again in a

short period of political "thaw" after overcoming a film conference in 1958 that held back more liberal rules in filmmaking. In addition, the building of the Wall in 1961 closed off not only the country but also isolated its film culture from Western influences. Maetzig's film about 19-year-old Maria Morzeck who works the nightshift from 8 p.m. to 3 a.m. waiting tables at the Berlin bar "Old Bavaria" fit the purpose of East Germany's films redefining a socialist utopia by harnessing the "prophetic vision and the energies of youthful reformers."[6] Maria is not a waitress by choice; her application to pursue Slavonic studies and become an interpreter was turned down because of her brother Dieter's conviction of a 30-month prison term for political reasons. The orphaned Maria, who lives with her aunt, is thus forced to accept the job as a waitress after graduation from high school. We also learn Maria is attracted to older men: during her time in school, she dates her Physical Education teacher. On a school trip to the opera, she flirts with Paul Deister whom she recognizes later when she is at the justice building to turn in a pardoning petition as the judge who sentenced her brother. After initial hesitation, Maria engages in a relationship with Deister, which eventually turns sexual at his cottage in the countryside. Maria moves to the cottage temporarily after her collapse at work and subsequent six-week recovery period after a spondylosis diagnosis. Deister leaves Berlin on the weekends to spend his free days with her, telling the villagers that they are cousins. After an argument between Maria and Paul, he leaves and attempts to commit suicide—something his wife tells Maria a week later when she suddenly appears at the cottage and discovers her husband's infidelity. Maria breaks up with Paul for good. When Dieter, released from prison meanwhile, learns about her love affair, he beats her up. In the end, we see Maria move out of her aunt's place and apply to university in the hope of a better future.

Leaving the plot open-ended and having a film containing a rather critical assessment of contemporary socialism turned out a much larger problem than anticipated and led to its eventual ban in 1965, the first of over a dozen DEFA features to be banned. *Das Kaninchen* and Frank Vogel's *Denk bloß nicht, ich heule* (*Just Don't Think I'll Cry*, 1965/1990) were chosen to be screened for the delegates of the Eleventh Plenary Meeting of the SED Central Committee— in the absence of the filmmakers, who had not been invited—and were extensively criticized.[7] In the wake of this meeting, which was initially intended to discuss the New Economic System but turned into a debate on the function and agency of art in East Germany, more and more films (and other works of art) were banned over the following months. *Das Kaninchen* became the paragon and eponym of the rabbit films, and is perhaps the prime example of film censorship in East Germany, as it opened the largest wave of film bans in East Germany in motion.

Curiously, even Kurt Maetzig's prominent status at DEFA did not protect *Das Kaninchen* from the repercussions leading to its ban; Maetzig, who had set up the DEFA in 1946, constituted its mission as a state-owned agency to propagate socialism and antifascism as foundational principles of East Germany. But after he tenaciously directed films promoting communist

ideals, he had gone too far with this film. His story was critical of East Germany on many levels: he showed a dysfunctional justice system, an economy of scarcity without access to food staples such as citrus fruit, and buildings that still bore the marks of the war that had ended 20 years before. When he was informed that *Das Kaninchen* would be banned, Maetzig sent a letter to the head of state, Walter Ulbricht, apologizing for the disservice he had done to the mission of socialism. The film remained forbidden, but Maetzig was eventually redeemed.[8] By publicly reprimanding a luminary such as Maetzig and disapproving his work, the SED essentially coerced other artists into compliance with the new parameters for filmmaking that were to follow the Eleventh Plenum—the return to the ideals of socialist realism.[9] Banning *Das Kaninchen* thus served as tool to reassert SED politics over a potential upswing of oppositional forces that party functionaries believed to recognize in this and other films of 1965.[10]

Furthermore, like many other of the features from that year dealing with contemporary issues, Maetzig's film represented a departure from the socialist realist traditions of DEFA cinema. Its stylistic proximity to the French Nouvelle Vague confused the functionaries; the development of an East German cinematic avant-garde threatened the cultural monopoly and therefore cinema as the very tool used to manipulate the population. A cinema attacking or even standing in contradiction to the very ideals of socialism, East German politicians argued, would play into the hands of the Western nations with its focus on decadence and nihilism, and would infiltrate the system from within.[11] The storyline of *Das Kaninchen*, in particular, was far too controversial. It revealed flaws in East Germany's judicial system that resulted in rather harsh sentences for petty crimes, an East German issue that had been addressed and resolved in the political "Resolution on Jurisprudence" in 1961.[12] Unfortunately the completion of Maetzig's film coincided with the revival of old judicial structures and also with the end of the short period of cultural thaw that had enabled the development of the series of critical DEFA films.[13] Suddenly, *Das Kaninchen* no longer attacked errors of the past but challenged the present situation, causing the Ministry of Justice to intervene in the development of the screenplay.[14] Another fact that exacerbated the situation had to do with the original text, a novel by Manfred Bieler, that was the basis for this screenplay.[15] Bieler's manuscript *Maria Morzeck oder Das Kaninchen bin ich* had been banned outright in 1961, yet Maetzig believed it possible that the political climate of the time had opened up enough to tackle the topic of an unjust East German judicial system by using a forbidden novel and by hiring Bieler to coauthor the screenplay.[16] According to Maetzig, he received wide support on all levels and was encouraged to make the film.[17] By the time of the actual film's approval process, this support had disappeared, and *Das Kaninchen* turned from a film intended to herald a radical departure and a new era of progressive filmmaking at DEFA into the paradigm for an even more repressive control of politics over East German cinema.

Following the erection of the Berlin Wall in 1961, DEFA cinema had developed in a variety of directions. Instead of looking toward West Germany, films from Eastern Europe and the Soviet Union became increasingly important and eventually helped form a new self-consciousness within DEFA.[18] Furthermore, a genre cinema with musicals, westerns, and sci-fi films developed entertaining films with political backgrounds, such as the spy thriller *For Eyes Only* (János Veizci, 1963) and films such as ... *und deine Liebe auch* (... *And Your Love, Too*, Frank Vogel, 1962).[19] DEFA filmmakers also embraced the opportunity to depart into another direction and developed films that engaged critically the problems of everyday life in East Germany.[20] Their consensus was that eventually this new batch of critical films would begin a new era of DEFA cinema—and even help the country find an identity free from being constantly contrasted with the accomplishments of West Germany. At the same time, East Germany's economy required realignment to address persistent economic problems.[21] The introduction of the New Economic System, a reform of the country's centralized structure intended to simplify planning and management, failed; this was, in part, due to the political changes in the Soviet Union in 1964 when conservative Leonid Brezhnev replaced progressive Nikita Khrushchev as the Soviet leader.[22] When the new leader Brezhnev rolled back the changes Krushchev had made to liberalize the country, it affected the Eleventh Plenary Meeting of East Germany's communist party, too—and with it, DEFA cinema.

Originally intended to introduce and debate the New Economic System, the Eleventh Plenary now had to find other topics to deliberate on, as it was clear that rolling out changes to East German economy would not be possible given the political climate in the Soviet Union. A fierce dispute about the political issues *Das Kaninchen* raised had taken place before the plenum and had resulted in the rewriting of the screenplay, thus offering a welcome opportunity to divert attention from the failure of the New Economic System.[23] After extensive debates in the Eleventh Plenum, East German head of state Walter Ulbricht proclaimed in his closing speech that DEFA cinema had mutated into an oppositional practice used by adversaries to the state.[24] The films of 1965 were believed to be political and, as a result of this, were banned to prevent a potential political disaster.

Essentially *Das Kaninchen* and the other films from 1965 became the scapegoats that were blamed for the failure of East German politics—ironically the same issues the new films about the conditions in East German society were hoping to address. After all, at the core of *Das Kaninchen* and other Rabbit Films stands not so much as an outright attack on East Germany or socialism, per se, but a new route taken by DEFA's directors as they "preferred the indexical recording of preexisting realities over the escapist and illusory quality of socialist realist or mainstream cinema."[25] In this case, these films fit into the larger context of the European New Waves of the 1950s and 1960s, making alternative, thought-provoking cinema a counterpoint to cultural mass entertainment. Jürgen Böttcher's *Jahrgang 45* (*Born*

in '45, 1965), for example, is reminiscent of the French Nouvelle Vague's "cinema of attitudes and postures,"[26] and *Das Kaninchen* discloses in its cinematography and soundtrack its stylistic proximity to other European new waves. Also in *Das Kaninchen*, techniques that were used abound in other new wave cinemas, such as the voice-over narration by the protagonist, a fragmented plotline that jumps back and forth in time, and alienating effects, such as Maria staring straight at the viewer.

Perhaps the most salient indication of *Das Kaninchen* as part of an East German New Wave emerges in the work of cinematographer Erich Gusko.[27] One of the prominent names of DEFA documentary film in the initial years of DEFA, Gusko contributed to the realism of *Das Kaninchen*. At the same time, Gusko's camerawork clearly shows how the film plays with tools that are prominent in new wave cinemas. We frequently notice the use of the handheld camera, cleverly employed to translate the protagonists' postures, movements, and position in the mise-en-scene into a sketch of their emotional state; for example, in the gym, when the camera captures Maria and her teacher as he assists her with an exercise, Maria's voice-over narration describes their sexual relationship that will follow. In this instance, the camera replicates the sexual act anticipated in the voice-over with a shot of the teacher leading Maria from the vaulting horse in one continuous move onto the bed in his bedroom. As the plot jumps in time, following Maria's stream of consciousness in her recap of the events, we obtain insight into her memories. Gusko recycles this graphic match time and again throughout *Das Kaninchen* as his way of time-lapse photography, sometimes alternating it with a slightly repositioned camera (along with changes to the seasons and the costumes during the long takes showing the afternoon walks of Maria and Deister) and the occasional jump cut (during the trial in the village) as a way to unsettle the observer.

Whereas these fractures in the time continuum are examples of the camera driving to break the illusion, the use of long takes with a stationary camera that pans and zooms achieves an opposite effect: it aims to involve the viewer. Early in the story, we encounter Maria in the kitchen, kneading dough while her aunt tests her Russian vocabulary for an upcoming school exam. The camera captures the conversation not in a shot–reverse shot pattern but prefers a two-shot to allow the viewer to observe from the distance. When the doorbell rings and Maria walks out of the room to answer the door, the camera retains its position and follows Maria with a quick pan of 180 degrees, simulating the gaze of an observer positioned in the same room as the two women. In the following uncut sequence, lasting almost 90 seconds, we witness an interrogation of Maria conducted by two secret police officers in the kitchen. The handheld camera quickly follows the conversation between the officers, Maria, and her aunt by panning around and focusing on the speaker, capturing them in a partial profile, to suggest the integration of the viewer in the action. Throughout the film, the camera repeats similar motions: for instance, it uses a whip pan simulating a rapid turning of the head when Maria sees Dieter in the court building. As she yells his name,

the camera pans again by 180 degrees until it perceives Dieter, rests briefly, and then zooms in.

In this case, Gusko applies the tools of documentary film capturing life events, with the camera attempting to keep up with the pace of events. At the same time the documentary character is constantly disturbed, something we notice when the already fragmented narrative also jumps around the film's time continuum or when the action comes to a halt as we get to hear Maria's inner monologue in a voice-over commentary of the events taking place. In one of the key scenes of the film—the face-off between Paul Deister's wife pointing a hunting rifle at Maria—the mise-en-scene even turns into a living tableau to heighten the tension and break the illusion of reality (see figure 8.1). Translated into a political message, the purpose of these constant ruptures could be seen as Maetzig's encouragement for viewers to dwell, reconsidering socialist East German society with a critical eye, and to dare to take risky but necessary steps out of a socialism set in its ways with the goal of liberating oneself from its calcified structures.

As we know now, this hope disintegrated with the Eleventh Plenum. After *Das Kaninchen* and *Denk bloß nicht ich heule*, the other films and other arts from 1965 that followed in the next years were either banned right away or had only brief runs at East Germany's movie theaters before disappearing

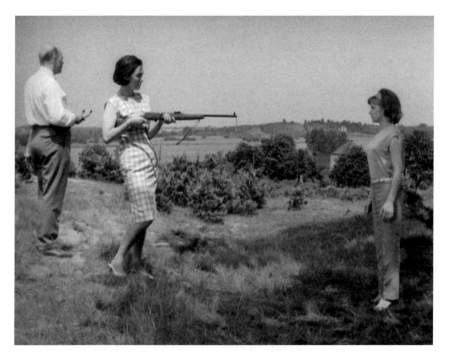

Figure 8.1 Freezing the action in a tableau vivant of Mrs. Deister and Maria in *Das Kaninchen bin ich*. Screen capture, DVD, *Das Kaninchen bin ich*.

for good. Some of the critical filmmakers of 1965 had to leave DEFA and work for East German television before they were allowed to return again in the late 1970s and 1980s to contribute to another round of films about contemporary society. Others were fired from DEFA and left East Germany for good—after having to wait several years before the government granted their requests for expatriation.

For DEFA film, the loss was even greater considering the cinematic potential that was stopped in its tracks. After 1965, self-censorship stifled much of the critical creativity until the 1990s, when a fourth and final generation of directors made the *Wendefilme*.[28]: Until that point the already highly effective system of preapproving film projects and ratifying them on numerous levels of the state apparatus became more effective after 1965 when the "inner censor" of artists prevented their engagement with critical topics.[29] The films were eventually revived, but only months before unification. The East German federation of filmmakers opened the former "poison cabinets" of DEFA cinema and released the Rabbit Films after a 35-year ban, first to movie theaters, and, after another hiatus, on Video Home System (VHS) tapes that would become bestsellers in post-unification Germany.[30] And ever since a group of film historians selected *Das Kaninchen* as one of the one hundred most important German films of all time, it has become clear that the rabbit films may arguably be the focal point of DEFA filmmaking.

Renegade Films, DEFA Musicals, and the Genre Cinema: *Heißer Sommer* (*Hot Summer*, Joachim Hasler, 1968)

George Cukor's *My Fair Lady* opened in East Germany on October 8, 1967, less than a year before the DEFA musical film *Heißer Sommer*. Joachim Hasler's summer blockbuster came into East German cinemas on June 21, 1968, and attracted over two million spectators, almost the Hollywood musical's film attendance, which drew close to 2.25 million viewers.[1] Convenient screening locations, a storyline teenagers and young adults could identify with, contemporary tunes from the East German music charts and their singers as lead actors, and the presentation of East Germany as visually appealing homeland all contributed to the success that made *Heißer Sommer* a cult film and a timeless classic of East German cinema.

The story follows the summer adventures of two groups of teenagers vacationing at the Baltic Sea. While hitchhiking to the coast, ten boys from Karl-Marx-Stadt (renamed Chemnitz again after unification) run into a group consisting of eleven girls from Leipzig, also heading into the same direction to spend some weeks on the beach. The two groups enter into a bet on whether the boys or the girls will make it to the destination first. In the course of their journey, their paths cross multiple times, and each group attempts to slow down the other's progress. Once they have arrived at their destination, the boys pitch their tents on the beach, while the girls move into a meeting room that the local farming coop turns temporarily into a dorm room. In the days to follow, the groups play a series of pranks on each other: the boys, for example, release a mouse in the dorm to frighten the girls. The girls take revenge by teasing the boys repeatedly about their age and immaturity (packaged in a song about boys who are not men yet). Slowly, however, couples begin to form, and the teenagers spend less time with their own groups than with each other. One of these relationships expands into a love triangle between Brit and the two boys Kai and Wolf. Brit is attracted to Kai, but when her girlfriends issue a dare, she spends the night with Wolf in a barn. Rumors ensue, and when Kai and Wolf brawl for Brit, she decides to return home, but ends up staying when she reveals that nothing happened

between her and Wolf. Eventually Brit and Kai become a couple and the film closes with a happy ending.

By that time in 1968, East Germans were certainly in dire need of happiness, since reality looked quite different in the Eastern Bloc. During the early months of 1968, a military conflict loomed in Czechoslovakia secondary to a political reform movement under Alexander Dubček called "Prague Spring." The movement promised a democratization of the country but instead led to the Warsaw Pact military forces (led by the Soviet Union) to invade. This move sent a clear signal from the Soviets to their satellite states that separatism would not be tolerated. At the Seventh Party Congress the year before in East Germany, Head of State Walter Ulbricht had requested the drafting of a new constitution that put the hegemony of the SED in writing, reaffirming the country's political alignment with the Soviet Union. In 1968, the constitution was then ratified, declaring East Germany no longer a democratic but a "socialist state of German nation."[2] The words of this new constitution signaled to both the Soviet Union and the East German citizens that the country would remain a loyal ally, and ideas of democracy, free elections, or rapprochement with West Germany were not on the political agenda.

East Germans therefore eagerly relied on the cinema as means of coping with political reality. They sought out productions that were either critical of the political developments and of everyday life in East Germany or those that attempted to escape the present altogether by heading to a growing number of DEFA genre films.[3] Production of genre cinema became possible after a number of events impacted DEFA filmmaking significantly. First, the 1958 film conference put an end not only to the critical films that emerged after Stalin's death in 1953 but also to the now-outdated style of filmmaking at DEFA that still bore traces of a prewar aesthetic.[4] Second, after the building of the Berlin Wall in 1961, the number of film imports to East Germany from the West ceased almost completely for a decade; DEFA films had to fill this void. Third, the 1965 Eleventh Plenum brought an almost blanket ban of DEFA's annual production of feature films that depicted the bleakness of everyday life and stopped the somewhat popular films of what would have become the East German New Wave.[5] Filmmaking, according to the official political doctrine, was to adhere more to the principles of socialist realism by depicting the role of the working class. As a result of the ban, DEFA's audience sizes continued to decrease, and it was vital to coax audiences to the movie theaters. One response was an increased focus on the production of genre films—sci-fi, Western, and musical.

The musical films continued a popular tradition in German cinema.[6] *Revuefilme* (revue films) had started soon after the introduction of sound film in 1930 and continued through the Nazi era. During the Second World War, particularly, a plethora of musical films were produced to create a fictional, soothing alternative life on-screen to distract the German population from the realities of war. The Nazi-controlled centralized UFA

conglomerate had perfected the art of the musical film as a political diversion tactic by producing one after another and by casting famous singers such as Zarah Leander and Marika Rökk to star in these lavish productions. For these historical reasons, DEFA departed from the genre in their first productions, making the rubble films to indicate a radical break with the past and to establish the antifascist narrative as an identifying factor for the new studio and for an East German nation still forming.[7] In order to raise funds as foundation for their own productions, however, DEFA had to rely on a number of unfinished revue films from the Nazi era.[8] After the DEFA completed the film *Die Fledermaus* (*The Bat*, Géza von Bolváry, 1946), started by the Nazi-regulated Terra Film company in 1944, a number of so-called *Überläuferfilme* (renegade films) provided DEFA with a monetary foundation to shoot films promoting DEFA's antifascist vision. Here, we witness firsthand the balancing act of DEFA: attempting to create its unique style of filmmaking while having to cater to audiences interested in film primarily as a means of entertainment and distraction. Often, the musical films attracted more spectators than did the didactic rubble films.

As early as 1949, therefore, the studio embarked on a variety of strategies to make music films—or at least to include music in its films—by shooting the operas *Figaros Hochzeit* (*Figaro's Wedding*, Georg Wildhagen, 1949), *Die lustigen Weiber von Windsor* (*The Merry Wives of Windsor*, Georg Wildhagen, 1950), and *Zar und Zimmermann* (*Czar and Carpenter*, Hans Müller, 1956). East German television took over this genre after the last opera film, *Der fliegende Holländer* (*The Flying Dutchman*, Joachim Herz, 1964). Even though East German critics frowned on these "big-budget productions"[9] for lacking a sense of class consciousness, DEFA shot musical comedies, such as *Rauschende Melodien* (*Sweeping Melodies*, Erich Wilhelm Fiedler, 1955), and even used the new 70 mm technology when Horst Bonnet shot *Orpheus in der Unterwelt* (*Orpheus in the Underworld*, Horst Bonnet, 1973).[10]

In the late 1950s, pop films (*Schlagerfilm*) and musicals slowly replaced the traditional operas and operettas. As a modernized variation of the revue film, pop films and musicals looked to entertain their predominantly young audiences by presenting modern songs in the films. After the first musical comedy *Meine Frau macht Musik* (My Wife Makes Music, Hans Heinrich, 1958), other films, such as *Revue um Mitternacht* (*Midnight Revue*, Gottfried Kolditz, 1962) followed. The musical *Geliebte weiße Maus* (*Beloved White Mouse*, Gottfried Kolditz, 1964) remains one of the most popular DEFA films. In 1968, Joachim Hasler created an East German smash hit when he cast two actual pop stars, Frank Schöbel (as Kai) and Chris Doerk (as Stupsi) in lead roles of his film *Heißer Sommer*.[11] Despite the popular success of productions in this genre, DEFA produced "only about a dozen musical films during the entire 45 years of its existence."[12] Even though this number may be too small, DEFA clearly neglected the genre, evidenced by the lack of formally teaching the musical in film school,[13] and the delay in following up the tremendous success of *Heißer Sommer* with a sequel, *Nicht schummeln,*

Liebling! (*Don't Cheat, Darling*, Joachim Hasler, 1972). In short, the musical film remained problematic until 1983, the year of DEFA's last musical film *Zille und ick* (*Zille and I*, Werner Wallroth).

Were DEFA's musical films problematic because they could be characterized as "non-commital apolitical entertainment" and therefore clashed repeatedly with political doctrines?[14] The answer is not that simple, since the genre stayed around despite the fact that the East German musical films appeared to be a continuation of old Nazi traditions. In the case of the later films in the 1950s, they may have even appeared as variations on the popular West German genre *Heimatfilm* (films about Germany as homeland) and in the 1960s, as adaptations of the pop film that made up almost a quarter of West Germany's film production.[15] In fact, the musical film for DEFA offered a convenient way to promote socialist ideals in disguise to young East Germans. In fact, *Heißer Sommer* even invites being read this way, as the plot and other signs indicate that the film carries an abundance of subliminal messages designed to sway the minds of East Germany's teenagers. The establishing shots introduce this political message in presenting East Germany as modern and progressive society. Unlike the banned films of 1965 that depicted East Germany as a gray, drab country with unhappy people leading depressing lives,[16] *Heißer Sommer* presents the opposite—a country of idyllic locations, overflowing with buoyant spirit and happiness, presenting young people with an abundance of opportunities. Most of the film takes place at the Baltic Sea, a popular site for East German beach vacations. The scenes set in the urban environment of Leipzig, where the boys and the girls meet, deserve a closer look as it is here that we can observe best how an indirect presentation of buildings, architecture, the environment, and the infrastructure communicates the notion of East Germany as a successful, livable socialist society. The country has now moved beyond the phase of postwar reconstruction and has emerged as independent nation.

Heißer Sommer opens with the female and then the male group of teenagers singing the film's title song and dancing through a selection of Leipzig's public spaces. The camera begins by capturing a colorful city square bustling with people and traffic on a beautiful day before it pans to the right to reveal the remainder of the square, and finally comes to rest on a fountain. As it cuts to a young woman in front of the city's new post office, the accompanying soundtrack adds a beat to the musical theme, and the woman, Stupsi, begins to sing the theme song. After a jump cut, two additional young women join her on-screen for the next line of the song before all ten women conclude the first stanza in front of Leipzig's opera house. After a musical interlude, the group of young men emerges to sing the song's second stanza while dancing a variation of the choreography. During this, the camera tilts and pans slowly along and down a well-preserved and ostensibly recently renovated historic building in the city center.

In addition to its introduction of the protagonists, this sequence also serves as a showcase for East Germany by using its international trade city,

Leipzig, as point of departure for the journey to the Baltic Sea. The entire mise-en-scene of renovated buildings, omnipresent streetcars representing up-to-date public transportation, and a relatively large number of private vehicles suggests that in 1968, East Germany has become a modern socialist society able to offer an impressive level of luxury to its citizens; the plot picks up this idea later in a dream sequence, when two of the teenagers dance on the roofs of the expensive East Berlin dance club Moskva.

Travel to the Baltic Sea appears to be a regular pastime for East Germany's teenagers, thus normalizing society and putting it in line with citizens of Western nations having the freedom to travel at leisure. Thus, even though travel for East Germans at that point in time had been severely limited since the building of the Berlin Wall in 1961, the world appears to be open to East German teenagers; further, one need not travel abroad but can as well have fun at home, *Heißer Sommer* suggests to the viewer. Conveying the message of a happy young generation of East Germans on summer vacation in their own country was not an easy one, and putting this into the form of a musical even trickier. As it turned out later, some East German critics disliked the film that showed the lighthearted side of socialism using the film musical as genre. Audiences, on the other hand, wholeheartedly embraced the film because it was easy to digest and very entertaining—a welcome respite from other, quite grave DEFA films.

From the onset, *Heißer Sommer* was intended to accomplish a renewed identification of audiences with DEFA cinema. The marketing for the film stimulated interest early on: Even before it hit the theaters and was shown on campgrounds and open-air festivals, the East German label Amiga had already released a record of the film's music performed by the country's two big pop stars, Frank Schöbel and Chris Doerk. By having cast them to play the lead roles in the film as well, it was obvious that nothing was left to chance and that the film was intended to be an East German summer block-buster, pleasing the masses with the familiar faces of pop stars and their current hits.

With its score composed by the father-and-son duo Gerd and Thomas Natschinski, *Heißer Sommer* reveals further that it was envisioned as a reju-venator for a stagnating DEFA cinema with sinking theater attendance. Gert Natschinski was arguably the best-known composer, writing catchy tunes and film music for DEFA since the 1950s, and because he was also firmly integrated in East Germany's political structures, he was the logical choice for the new musical film.[17] His son, Thomas Natschinski, was still a student of composition at the Hanns Eisler College for Music in Berlin but had been significantly involved in the East German music scene. Thomas was a found-ing member of the German-singing rock band Team 4 that offered a domes-tic musical counterpoint to the English-language songs from West Germany. When the cultural changes in 1965 resulted in a ban of pop and rock bands and required a strict licensing procedure, Team 4 renamed itself Thomas Natschinski and His Group and received a license as an officially sanctioned proponent of cultural politics.[18] Thomas and Gert Natschinski therefore

represented the top of the line East Germany had to offer in terms of popular music in the late 1960s. Political conformity was therefore guaranteed, and the combination of the above elements all but guaranteed success.

Having Joachim Hasler direct the musical film, furthermore, indicates that *Heißer Sommer* was to promote a socialist message. He had originally worked as cinematographer for Kurt Maetzig, one of DEFA's eminent socialist directors. As director, Hasler had also delivered politically conforming films such as *Chronik eines Mordes* (*The Story of a Murder*, 1965), a film that made him viewed as a "specialist for anti-West German films"[19] in West Germany. For *Heißer Sommer*, Hasler framed the genre of the musical film with the depiction of East Germany as homeland. He introduced a plethora of singing, dancing, and exuberant, joyful teenagers as sign that the long and difficult period of building East Germany was now concluded. Indeed, the teenagers traveling to the Baltic Sea belong to the first generation of children born into a postwar, socialist East Germany. Like East Germany, founded in 1949, they are now young adults who have grown up entirely in a nation free from war and the threats of fascism, allowing them to be carefree and enjoy life. At the same time, testing one's limits in socialist society had now become an important part of the maturation of a socialist in the making. The dialogue among the teenagers displays their feelings of value in being part of the collective. They also appeal to each other not to run away like cowards (perhaps in reference to the now-closed border to West Germany). In communal dance scenes, they do not exhibit a "naïve choreography,"[20] but transform the film into a socialist musical by displaying equality, mutual respect, and the rejection of leadership—likely a reason why the characters played by Doerk and Schöbel do not end up with each other in the end. The film's prevailing mood is that of frivolity, no longer of rebellion that the previous generation of postwar children exhibited.[21] On the contrary, the teenagers complete their daily chores on the farm and at the harbor and do

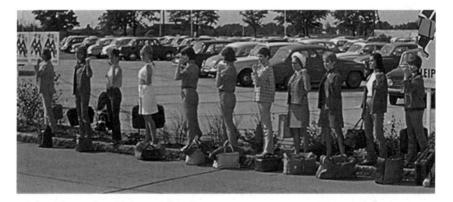

Figure 9.1 Hitchhiking to the beach in a modern East Germany—modestly clothes—in the film *Heißer Sommer*. DVD screen capture *Heißer Sommer*.

not start a sexual revolution like their 1968 counterparts in West Germany (even the night in the barn, it turns out, lead only to the recitation of poems). And their choice of modest fashion (see figure 9.1) likely did not cause concern among their parents. *Heißer Sommer* shows an ideal East Germany—a country in which even a beach movie now could easily take place.

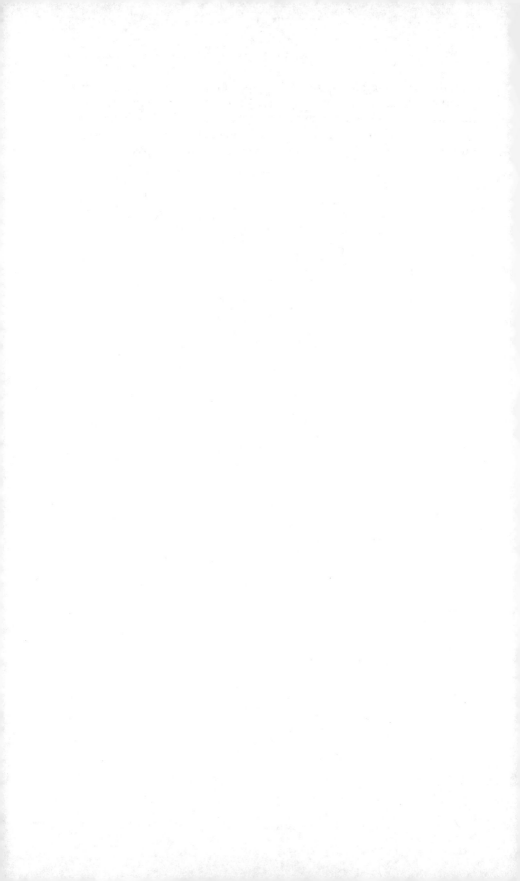

More Genre Cinema, the "Red Western," and Stardom in East Germany: *Apachen* (*Apaches*, Gottfried Kolditz, 1973)

An incredulous look—generally the initial reaction when someone encounters one of the East German Western films for the first time—often yields to an admission that the film was unexpectedly enjoyable and entertaining. The fashion in which DEFA took up the Western, a film genre that "had grown [...] to a sophisticated formula in which American history and ideology—and the Western genre itself—could be reflected upon and examined in detail," also reveals once again how East German feature films were deeply entrenched in the communist party's political agenda.[1] Genre cinema was eyed suspiciously in DEFA for some time for its proximity to filmmaking à la Hollywood and for its lack of either socialist realism or political didacticism.[2] A number of events during the height of the Cold War resulted in a change of mind: between 1966 and 1979, DEFA produced a dozen Westerns that turned into blockbusters. Along with the films, Gojko Mitic emerged as star actor who ranked among the most admired faces of East German cinema by the time he made his eighth DEFA Western, *Apachen*, in 1973. Perhaps even more important, the stories and the film star Mitic brought audiences back to movie theaters to watch the highly anticipated *Indianerfilme* (films about the Native Americans), as DEFA's "red westerns" came to be known, and seven of them broke the record of more than three million tickets sold each.[3]

Apachen easily surpassed this mark, with almost 3.8 million tickets sold (in a country of approximately 17 million residents), making it the fifth-best East German Western of all times. This accomplishment becomes even more important if one takes into account that it was released in 1973, two years after the new East German head of state, Erich Honecker, had announced an end to taboo topics in art and also introduced a more relaxed politic on the import of films from noncommunist countries into East German theaters.[4] Despite the growing market share of television that syphoned viewers from the cinemas, the spellbinding quality of *Apachen* and the audience's general unbroken fascination with stories about Native Americans made this first

film in a two-part series about the Apache tribe so popular, and brought East Germans back to the movie theaters.[5]

Apachen is based on a true incident, the 1837 Johnson Massacre of the Apaches that took place in the mining community of Santa Rita in New Mexico.[6] In the film, the plotline follows what has become lore about the massacre: The tribe is preparing to head to the annual market in Santa Rita, where they are going to pick up meat (the tender beef steak mentioned by the tribe chief, Nana, early on in the film) and sacks of flour as payment in exchange for copper mining rights awarded to Mexican settlers. Each year, the Mexicans celebrate the renewal of these rights with a fiesta, and viewers learn that the free mezcal results in a drinking bout from which the Apache warriors take days to recover. This year, however, a geologist and representative of an American trust, James Johnson, plans the genocide of the tribe during the fiesta in order to gain access to silver deposits he expects to find in the area. He takes a cannon to Santa Rita, and while the Apaches are congregating in the market square to distribute the sacks of flour, Johnson along with his American accomplices and a few Mexican settlers, fire the cannon at the Apaches. They also shoot at as many of the fleeing Apaches as possible in order to profit from the bounty placed on the scalps of the Native Americans. A young Apache, Ulzana, who had already encountered Americans before and had in vain cautioned Nana against a potential ambush, escapes with few remaining warriors. Ulzana takes revenge by launching an attack on Santa Rita, and forcing the Mexicans to abandon their post. The Apaches leave the captured Johnson behind to die, but the US Army arrives in Santa Rita in time to save his life. In return for the Apache's attack, Johnson takes Ulzana prisoner and tortures him with a whip. When the remaining Apaches free Ulzana, they set the buildings on fire and drive the Americans out of the area. Ulzana kills Johnson with a knife in the last battle and leaves him in a building to burn to death, thus restoring, at least temporarily, the hegemony of the Native Americans in the region.

Six years before *Apachen* was released, DEFA learned how to popularize this new genre of Westerns by turning to its successful launch of the sci-fi genre with the DEFA film *Der schweigende Stern* (*Silent Star*, Kurt Maetzig, 1960). For its first *Indianerfilm*,[7] DEFA chose the popular novel *Die Söhne der Großen Bärin* (*The Sons of Great Mother Bear*, 1951) by East German historian Liselotte Welskopf-Henrich. The adaptation of Welskopf-Henrich's story became an instant success with audiences for its entertainment value, and it also fulfilled an educational function in its open criticism of progress and greed by the (white) US American population that eventually led to the genocide of the Native Americans. Due to this strident message, the *Indianerfilme* remained unaffected by the political debate about East German arts in the Eleventh Plenum; on the contrary, the ban of the *Kaninchenfilme* (rabbit films) may have sent more viewers to *Die Söhne der Großen Bärin* in 1966.[8]

At least part of the success and perhaps the strongest appeal to see an *Indianerfilm* was the lead actor, Gojko Mitic—a well-built Serbian who

turned into a star after his role in *Die Söhne der Großen Bärin*. Filmgoers observed in *Apachen* how the film's two co-screenwriters, Kolditz and Mitic himself, scripted Mitic's exoticism as a visual pleasure into the plot (see figure 10.1). The repeated appearance of Mitic's seminude, well-built body certainly fulfilled erotic expectations of the audience that had already been stimulated by previous films. In addition, his previous work in West Germany, his insistence on doing his own stunts, and his exotic (nonwhite) body enabled him to stand out in the East German system of "audience darlings."[9] His unofficial nickname "DEFA's Chief Indian" is more than telling: DEFA turned Mitic into a fetishized object representing the internationality of East German cinema.

Like the other DEFA *Indianerfilme*, *Apachen* retained most of the genre conventions of the Western: beautiful, long takes of panoramic vistas shot in widescreen; a musical score capturing the ups and downs of life in the undeveloped Wild West; rugged cowboys bonding at campfires while trying to survive; gun fights and frequent battle scenes between the cowboys, the US military, and the Native American population; and even a final "shootout" between the hero and the villain. In contrast to the "Western" à la John Ford that featured white people (played by the likes of Gary Cooper or John Wayne) as heroes, the *Indianerfilm* retells the stories from the vantage point of the native population. Shifting the perspective away from the colonizers to the colonized allowed director Gottfried Kolditz, his co-screenwriter Gojko Mitic, and the other members of the artistic work group Roter Kreis (Red Circle) to bestow more attention to the culture and customs of the Native Americans, providing a balanced picture that challenged the image of the "red savage" prevalent in Westerns.[10] The first five minutes of *Apaches* are completely dedicated to the harmonious and peaceful coexistence of the

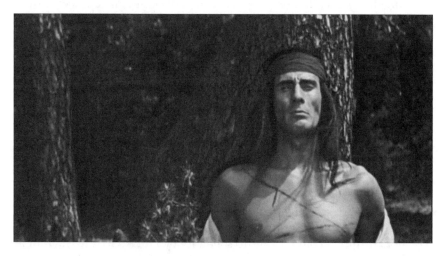

Figure 10.1 The exotic body of the "DEFA Chief Indian," played by Gojko Mitic, as a visual pleasure for East German audiences in *Apachen*. DVD screen capture.

Apache tribe and the land: We see a number of panoramic shots of the plains, hills, and mountains interspersed with a sequence of a group of Apache warriors riding their horses, a river running through a gorge, and a warrior—later to be identified as Ulzana—setting a small trap, presumably to catch food. Not a word is spoken; instead, a slow tune played predominantly by a flute and a drum, reminiscent of Native American music, strengthens our feeling that the Apaches are the rightful inhabitants of this area. When Ulzana sets the trap, a buoyant flute accompanied by an acoustic guitar brings us emotionally closer to the warrior, who is introduced to us in a series of close-ups and long shots. Suddenly, the peace is interrupted by a fast-moving musical theme of dissonant chords and melodies that announces the arrival of the group of white settlers. The fronts are clearly delineated in this sequence: In *Apachen*, the Native Americans are good, while the white settlers are the evil intruders without a legitimate claim to the land. *Apachen*, like the other *Indianerfilme*, turns the world of most Westerns upside down to become what film scholar Vera Dika called a "blank parody, a copy of the U.S. Western that included culturally and historically resonant German elements with little irony."[11]

In Dika's analysis of *Die Söhne der Großen Bärin* (*Sons of the Great Mother Bear*, Joseph Mach, 1966), the first *Indianerfilm* to come out of East Germany, she advocates for a reading of the red Western as a "'re-mythification,' that is, a reformulation of established genre conventions for the purpose of telling a new myth, now to a specific people at a particular time in history, and accomplished by the nearly blank re-presentation of generic form and variation."[12] Indeed, it makes sense to also approach *Apachen* as a product with a political agenda lingering below its surface. As DEFA usurped a genre that Andre Bazin called "the American film par excellence," it turned the perspective around by making the Native Americans the protagonists of their Westerns.[13] Retelling the conflicts between the native population and the Europeans from the perspective of the oppressed challenged the hegemony of the (white) North American colonizer, and it offered a multitude of opportunities to reason in more general terms for a moral dominance of socialism. Equally threatened by an imperialist North America, East Germans and other socialist nations were now brothers in spirit to the Native Americans.[14]

Apachen was a coproduction of DEFA with the Romanian Buftea studio and the Soviet Mosfilm, and it featured a number of non-German actors such as Mitic and Milan Beli from Yugoslavia (Beli played the American villain Johnson), Leon Niemczyk from Poland as Ramon, and Colea Rautu from Romania as Nana, along with other Romanian actors playing the Apaches. By way of the international cast, the *Indianerfilme* turned into vehicles of international solidarity in terms of content (feeling empathy toward the oppressed) and of their shared production environment (being coproduced with other socialist nations).[15] Even the choice of location for *Apachen* affirmed a commitment to solidarity by DEFA: Setting the film in the Karakum desert (in Turkmenistan) and in Samarkand (in Uzbekistan) ensured the recognition of landscapes and faces, making these places look

familiar to audiences in socialist nations.[16] The story of *Apachen* may have taken place in New Mexico, yet audiences of DEFA *Indianerfilme* were so accustomed to the landscapes of Yugoslavia and the Soviet Union that pictures of the original locations might have caused viewers to discount them as inauthentic.[17] Essentially, the *Indianerfilme* had been successful in manipulating audiences to accept the East German characters, Eastern European and Asian locations, and the "twisted" plots as authentic.[18] Even more, the involvement of Eastern European studios, people, and locations made the DEFA Westerns a successful genre for export to those countries.[19]

The attention to technical detail also facilitated the acceptance of the DEFA Westerns as "authentic" genre films. *Apachen* was shot in Totalvision, using an East German anamorphic lens that had been developed to avoid having to license the US Cinemascope lens system.[20] Unlike in the United States, where Panavision had largely replaced the old lenses by that time, DEFA continued to use Totalvision for financial reasons since shooting in 70 mm and retrofitting the country's theaters turned out to be too expensive.[21] Like any Western movie, *Apachen* also benefits from the cinematic aspect ratio that allows panoramic shots capturing the beauty of the Wild West landscape.[22] In the five initial minutes, long takes of the scarce flora, rolling hills, and rushing waters enchant viewers, and the camera returns to these views time and again, often panning slowly to follow a group of Apaches riding through the Chihuahua desert. Accompanied by Nana's voice-over that charts the vastness of the lands ("wide is the country of the Apaches"), the camera captures the riders as small specks in extreme long shots, and even after moving closer in the following scenes, the camera is still far enough from the warriors to retain the spacious atmosphere. In other instances, like the scenes when the Apaches chase Johnson or when the Mexicans leave Santa Rita, cinematographer Helmut Bergmann positioned the camera in ways that allowed him to capture the wide horizons and the mountainous terrain without sacrificing the captivating pictures for content when panning to follow the riders on horseback. In addition to creating authentic settings for Westerns, these panoramic views served as a travel substitute for some East Germans. Because of the travel restrictions that limited travel abroad to a small, select portion of East Germans thought to be trustworthy citizens—and even then only to socialist countries—the Westerns became avenues for travelling in their minds to faraway and unreachable places such as the United States.

The reception of the *Indianerfilme* also needs to be read via their dichotomous relations to (West) German traditions and influences. Germany's infatuation with the American Indians started long before the *Indianerfilme*. In the late nineteenth century, writer Karl May published fictional stories about the adventures of his alter ego in the Wild West.[23] Despite never having travelled there while writing his pulp novels, May's works about Old Shatterhand, a German adventurer fighting alongside the Apaches and their chief Winnetou for justice and humanity, found a large-scale following, and to this day, thousands of readers still seek out his stories.[24] West German

readers purchased the books in such numbers that the West German com-
pany Rialto filmed their first Western, *Der Schatz im Silbersee* (*Treasure of
Silver Lake*, Harald Reinl, 1962), based on May's story of the same name, and
followed it with other films that were all very successful.[25] In East Germany,
however, May's works were not sold or printed, and public libraries removed
them due to chauvinism and racism.[26] In addition, in East Germany, the
May novels did not go back into print until 1982, and the film did not screen
in East Germany until December of that year.[27] In the early 1960s, then,
Native American culture was not found on East German screens.

Nevertheless, East Germans still celebrated Native American cultures in
very imaginative ways. For instance, some traveled to Czechoslovakia and
other Eastern European countries to see these films.[28] Others organized
a lively club scene of "tribes" spread out all over East Germany that con-
gregated in homemade teepees to spend their weekends living like Native
Americans. Clubs such as Old Manitou in Radebeul near Dresden (founded
in 1958), Dakota in Meißen (1961), and Sieben Ratsfeuer (Seven Fire
Council) in Magdeburg (1963) even became recognized as cultural organi-
zations in East Germany and performed in official, state-organized events,
parades, and celebrations.[29]

Still, the building of the Berlin Wall had halted the import of West German
films and thus created a void for these enthusiasts at a time Rialto turned
out the Western blockbusters.[30] It was time for DEFA to supply their social-
ist take on popular genres to fill the gap created by the import stoppage.
Director Kurt Maetzig called for a reconsideration of socialist filmmaking to
include genre cinema in 1960. East German cinema would need to develop
a smorgasbord of genre film in order to remain competitive in attract-
ing domestic viewership, especially when West German television broad-
cast films that most East Germans could receive in their homes.[31] The red
Western became one of these genres, envisioned to address these shortcom-
ings and to attract domestic audiences with socialist-oriented entertainment
that still followed the doctrine of cinema as an "instrument of Communist
education [...] and organization of the masses."[32]

GENDER, CLASS, AND SEXUALITY: ENDING TABOOS IN *DIE LEGENDE VON PAUL UND PAULA* (*THE LEGEND OF PAUL AND PAULA*, HEINER CAROW, 1973)

In 1971, East Germany's new head of state Erich Honecker announced an end of taboos for the arts and signaled that critical approaches to socialism would be welcome. Prior this change, a film such as Heiner Carow's *Die Legende von Paul und Paula*, which vehemently criticized East German contemporary society, likely would not have made it past the censors; however, the eradication of taboos allowed it be released in 1973. Its plot—and at times visually confusing love story about an adulterous relationship between a single working mother and a successful SED party member—combines exaggerated performances, esoteric dream sequences, symbolism, and rock music into a smorgasbord that promised DEFA's departure into a new style of cinema. Surreal scenes, the exposure of the state's infiltration of the private sphere, the persistent challenge of hypocritical behavior in socialism, and the depiction of sex on-screen ensured a winning combination with the public. Structured around dichotomies, *Paul und Paula* presented a love story that suggested East Germany's ambivalence toward gender and class.

Paul and Paula's story consists of a series of unhappy relationships. They are neighbors, but other than their similar first names, they appear to have little in common. Paul, a minor government official on his way up the career ladder, lives in accordance with the rules and boundaries set by the East Germany's political system. He is married to a beautiful but stupid woman who has extramarital affairs. Because of his position, he cannot divorce his wife, or even just leave her, as this would taint not only his reputation but also that of the party. When Paul meets his neighbor from across the street, Paula, in a bar, they fall in love with each other, even though (or because) she is the opposite of Paul in many ways. Aside from the gender difference—which does play a central role in the film, as East Germany had supposedly overcome gender difference and achieved emancipation—Paula is socially disadvantaged. She lives in an older residential building without the amenities, such as central heat or an in-home bathroom, that Paul has in his newly

constructed, modern apartment just across the street. Her job is also quite the opposite of his: Paula works in a "typical" female occupation as cashier in a grocery store. At home, Paula is mother to two children from different fathers. In one of the few similarities with Paul, she leads an unhappy love life. When she returns home from the hospital after having given birth to her second child, she surprises her partner in bed with another woman. From then on, she raises her children as single mother, and when Mr. Saft, an older, wealthy businessman, proposes to her, she initially considers this offer for the future of her children. This changes when Paul enters her life, and once he and Paula have spent a night together, she hopes for a life together. But while Paula's love to Paul is unconditional, Paul has a difficult time leaving his wife, which depresses Paula. When one of her children dies in an accident, she blames herself and breaks up with Paul. At this point, Paul realizes that he is willing to do anything for a future with her; he gives up all of his luxuries and fights for her love. Paula eventually takes Paul back and they decide to have a child, even though her doctor advises against it because of medical risks—and Paula dies promptly when giving birth, leaving Paul with three children: her daughter, his son, and the child they have together. Because of her sacrifice, risking death for her love to Paul, and his decision to leave his career behind for a life with Paula and their children, their story becomes legendary.

As a reviewer of this film noted, *Paul und Paula* is "about the doomed love affair between an earthy, working-class woman and a stuffy government official, which became a cult hit in East Germany."[1] The reception in East Germany illustrated that the film hit a nerve in 1973, when more than three million spectators saw the film in the first year of its release, and many East Germans named their newborn daughters "Paula."[2] One of the reasons for such popularity was certainly the touching love story in this film. Unlike other films of that time that addressed relevant issues of the day in contemporary East Germany (the so-called *Gegenwartsfilme*) by creating sober evaluations in realist styles that emphasized the failure of interpersonal relationships, *Paul und Paula* turned it upside down and presented an optimistic outlook on relationships.[3] However, happiness, the film suggests, does not come on its own but requires commitment, persistence, and even surrender of at least a part of individualism. When Paula dies in the end, it becomes clear once again to the spectator that grief and sorrow also accompany bliss: even in socialist society one cannot escape the realities of life.

Paul und Paula also set new standards by challenging the official notion of East Germany having achieved emancipation. This type of critique was not unique, but unlike similar DEFA films, "it radiated optimism and lightheartedness, even when it addressed difficult or depressing subjects like adultery and death," likely the reason why the film became a blockbuster in East Germany.[4] In Carow's film, the protagonists have traditionally gender-coded professions: Paul had served his country in the military while his pregnant wife stayed at home; later, he leaves the house in the morning to ride with his all-male carpool to his office job. Paula works at a supermarket; once, we

see her ringing up customers in the checkout lane, and another time, she handles the bottle return at the same place—a job without chances to climb the career ladder. Compared to the well-educated East German women in DEFA cinema of earlier years who personified how emancipation had been accomplished in East Germany—at least on film—Paula's life appears to indicate regression into the traditional gender hierarchies.[5] Because *Paul und Paula* looks critically at the previously conveyed notion of emancipation by reinforcing gender stereotyping in the professions, DEFA would have run into trouble before 1971. However, with Honecker's end of taboos, it instead suggested that in reality gender discrimination still persisted and that true, widespread emancipation was only a legend. Heiner Carow also tackled this topic again in his drama *Bis daß der Tod euch scheidet* (*Until Death Do Us Part*, 1979), in which the gender fissure is even more pronounced when the husband beats his wife because she wants to start working; later films by other directors also pointed out gender discrepancies.[6] In most cases, though, the problem of a gender imbalance and the lack of emancipation was only the peg some directors—including Carow—used to voice their general disapproval with East German governance, neatly symbolized in *Paul und Paula* by Paul using the official party paper *Neues Deutschland* to sleep on when he camps out in Paula's stairwell.

Noteworthy about the relationship is that Carow located love as driving force behind Paula's (and eventually also Paul's) actions "exclusively in the private sphere."[7] Both protagonists leave traditional socialist society behind and no longer participate in the rituals of life in the public sphere. Paul quits his job and drops his uniform (literally, when he undresses to sleep with Paula, but also symbolically, when he waits in jeans and sweater on the stairs in front of Paula's apartment). Paula, on the other hand, had never really participated in the social life, engaged in socialist society, or taken advantage of the career opportunities East Germany offered to workers, and thus is "anything but the socialist female role model that was advertised in DEFA films at that time."[8] The political meaning of the film was lost on West German feminist contemporaries who misread the film as a "misogynistic schmaltzy film" and a slap in the face of feminism.[9] In East Germany, though, audiences embraced *Paul und Paula* because it combined realism and fantasy in a unique way that allowed filmgoers to recognize traces of their lives. Here, the decoding mechanisms required to watch a DEFA film, comparable to reading "between the lines" in an East German novel, went into full swing so that for East German viewers, *Paul und Paula* turned into an ingenious way of poking fun at the political system.

The dream scenes and absurd passages, especially, confused (and still confuse) non–East German viewers to the point that some have suggested that Paul and Paula were abusing drugs.[10] However, to East Germans of the 1970s, the hallucinogenic set, the accompanying suggestive song of "flying a kite," references to pornography, and the highly symbolic actions had little to do with the flower power movement of that time in the West. More than a mere poetic insert to denote the sexual intercourse of Paul and Paula, each

part in this "dream" sequence embodied a carefully designed jab at East German politics. Well crafted to resemble a sex act with foreplay, intercourse, and climax, the sequence provides the film's core message of the private lives of East Germans being under constant scrutiny by the government so that even in their most intimate moments, Paul and Paula are never alone. While in the bedroom, getting undressed to make love, Paul notices a group of musicians who suddenly appear on the couch one by one, each introducing his appearance with a few measures of a modern song played on his instrument. When Paul asks Paula if they are alone in the room, which she confirms, he inquires about the musicians on the couch. Once he mentions them to Paula, she smilingly shrugs off their presence and comments that they do not see—upon which the camera cuts back to the now-blindfolded group who play again, this time together but equally without a melody (see figure 11.1).

What appears to be an absurd scene showing the hallucinations of an inebriated Paul, who initially blames this vision on the consumption of too much pear brandy is, in fact, an acrimonious remark on East Germany's secret police, the Stasi. Called the People-Owned Company Eavesdroppers and Peepers (*VEB Horch und Guck*) in the vernacular, the nearly 89 thousand Stasi agents had set up an intricate and thorough surveillance network of technology and almost 175 thousand so-called unofficial contributors (*Inoffizieller Mitarbeiter*) across the country; between 1950 and 1989, they observed the lives of more than 16 million people in East and West Germany.[11] The agents did not operate clandestinely all the time and sometimes showed

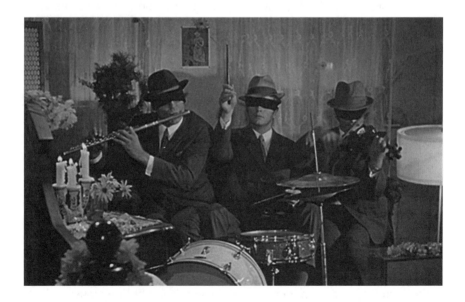

Figure 11.1 Blindfolded agents of East Germany's secret police during the love act in *Die Legende von Paul und Paula*. DVD screen capture.

their presence in order to intimidate and keep East Germans under govern-
ment control. Dressing the three musicians in suits was supposed to trigger
associations with the dress code of Stasi agents, while the hats added a comi-
cal reference to the head of the Stasi, Erich Mielke, who was known in East
Germany for his passion for hats.[12] For director Carow and his scriptwriter
Ulrich Plenzdorf, showing the three agents keeping Paul and Paula under
surveillance even in the bedroom and having them remark of the agents'
"blindness" was certainly risky, despite the end of taboos. Because Carow
and Plenzdorf kept the jabs at the system limited to short, ironic scenes that
allowed multiple readings—in this case also as dreams or alcohol-induced
visions that are not expanded on after the climax of the sequence (and the
sex act) with the bed going up in flames—they left the door open for more
traditional readings of the love story.

 Further, the frank depiction of a sexual relationship on-screen caused much
commotion in the party-controlled East German press, which denounced
the film for its preference toward showing individual pleasure in favor of pro-
moting socialist values. East Germany's leader, Erich Honecker, intervened
personally and watched *Paul und Paula* one day before the scheduled release;
he gave the film his blessing and allowed it to open as scheduled. This com-
bination of officially sanctioned negative critique—a procedure that in the
past had usually meant a DEFA film would either not be released at all or
would only open on a small number of screens—coupled with Honecker's
official visit essentially "vetoed" the unofficial ban of the film and likely
functioned as a marketing campaign and made the film a great success, with
more than 1.84 million tickets sold.[13] The popularity of the film at that time
was also likely due to the fact that many filmgoers expressed surprise about
it being allowed to depict reality and to point out rather openly the prob-
lems of the then contemporary East German society. In order to show their
support, audiences clapped enthusiastically at the screenings of the film and
even spoke up against the negative press reviews about the film.

 Among the driving factors for *Paul und Paula* to appeal to younger audi-
ences was that it not only showed the reality of life in East Germany, but
sex on-screen initiated by a woman. Charming these audiences was indeed
important, as Carow and Plenzorf intended to make this film a blockbuster
to counteract the waning popularity of DEFA films.[14] Among their strategies
was the introduction of Paula as a realistic and therefore unusual heroine for
the first time in DEFA cinema; additionally, they told her story in the form of
a legend—the genre usually reserved for the life stories of famous people—to
promote the importance of the private sphere and individual happiness over
the public sphere and the common good used in the cinematic parables of
the past.[15] A look at the way previous DEFA films were structured reveals
that these films wanted to strike a healthy balance between socialism and
the socialist persona by exploring new ways to bring together the public and
the private spheres. In *Paul und Paula*, Carow and Plenzdorf turned matters
around by clearly emphasizing the need to distinguish between these spheres
and to grant freedom to individuals by allowing them to pursue their own

goals. Here, the director and his scriptwriter aimed to reflect on the cinema screen a shift in East German culture in the 1970s toward protecting and sheltering individuality, essentially a "privatization of leisure"[16] against the influence of the public, later called a "society of niches."[17] Paula embodies this new idea as she strives to find happiness not in the fulfillment of her duty in socialism, but by living in ways that even contradict the notion of the ideal socialist persona. As such, she is an enlightened heroine who represents the type of a new East German woman. Without Paula, the genre of the women's film may not have developed in this way.[18]

In order to distinguish between the public and the private spheres, Carow and Plenzdorf turned to using opposites as building blocks of the film. If one reads the relationship and the environments of the two lovers dialectically, Carow and Plenzdorf proposed their vision of this new type of socialism, the interplay of these ostensibly polar opposites. In *Paul und Paula*, the opposites appear to clash permanently but find their unlikely synthesis in the love between the two protagonists. As already pointed out, their lives are marked by traditionally gendered professions, with Paula working in a supermarket and taking care of the children and Paul being part of the East German *nomenklatura* (ruling class), having served in the military and later occupying an office job. However, when the white-collar Paul takes off his clothes and gets into bed with the blue-collar Paula, they forget these distinctions and literally unify to symbolize a classless society of workers and intelligentsia. Thus, by presenting an extended sex scene centrally in the film, Carow and Plenzdorf did not intend to emphasize adultery, but rather to present a concept central to the socialist idea in a pragmatic and natural manner.

The musical elements in the film advanced this notion of uniting different spheres. After her first night with Paul, Paula breaks into singing German folk songs in the supermarket, joined by the hundreds of people shopping there who also know the songs. In contrast to this is the outdoor classical concert Paul and Paula attend on one of their dates, which is clearly new ground for Paula. She claps in between movements of the Beethoven violin piece because she is so touched by the music—and thus identifies herself as a person unfamiliar with the rules of highbrow culture. Paula's genuine emotional outburst inspired by the music (as compared to Paul's restraint because "attending a classical concert is simply something educated people of his standing ought to be doing") jumps across the audience, and soon everyone is applauding the soloist who appears pleasantly surprised about receiving a standing ovation.[19] Even the non-diegetic music, performed by the rock band Puhdys opening the film, and accompanying the sex scene as a commentary, comprises the dialectic of the popular versus the sophisticated entertainment.[20] Composer Peter Gotthardt and the writer of the lyrics Ulrich Plenzdorf, blended catchy pop tunes that appealed to a young generation with lyrics inspired by the bible ("*Wenn ein Mensch lange Zeit lebt*" / "When a person has lived for a long time") on the one hand and sexually suggestive ("*Geh zu ihr und lass deinen Drachen steigen*" / "Go

to her and let your kite rise") on the other to create a film without hypo-critical political undertones. To East German audiences, *Paul und Paula* represented the on-screen realization of what had had to remain unsaid in previous DEFA films.

Like no other DEFA film, *Paul und Paula* remains an artistic inspiration. For instance, turning buildings into political subtexts reappeared as motif in Konrad Wolf's *Solo Sunny* (1980) and Peter Kahane's *Die Architekten* (*The Architects*, 1990).[21] Challenging gender roles and criticizing failed emanci-pation became one of the most important topics in the women films through the late 1980s.[22] Audiences continued to seek out the film, even after unifi-cation. And when East Germany's past resurfaced in the *Ostalgie* movement, Paul even showed up as reference in Leander Haußmann's *Sonnenallee* (*Sun Alley*, 1999), one of the first movies addressing the nostalgia about East German past, when the hero, Mischa, also unhappily in love, runs into Paul, who disappears behind a door whose nameplate reads "Paul und Paula."[23] For contemporary audiences, the political subtext is no longer visible; how-ever, what remains is a timeless love story that has lived on as the legend of Paul and Paula—a self-fulfilling prophecy.

DEFA AND THE HOLOCAUST, THE ANTIFASCIST LEGACY, AND INTERNATIONAL ACCLAIM: *JAKOB DER LÜGNER* (*JACOB THE LIAR*, FRANK BEYER, 1974)

As a reaction to the fascism of the Nazi years, East Germany was founded with the premise of being an antifascist German nation. Therefore, antifascist narratives motivated the arts from the beginning and during the entire time of East Germany's existence. Hence, a large segment of socialist literature and film contained stories of persecution—and also of heroic resistance in the light of death looming for opponents of the Nazi state. Because of the way East Germany's foundational idea of antifascism interlocked with and had an influence on the arts, it is no wonder that many DEFA films centered on this topic, or at least included references to the nation's mission of fighting fascism and fascist traces.[1] DEFA, however, did not solely produce large quantities of antifascist tales, but they crafted internationally esteemed and highly awarded films such as *Jakob der Lügner* (*Jacob the Liar*, Frank Beyer, 1974), a motion picture that won prizes at the prestigious Berlin film festival Berlinale and received a nomination for the Best Foreign Language Film at the 1977 Academy Awards.

Set presumably in the year 1945 in the ghetto Litzmannstadt, located in the German-occupied Polish city Lodz, the film opens with pictures of seemingly deserted homes while the opening credits are still on-screen.[2] These shots serve as framing device to anticipate the end of the film, when the deportation of the ghetto residents leaves their homes as uninhabited as they appear in the beginning. Just as the emptiness takes over in the beginning of the film, the camera captures a door opening and an elderly man leaving his residence. As he wanders through the ghetto, it is still unclear why nobody else populates the streets—until he is stopped for breaking the curfew imposed on the residents by the occupying Nazi troops. Sent to the local police station to report his own breach of the regulations, Jakob Heym commits another violation when he enters the building: a big sign posted on the door reads "Entry for Jews explicitly forbidden." Unable to read this and the other German signs inside the station, and therefore incapable of

understanding the absurdity of the situation, Jakob wanders around the hall-ways trying to find the room he is to report to. In the hope of overhearing a conversation that will direct him to the appropriate person, Jakob starts listening at the closed doors and accidentally eavesdrops on a radio broadcast that announces that the Soviet Red Army is advancing. Upon Jakob's return to the ghetto (after having received a warning for violating the curfew), he shares the news with his depressed coworkers at the shunt yard to help pre-vent the rising number of suicides by ghetto Jews by providing some hope. Some residents doubt his information until Jakob pretends to own a con-traband radio he listens to for information. At that time, the news spreads through the ghetto, and soon the entire population requests war updates. Because of a resurgence of hope, Jakob begins to make up more and more stories that promise an end to the war. The suicides in the ghetto cease, but he is morally affected by the fact that he is lying to order to accomplish this. However, not everyone in the ghetto is happy about the continuing news, as they fear the Germans finding out about the radio will endanger their lives. Once the deportation begins, Jakob does everything in his power to keep up the hopes until the last minute by continuing to tell his invented stories, even while the Jews are being transported away by train.

Jakob does not offer the happy ending that would have shown the ghetto population rescued from Nazi extermination during the final days of the war. Yet it is precisely this lack of liberation by the advancing Soviet Army that made the film so believable, popular, and successful. Unlike other DEFA's antifascist films, in which the troops of the "big brother" Soviet Union came to the rescue, *Jakob* is distinguished by their visual absence. Frank Beyer still coded the Red Army in a positive way by having it sig-nify, via the invented radio news, liberation from fascism, an event that as a result would facilitate a new beginning for the residents. Konrad Wolf's *Ich war Neunzehn* (*I Was Nineteen*, 1968), Heiner Carow's *Die Russen kommen* (*The Russians Are Coming*, 1968), and Beyer's *Nackt unter Wölfen* (*Naked among Wolves*, 1963) took much stronger positions in favor of the Red Army, which appeared on-screen as evidence of the Soviet Union's central role in the liberation of Germany. Abandoning this visual convention allowed Beyer to create a portrait of humanity, personal guilt, and responsibility within human suffering that was credible and had universal appeal beyond ideologi-cal borders while still standing out among the over one hundred antifascist films DEFA produced. "Forgetting" to acknowledge the Soviet Army on-screen also allowed another reading: By relegating them only to the sound-track of the film instead (via the imagined radio news), Beyer essentially offers a critical comment on the role of the Soviet Union during the Prague uprising of 1968, a few years before the release of *Jakob*, when troops of the Warsaw Pact quelled the attempt for a democratization of Czechoslovakia by sending tanks to the country's capital to end the attempt with violence.[3] In a way, *Jakob* revisits these events when it shows the fallibility of the Red Army, who were unable to save the lives of the Jews at Lodz in 1944, and suggests another failure in 1968.

First and foremost, however, *Jakob* was intended to send a message in-line with the most popular non-genre of antifascist film that "captured the artistic ambitions, political commitments, and filmic sensibilities of this major socialist cinema in almost ideal form."[4] Multiple subgenres and a variety of settings make the antifascist film difficult to define. Some of them took place during the time of the Nazi regime and addressed issues such as the gradual transformation of Germany into an anti-Semitic society. As an example of this idea, Kurt Maetzig's early DEFA film *Ehe im Schatten* (*Marriage in the Shadows*, 1947) brought in biographical experiences of both Maetzig's mother, who had committed suicide to escape arrest by the Gestapo (the Nazi secret police), and of the life of German actor Joachim Gottschalk, who also killed himself when he was urged to leave his Jewish wife.[5] Another manifestation of the antifascist genre addressed methods the Nazis used to claim and retain power in Germany, such as the docudrama *Der Fall Gleiwitz* (*The Gleiwitz Case*, Gerhard Klein, 1961), which reconstructed the attack on the German radio station Gleiwitz; this attack was undertaken—on their own initiative—by a special section of the SS (Schutzstaffel [defence corps]) in order to have a reason to launch the Poland campaign that started World War II.

But stories of catharsis and resistance against the Nazis also became popular topics. For instance, Heiner Carow's *Die Russen kommen* showed the case of teenage Günter who returns home as a disillusioned POW (Prisoner of War); the film *Dein unbekannter Bruder* (*Your Unknown Brother*, Ulrich Weiß, 1982) takes a somber look at the dangers of resistance fighters, something that an earlier film, *KLK an PTX—Die rote Kapelle* (*KLK Calling PTX—The Red Orchestra*, Horst Brandt, 1971) had still glorified as courageous movement.[6] The topos of the German communist resistance fighter being trained by the Soviets and returning to Germany to fight Nazis and liberate the homeland was introduced in movies such as *Ich war Neunzehn* (*I Was Nineteen*, Konrad Wolf, 1968) and *Mama, ich lebe* (*Mama, I'm Alive*, Konrad Wolf, 1977). Some films, such as *Nackt unter Wölfen* and *Jakob*, showed the atrocities committed by Nazis in concentration camps, and another group of films, such as *Die Mörder sind unter uns*, illustrated how fascism was still present in postwar Germany, where former Nazis lived comfortably despite the war crimes they had committed.[7] In most of DEFA's antifascist films, the victims are not Jewish, but communist. These narratives shifted the discourse of victimhood away from the Holocaust and introduced the communist resistance fighter as the object of suffering instead.

Jakob broke out of this pattern, redirecting the attention away from the communists and back on the Jews and the Holocaust. It was not the first DEFA film to do so—Konrad Wolf had broken new ground already in 1959 with his East German–Bulgarian coproduction *Sterne* (*Stars*)—but Beyer went further. Read alongside the antifascist DEFA films from the 1950s and 1960s, *Jakob* critiqued the conventions established as part of the founding idea of East Germany as a socialist and antifascist and nation. Instead, the film directs the attention to the Jewish victims of the war, challenging

previous narratives of heroic antifascist communists who became martyrs in their fight against Nazis. In *Jakob*, the protagonists stand in stark contrast to these "socialist archetype[s]," whose lives often depicted them as one-dimensional figures, devoid of private lives, completely imbued with the ideology of revolutionary socialism, and who "became immortal symbols, rather than flesh-and-blood individuals."[8] Jakob and Kowalski, two of the central characters in *Jakob*, may be stripped initially of any associations to their private lives, too, but unlike in the antifascist films about the communist heroes, the perceived lack of multidimensionality has to do with their living conditions in the ghetto. Other than performing their forced labor loading train cars with provisions for the German troops, there is not much left in life, as Jakob mentions in the beginning of the film when he leaves the house for a walk. Yet numerous flashbacks to preoccupation times breathe life into the protagonists: Jakob fries his famous potato pancakes in his small corner restaurant, gets a shave at the barber's, and enjoys happy times with his girlfriend (see figure 12.1). Adding this dimension humanizes the ghetto inhabitants and transforms them from being *Untermenschen* into the individual people they used to be. By adding vivid colors to the mise-en-scene that take advantage of a full color spectrum in order to create a stark contrast to the brown and grayish tones of the ghetto, Beyer clearly distinguishes the happy past from the bleak present, bringing psychological depth to the protagonists. The aim of reminiscing about the past is, therefore, to establish Jakob not as heroic figure predestined for a life as antifascist hero, but as a human whose everyday resistance consists of tools other than weapons and agitating speeches railing the masses. As Frank Beyer mentioned in an interview, the theme of the film goes beyond antifascist resistance (even though Jakob is both antifascist and a resistance fighter) to address the larger issues of truth and reality.[9]

In *Jakob* and in other films, Beyer directed the focus away from heroism and "privileged the existential questions of guilt hope, and personal responsibility"—something he would repeat in his 1983 antifascist film *Der Aufenthalt* (*The Turning Point*) about a young POW imprisoned in Poland who questions the meaning of World War II upon his return to Germany.[10] For *Jakob* to be understood as case study that "did not happen this way—but maybe it did," this disclaimer that opens the film proposes authenticity for the story, to distinguish it from the invented heroic narratives so prevalent in DEFA's antifascist films. In *Jakob*, the ordinary triumphs over the utopian, evidenced by the notion that heroism consists of lying about the existence of a radio. Further, the use of simple, non-diegetic sound bolsters this feeling of triviality. With the exception of the flashback dream sequences that feature rich musical background—such as an orchestra performing a Slavic-themed waltz—a simple "foreign" tune played by a lone violin repeats frequently in the film as its only musical sound. Like in his use of color, Beyer also uses harsh contrasts in the choice of music—not to alienate, but to create an intermedial combination that both blends and distinguishes dreams from reality and truth from lies.[11]

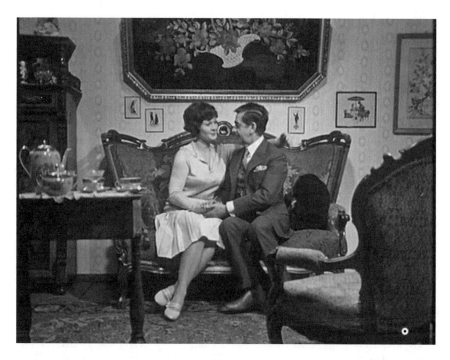

Figure 12.1 Flashback sequences as tools to provide a multidimensional picture of a new antifascist hero in *Jakob der Lügner*, an alternative to heroic antifascist narratives of DEFA. Screen capture, DVD *Jakob der Lügner*.

The choice of actors for the film illustrates further how *Jakob* departed from the heroic antifascist narratives. Initially, Frank Beyer had planned to either cast his friend, Czechoslovakian Vlastimil Brodsky, or the popular West German actor Heinz Rühmann for the role of Jakob. However, the leader of East Germany, Erich Honecker, not Beyer, made the final choice and picked Brodsky for political reasons, hoping to create a distinct East German cinema at a time when DEFA was in crisis.[12] Perhaps, too, Rühmann's past played a part in this decision: After all, he had acted in over 35 films produced during Nazi rule, and even though he had been classified of having only been a Nazi sympathizer, employing Rühmann would have caused substantial discussion.[13] Snubbing Rühmann allowed DEFA to avoid this debate and defer to international solidarity instead, something that would be strengthened by casting Brodsky, despite his marginal knowledge of German that required his dialogue to be dubbed.[14] Thus, choosing Brodsky was a political move, not an artistic decision, to avoid an on-screen competition between the West German actor associated with fascist cinema and two East German stars who had become synonymous with antifascist film. Eventually, the decision against Rühmann turned out to be a good one: Brodsky's acting impressed the jurors of the 1975 Berlin Film Festival and won him the Silver Bear for best lead actor. *Jakob* then went on to be nominated for an Academy Award in 1977—the only East German film ever.

With all this success in mind, it is hard to imagine that *Jakob* almost did not come into being. In 1964, East German author Jurek Becker had already approached the studio with a script entitled *Jakob der Lügner*, which he had adapted from one of his father's stories about a man owning an illegal radio in the Lodz ghetto and reporting about the progress of the war. Becker, a survivor of the ghetto and the concentration camp Sachsenhausen, changed the story in his screenplay to be about a ghetto resident pretending to possess a radio and reporting made-up news to cheer up his fellow inhabitants. DEFA assigned Beyer to collaborate with Becker on a revision of the screenplay in preparation for production. Because the script addressed taboo topics such as the existence of Polish ghettos, anti-Semitism, and the collaboration of Poles with the Nazis, DEFA did not receive a permission to shoot in Poland. Meanwhile, the series of *Kaninchenfilme* in 1965 had affected Frank Beyer's career.[15] He had become persona-non-grata at DEFA for making the film *Spur der Steine* (*Traces of Stones*, 1965), and as he was not willing to admit to having made a film harmful to socialism, he received no further directorial assignments. The film project *Jakob* was also shelved. Jurek Becker took the screenplay, turned it into a novel, and published it in 1969 at the East Berlin publishing house Aufbau and soon after in West Germany, as well. With the international success of the book, a screenplay at an advanced stage, and the West German public television channel ZDF (Zweites Deutsches Fernsehen) indicating interest in the screenplay, DEFA revisited the project.[16] Frank Beyer returned from his artistic exile, in which he had directed plays at a theater in Dresden until 1969 and then worked for East German television DFF. DEFA coproduced *Jakob* with the DFF, allowing Beyer to redeem himself, while the studio was able to take advantage of his knowledge of the project and save face. *Jakob* premiered on East German television first, and went on to become one of the best-known DEFA films internationally.[17] In 1999, Hollywood director Peter Kassovitz remade the film under the title *Jakob the Liar*, starring Robin Williams as Jakob—and Armin Mueller-Stahl, now a familiar face in the United States of America, as another ghetto resident, Dr. Kirschbaum.

The remake received poor reviews in the press and criticism among many film scholars for changing the ending into a happy one.[18] By doing so, the Hollywood remake actually followed Becker's original ending in the novel, in which the narrator moves the story "beyond the jurisdiction of the Holocaust."[19] However, addressing Germany's fascist past and working through it was one of the central traits of DEFA's antifascist cinema. By confronting the Nazi years and accepting them as Germany's legacy already in the 1940s, DEFA (and East Germany) were years ahead of West German cinema. There, a systematic examination of these years took until after 1962 when the Oberhausen Manifesto declared the death of "Daddy's Cinema."[20] This old cinema that had celebrated escapism with so-called *Heimatfilme* (homeland films) featuring green meadows, blue skies, and the beauty of nature was now vehemently attacked by filmmakers of the Young German Cinema and later by a New German Cinema that systematically exposed the

dark past of their parents, creating a number of anti-*Heimatfilme*. In *Jakob*, nature also takes on a new meaning, invoking hope, harmony, and peace as emblems of a world without fascism and not as deliberate and convenient ignorance like in West German films. Not without a reason the ghetto is void of flowers or trees: it is a place that lacks humanity. And when in the final scenes on the freight train, the blue sky and the white, puffy clouds soothe the riders and make viewers long for the happy ending, the whistle of the engine disrupts the hope, announcing what the camera does not need to capture—the arrival at the gates of a concentration camp, the destination of the train.

The visual power of this scene alone could serve as a representation of many DEFA antifascist films. It is this non-genre that brought about the best in directors and artistic working groups, suggesting that antifascism must have indeed been central not only to the cinema, but to the entire East German society. A wide variety of productions across many genres and decades attests to its importance, and virtually all stars played at least one role in an antifascist film. *Jakob* remains the paradigm of antifascist DEFA cinema for using a different approach and for addressing the Holocaust and its effects, instead of repeating the official discourse of the communist as victim and hero.

13

THE WOMEN'S FILM, KONRAD WOLF, AND DEFA AFTER THE "BIERMANN AFFAIR": *SOLO SUNNY* (KONRAD WOLF, 1980)

The ideological foundation of socialist East Germany was vehemently attacked in Konrad Wolf's 1980 film *Solo Sunny*—about the triumph of the individual over the collective—but, surprisingly, a scandal about it never materialized because of the film's sudden popularity abroad. When the jury of West Berlin's international film festival, Berlinale, nominated the DEFA submission for best picture and awarded the Silver Bear (the prize for the best actress) to Renate Krößner for her role as Sunny, it was no longer possible to have the film disappear from East German movie screens. It became a cult film almost right away, and more than a million people watched it in sold-out shows during its run of 19 weeks nonstop at the Kino International in East Berlin. The film hit a nerve with audiences who, like Sunny, were looking to break out of their daily routines and assert their personal space in a society that favored conformity over individual freedom. To them, Sunny became the on-screen realization of their dreams and a role model.

Like no other film of these years, *Solo Sunny* represents the multiple layers of life in East Germany in the late 1970s. It was shot in East Berlin's Prenzlauer Berg, a district that saw little renovation during the time of socialist rule. *Solo Sunny* captured a spirit that screenwriter Wolfgang Kohlhaase described as a desire by residents of this district to "live strong."[1] Many East German artists occupied the run-down nineteenth-century buildings designed as tenement houses for workers, and residing in Prenzlauer Berg had become synonymous with living an artistic and alternative lifestyle.[2]

In the film, Ingrid Sommer, known as Sunny, a second-tier pop singer in the band Tornadoes, is single and lives in one of these typical Berlin-style apartments facing the courtyard (see figure 13.1). Her job requires her to travel around East Germany as part of a small variety show that plays at small town festivals. Secretly, however, Sunny dreams of her breakthrough as pop singer, able to make her living by singing "solo." She also goes solo in her private life, refusing permanent relationships; for example, she turns down the taxi driver Harry's marriage proposal even though he offers her financial security. Instead, Sunny prefers to stay in charge of her own life, something

Figure 13.1 A stark depiction of living conditions in East Germany: Sunny's apartment building in Prenzlauer Berg. DVD screen capture *Solo Sunny*.

she reaffirms in the film's final sequence as she describes herself: "I'm blunt, I sleep with whomever I want, I call a jerk a jerk, I am the one the Tornadoes kicked out. I am Sunny."

This quote evokes one of the initial scenes when Sunny, still in her robe after getting up, opens the blinds in her bedroom and addresses a young man in her bed with the words: "It's without breakfast." When he protests about being kicked out, she replies, "It's without discussion, as well," providing evidence of her independence and her ability to take charge. In this role reversal of a morning-after situation, Sunny is marked as a strong-willed, emancipated young woman. While this scene supposedly emphasizes gender equality in East Germany, the situation will be looked at more closely later in this section, as it is here that Konrad Wolf sets up a major criticism of everyday life. Sunny's fellow musician, Norbert, attempts to rape her one night after a show, thinking that, with her lifestyle and extroverted personality, she would sleep with anyone. She fights him off and injures him, hitting his head with one of her high heels. However, instead of supporting Sunny after the attack, the band members replace her with a younger, and supposedly less-resistant, singer. After the rape attempt, a failed relationship with the band's saxophone player, Ralph, and her deliberately overdosing on pills at a friend's house, the film closes with Sunny regrouping, realizing that she cannot change to please society, and answers an ad from a band looking for a new singer.

West German film critic Heinz Kersten described *Solo Sunny* as DEFA's "most radical portrait of unconventional people," suggesting that Sunny's brusque demeanor made her an antiheroine rather than a role model, and

identified her as the most emancipated woman of East German cinema.[3] Similarly, for many weeks East German papers printed letters to the editors that praised Sunny as a particularly good example of "strong, resilient women."[4] Yet DEFA cinema had provided viewers with a number of "determined and indestructible" female protagonists before, so why did Wolf's film cause such a lively reaction among audiences and critics alike?[5] This question will be addressed later, but the differing role of men and women directors begs discussion.

The success was certainly not due to the fact that a male director had made a women's film; after all, most DEFA films with female protagonists that addressed gender issues had been directed by men. In fact, during DEFA's 46-year history, only five women directed feature films for the big screen: Bärbl Bergmann, Ingrid Reschke, and Hannelore Unterberg created children's films, and Iris Gusner and Evelyn Schmidt made films about the balancing act of work and family life for East German women.

Supposedly ahead of their Western counterparts, emancipated and equipped with equal rights, DEFA's female directors still struggled with the double burden of family care and work, creating a stark contrast between ideology and reality.[6] Unlike in West Germany, where the journal *Frauen und Film* promoted the feminist agenda of West German women directors such as Helke Sander, the women directors of DEFA were at the mercy not only of the male-dominated DEFA studio but also of the critics and colleagues publishing in East Germany's major film journal *Film und Fernsehen*.[7] The SED-controlled journal ignored issues of feminism because it was "proud [...] of the measures they had introduced to provide equal opportunities for women at work,"[8] and disallowed the development of an overt feminist movement at DEFA. The studio therefore usually commissioned films about gender equality and emancipation, such as *Der Dritte* (*Her Third*, Egon Günther, 1972), *Die Legende von Paul und Paula* (*The Legend of Paul and Paula*, Heiner Carow, 1973), *Bis daß der Tod euch scheidet* (*Until Death Do Us Part*, Heiner Carow, 1979), and *Solo Sunny*, to male directors.

Nevertheless, their films addressed the slow progress of emancipation by focusing on the position of East German women in the workplace and turned women into "a more realistic reflection of the position of female workers."[9] However, despite this attempt to show that despite a policy of closing the gender gap, not much had really changed in terms of gender equality. Female engineers in films such as Frank Beyer's *Die Spur der Steine* (*Trace of Stones*, 1966) who oversaw construction sites were not the norm. Instead, women worked in grocery stores like Paula in *Die Legende von Paul und Paula* and were expected by their husbands to be only mothers and housewives—and at least less prestigious than men in work positions—the topic of Carow's *Bis daß der Tod euch scheidet*. In the few feature films by female directors, Evelyn Schmidt and Iris Gusner expanded the cinematic gender discussion by adding autobiographic notes as their expression of the tremendous pressure on East German women having to succeed both at home and in the workplace. The reality for East German women was quite different from the statements

of the East German Women's League (DFD), which propagated the benefits of SED politics and consolidated the official picture of the modern East German woman—juggling family duties, her work, and political engagement without effort; many of the almost 50 films about contemporary issues with female protagonists attest to this.[10] Not a single film shows any woman holding political office, which accurately reflected reality, since few women were in politics at all.[11] Although films with female protagonists had progressed somewhat over the decades, from the perception of "East German women [...] to have been remarkably accepting of the double burden of career and family"[12] to a more nuanced portrayal that now showed their awareness of a gender gap in relation to these issues,[13] they never confronted the gender order directly by questioning society in general. Konrad Wolf's *Solo Sunny* was different from other women's films in this respect by focusing on a woman who deliberately chose to be on the fringes of bourgeois society.

Solo Sunny surprised many, not only as an unconventional women's film, but an unusual film for Konrad Wolf. It appeared to not quite fit his previous artistic profile at all. At DEFA, the name Konrad Wolf stood for a director who "committed himself to the building of a Communist society and culture in East Germany."[14] His political conviction becomes obvious if we take into account that he was president of the East German Academy of the Arts (Akademie der Künste) from 1965 to his death in 1982—and therefore a high-ranking person in the state apparatus—and by looking at his film topics. These range from critical explorations of National Socialism before and during the war and include the two autobiographical films *Ich war neunzehn* (*I Was Nineteen*, 1968) and *Mama, ich lebe* (*Mama, I'm Alive*, 1976). Further, some films dealt with the role of the artist in socialist society, such as *Der nackte Mann auf dem Sportplatz* (*The Naked Man on the Sports Ground*, 1973). Finally, other productions were about contemporary issues: *Sonnensucher* (*Sun Seekers*, 1958 banned/1972 released), *Der geteilte Himmel* (*The Divided Heaven*, 1964), and his last feature film before his death, *Solo Sunny*.[15] Despite the temporary ban of *Sonnensucher* in 1958 (upon request of the Soviet Union because of the highly sensitive topic of uranium mining during the Cold War),[16] Wolf's films were sometimes viewed ambivalently because of his involvement in East German politics.[17] However, though Wolf may have received some leeway when it came to production deadlines, it would be wrong to infer that his films painted naïve pictures of life in East Germany. Many of his works pondered rather critically the respective conditions in socialist society and did not shy away from controversial topics, such as the inhumane effects of the Berlin Wall in *Der geteilte Himmel* or the role of modern art and the artist working against the constraints imposed by socialist politics in *Der nackte Mann auf dem Sportplatz*.[18] Seen from this vantage point, we might read *Solo Sunny* as a continuation of Wolf illuminating the corners of socialist society.

Much like Rita in *Der geteilte Himmel* developing into a person detached from male influence, Wolf creates Sunny as independent person. Troubling

to East Germany's censors may have been how the plot turns away from the collective as it grants Sunny the space for individual development as legitimate pathway of socialism by linking the plea for personal happiness with the story of an unconventional, emancipated woman in a patriarchal society. Audiences loved the unusual approach and the precise portrayal of the visceral quality of life in Berlin's Prenzlauer Berg. The interplay of many components facilitated such a lifelike portrayal. Without the constellation of a storyline based on the biography of a real person, a convincing screenplay that captured the vernacular spoken in Prenzlauer Berg, a cinematography that placed the film audience in the middle of the constricting yet almost redemptive environment of the courtyard apartments, a film such as *Solo Sunny* by a director such as Konrad Wolf would not have been imaginable. In addition, the changes in the DEFA studio following the expatriation of East German author and singer Wolf Biermann that led to the exodus of many prominent artists in the late 1970s attributed to it. The decision to move forward with the project came when Klaus Höpcke, second-in-command at the Ministry of Culture and responsible for forcing out a large portion of the country's cultural elite in the wake of the "Biermann Affair," was looking for a way to redeem himself. Höpcke approved a screenplay about a nonconformist woman that Wolfgang Kohlhaase had been working on since the mid-1970s; Kohlhaase presented the script of *Solo Sunny* to the director he had collaborated with for a number of films, Konrad Wolf—who turned down the project at first, presumably because he could not envision himself working on this subject matter. Yet he may have changed his mind because of the underlying premise of *Solo Sunny* as tale of a woman continuously assessing herself and searching for her place in society. Much like his other work, then, *Solo Sunny* raises "questions of perception and awareness, and of the material and mental barriers that obstruct them."[19] And indeed, Sunny's original story is that of a social misfit who escapes into rebellion and civil disobedience as answer to society rejecting her.[20]

The actual life story was that of a girl born to immigrants from eastern Europe, Sanije Torka, who grew up in children's homes and later in juvenile detention centers (*Jugendwerkhof*) in an attempt to rehabilitate her into socialism.[21] In 1976, Sanije told her story to the East German journalist Jutta Voigt, who never got to publish the interview because Sanije's life story deviated too much from the ideals of socialism to be printed in an East German publication.[22] Kohlhaase, who regularly saw Voigt at the East German artist's venue Die Möwe, based the screenplay on one period of Sanije's life, but changed the name into Sunny, both in reference to the name of the film protagonist Ingrid Sommer and to protect Sanije from repercussions.[23] Sanije's technique to survive mentally, it appeared, consisted of testing out the limitations of socialist society by working as a singer and entertainer and by vehemently resisting giving up her individualism. Kohlhaase retained Sanije's personality and her character as a renegade unwilling to toe the line. This decision turned out to be one reason for the film's success.

Directing the film with such an usual protagonist required a change Wolf's style, something that is reflected in his choice of personnel. In order to capture the unique spirit of Sunny as part of the Prenzlauer Berg environment, Wolf selected people with ties to this part of Berlin. For starters, Wolf made Kohlhaase his codirector because of his knowledge of the Berlin jargon throughout the film. In one instance, Sunny even points out that taxi driver Harry uses a Berlin variant (and grammatically incorrect form) of "you," to which he objects and corrects her proper German with the Berlin variation. This scene takes on a nearly self-mocking meaning, as Renate Krößner's speech throughout the film is ostensibly marked as from Berlin in dialect and lexicon. In fact, Krößner was deemed so ideal for the role that Wolf and Kohlhaase picked her to play the pop star even though she had no training as singer. East German jazz singer Renate Doberschütz became Krößner's voice double for the songs and cocomposed some of the songs together with Günther Fischer.[24] Fischer, an internationally acclaimed East German jazz composer with engagements in Hollywood, had never worked with Wolf before, yet he captured the mood of the film so well that his soundtrack replicated the "intrinsic episodic quality of the dramaturgy evolved by Wolf over the preceding twenty years."[25] Similarly seamless teamwork occurred in the cinematography, even though Wolf had chosen the young Eberhard Geick—who had trained as master student with well-established documentary cinematographer Erich Gusko—over his longtime director of photography Werner Bergmann, who had shot all of Wolf's previous films.[26] Geick had filmed about a dozen of short documentaries and contributed to capturing events much closer to reality by employing an "energetic use of the camera with its rapid movements"; this conjured the documentary style, making *Solo Sunny* appear the depiction of everyday life in East Germany.[27] Wolf also decided on Geick because he lived in Prenzlauer Berg and knew exactly which points of view and camera angles would be necessary to capture an authentic glimpse of the district.[28] Geick succeeds in creating a documentary snapshot of East Germany: views from a camera placed inside the moving taxi and the band van that show the country from the vantage point of an East German, rolling past unfinished construction sites of new housing developments, old ladies leaning on their windowsills and watching children playing in overgrown courtyards, a battery of trash cans lined up next to the building entrance, and an airplane approaching the airport. *Solo Sunny* became a success, not necessarily because Konrad Wolf directed it, but because he took the risk to work with people providing a new, untainted, and naturalist perspective on aspects that appeared in the film.

One wonders if Wolf would have continued his films for the big screen in this vein had he not died of cancer only months after its release. Each layer of the film challenges East Germany by simply showing the reality of socialism and exposes its shortcomings. Problems in socialism, the film suggests, are omnipresent and surface if individuals take charge of their lives.[29]. Sunny, for instance, claims her body as her own, thus butting head with socialism as both a patriarchal and a controlling system.[30]

The timeless impact of the film, shows best in what one could consider a sequel, the film *Sommer vorm Balkon* (Summer in Berlin, Andreas Dresen, 2005), to which Kohlhaase wrote the screenplay. The plot is still set in contemporary Berlin, now after unification, and once again we watch the dreams, failures, and the daily struggles, of not one, but this time two women on the fringes of German society. Many critics, however, missed the reference of this film to *Solo Sunny*, Konrad Wolf, and the connection to an East German past.[31]

14

PASSED BY HISTORY: DYSTOPIA, PARABLE, AND BOOKEND: *DIE ARCHITEKTEN* (*THE ARCHITECTS*, PETER KAHANE, 1990)

When Peter Kahane's film *Die Architekten* premiered on June 21, 1990, it depicted a country that no longer existed. This would not be remarkable if the film was revisiting a historical period in time. However, Kahane's movie looks back merely a couple of years to East Germany in the late 1980s, yet it portrays a country that gives the impression of being stuck in the past, unable to offer opportunities for young generations, and not having developed much for decades in terms of quality of life. Like no other DEFA film, *Die Architekten* reflects the melancholia and disappointment of many East Germans with their country; read in conjunction with its production history, it reveals even more the desperate state of East Germany on all levels at the time of its collapse. In a way, the film works both as Kahane reckoning with an East Germany that suffocates its citizens and as an appropriate conclusion to a DEFA cinema that started in rubble and now ends in symbolic rubble.[1]

Die Architekten follows the life of East German architect Daniel Brenner. Already in his late thirties, Daniel has not had the chance to prove his talent since he has been limited to designing bus shelters and similar petty projects. Instead of a young generation of architects, the old guard still designs the vast majority of buildings, claiming all attractive, large, and eminent jobs. As a result, even the most recent developments imitate existing constructions. Nevertheless, Daniel remains optimistic, hoping to get his chance to direct a large project one day. When he is asked to plan a shopping and cultural center for a subdivision on the edge of Berlin, Daniel dreams of countering the gray, drab developments omnipresent in East Germany by adding a town square, restaurants, and a movie theater, and by decorating the subdivision with modern sculptures and gardens. Together with a collective of friends from architecture school, he draws up a comfortable and family-friendly place—but pays too much attention to the project and neglects his wife and young daughter. As the family has recently moved to this somewhat new subdivision consisting only of residential high-rises on the far fringes of Berlin, they have no entertainment choices, and because of the distance, their former friends no longer visit as they used to when the family still lived

in the city. Wanda gets depressed because of the drabness all around, and when Daniel continues to postpone a move back into the city, she announces that she is filing for divorce. Eventually, Wanda and their daughter Johanna leave East Germany for Switzerland.

As it turns out later in the film Daniel's sacrifice of his family for his job is pointless. When he proposes his ambitious plans for the development, the authorities request changes to his design, cutting costly measures such as the restaurant and the movie theater; they even demand the renaming of a sculpture to be more in-line with socialism. Daniel realizes that he has to concede to all of the requests to see his project realized, yet after more and more revisions, it eventually becomes clear that the new subdivision will be merely a replica of previous developments. He resigns to his fate of having to follow established guidelines at the symbolic groundbreaking and finally has a mental breakdown when he realizes that he sacrificed his family in vain.

Throughout the film, one can feel the gloomy mood lingering over East Germany and the anguish about the way life seems stalled for the protagonist. In Daniel, we recognize Peter Kahane's alter ego, who felt unwanted at DEFA. He was already 36 years old when he received his first directing contract with the studio to make *Ete und Ali* (Ete and Ali, 1985)—an event referenced somewhat in the film by Daniel's similar waiting period for design of his first real project.[2] Kahane translated his emotions, mostly anger and frustration about the bureaucracy at DEFA that delayed him from making films earlier in his career, into the figure of Daniel. In a 1993 interview, he confirmed his irritation about the system and how it stopped him from contributing: "I always had the feeling they did not want me in this country. I wanted nothing more desperately than to participate in East Germany. I wanted to finally have arrived."[3] Yet Kahane's was not a singular case but rather an example of the fate of his generation. In fact, the screenplay to *Die Architekten* was developed based on a story by Kahane's contemporary, DEFA screenwriter Thomas Knauf. In 1987, Knauf had written a story about ten architects "going belly-up" (following a nursery rhyme's basic premise of ten people dying one by one) as a symbolic attempt to deal with the fact that his generation had become the "lost generation" in DEFA cinema.[4] He received a contract to write a screenplay for this film, and the studio assigned Peter Kahane to direct to the project. During their discussions about the script, Kahane advised Knauf to rewrite the storyline so it would include a more dramatic failure by the group of architects working on a single construction project. Over the course of the following three months, Knauf—although "permanently arguing with the director"—eventually agreed to use only one project that would show the persistent struggles in everyday work life, and authored a provocative screenplay.[5]

At that time, it was unclear if DEFA and SED would allow the shooting of such a controversial film—and, initially, the screenplay underwent the usual censoring debates.[6] The script was accepted in 1988, and the production was slated to start in April 1989.[7] However, after more deliberation with the new DEFA general director Gerd Golde, who had just replaced Hans Dieter

Mäde, and a discussion of controversial scenes and dialogue with other high-ranking DEFA members and SED officials, Knauf was asked to eliminate only one sentence.[8] Technical difficulties and the use of equipment at other productions delayed the actual start of the shooting by a few months so that filming did not start until October 3, 1989. Overall, it was remarkable that the approval process did not require still more edits by either the studio director or the Ministry of Culture. Once the shooting commenced, however, it became clear that other factors would complicate the filming.

For one, the opening of the Berlin Wall made the film an anachronism. Over the previous months, East Germany had seen regular Monday protests for democracy. After thousands of East Germans had escaped to West Germany via the open border between Hungary and Austria and the West German embassy in Prague earlier in the year, it was obvious that internal changes in East Germany were looming.[9] When Kahane started shooting for *Die Architekten* in October 1989, he did not foresee that roughly a month later the Berlin Wall would be opened, and a new, albeit brief, era of a democratic East Germany would begin. In an interview Kahane explained how they experienced (and somewhat "missed") this historic event while shooting footage. As they were filming at Berlin Alexanderplatz on the evening of November 9, a television played in a shop window, broadcasting the evening news in which SED member Günter Schabowski made a historic mistake as he was reporting on the most recent debates of the East German parliament. Schabowski overlooked a date on his notes and stated that a new decision to allow East Germans to travel without requiring previous approval was in effect immediately (instead of the following day, when this information was supposed to be broadcast via East German radio); West German media declared a few hours later: "The border is open."[10] Kahane and his team, who had ignored the East German press conference playing in the shop window, only realized that something important had happened when an American news team asked them for an interview about the opening of the Wall.[11] With the opening of the Wall and the various changes, Kahane gradually realized that his film, which was intended to point out deficiencies in East German society, had become obsolete during shooting.

The new preconditions of life with an open border between East and West Germany (and East and West Berlin) also posed logistical challenges. With the borders down, any East German without the need for a visa or even a passport could travel to West Berlin and West Germany. Yet, while many took advantage of the situation and left East Germany to either travel or to leave for good, the entire film crew showed up after the weekend and stayed together to complete the film; this clearly suggests their commitment to the project and to their conviction of the significance of the film despite the historic changes. Even before the official opening of the Wall, scenes shot at the crossing point Friedrichstraße (where Wanda and Johanna bid farewell to Daniel before leaving East Germany for West Berlin), the crew dealt with an increased exodus of many non-film–related people who had been granted exit visa in reaction to the thousands of East Germans who

had been leaving for West Germany via the open borders in Hungary or the West German embassy in Prague. Kahane commented that, because of the permits that allowed them to include Friedrichstraße in their screenplay, the emigration scene required the crew to stop the stream of people heading toward the crossing point in order to shoot Wanda and Johanna and the hired extras . Despite psychological strains—the fear that the film would fail due to its historicity and the temptation to leave for "greener pastures"—the same people that had started *Die Architekten* also finished it in early 1990.

Perhaps another incentive for the crew to stay for the completion of the film was the ever-growing challenge to simulate a divided Berlin with an intact Berlin Wall, thus capturing a fenced-in atmosphere of despair, while in reality changes were taking place from day to day. With more liberal policies in place after the Wall had opened, Kahane was now allowed to add a scene at the Brandenburg gate but worried that the Wall there would have already been dismantled by the day of their shooting permit. The Wall was still intact, Kahane recalled in an interview, but in preparation for the official demolition, many camera teams had already set up their lighting towers and cranes to document the historic event. Only the ingenious placement of the camera allowed the cinematographer to catch an unobstructed view of the Berlin Wall and the Brandenburg gate as it used to be—rather ironic, as the film laments the Wall as inhumane construct that divides families.[12] Kahane filmed new scenes because he wanted to capture other East Germans suffering from disorientation due to the sudden changes; most did not end up in the film. For example, only a few lines of dialogue remained from extensive footage of a real protest that took place in front of a church in East Berlin. One of the other amendments made was the closing scene, when Kahane "abandoned the film's somewhat redeeming original ending and let their hero collapse in despair in the film's final scene."[13]

In a way, *Die Architekten* functions as a bookend to DEFA cinema, closing the chapter of DEFA film started by *Die Mörder sind unter uns* (*The Murderers Are among Us*) in 1946. Wolfgang Staudte's film took place in the destroyed buildings of Berlin waiting to be reconstructed for a departure into a new, and better, Germany. While the rubble has meanwhile been cleared in *Die Architekten*, development has stagnated, and the buildings that had originally been constructed to address the dismal housing situation in East Germany no longer symbolize progress but have turned into monuments of anonymity and distress.[14] The modern high-rises built on the fringes of the city may have offered shelter and were equipped with amenities that were unavailable in the city (such as central heat instead of coal and en suite bathrooms instead of communal toilets). The quality of life in one of these modern, satellite towns, in contrast, was virtually nonexistent, as Daniel points out while riding in a car with one of his friends: "No movies, no theater, no bars. [...] Nobody visits us anymore." Wanda formulates her profound aversion even more poignantly: "I'll die here of stimulus deprivation" and asks Daniel to move back into town.

Framed by these conversations, *Die Architekten* introduces the architecture project Daniel has been charged with, namely presenting his vision how to transform the sofar residential-only complex by adding the new shopping opportunities and the cultural center. Instead of the drawings and models that will undergo constant revisions later on, we are immersed in Daniel's childlike joy as he rides his bike up and down dirt hills, pretending to already be in the middle of newly constructed commercial buildings—dodging vegetable stands; asking his wife not to run over shoppers in the grocery store; pointing out the locations of restaurants, cafes, and a post office; buying his daughter an imaginary ice cream. The film returns briefly to the location only once, when Daniel has assembled his team of architects for the project and takes them to the complex of high-rises for an on-site visit. The camera pans to capture doubtful facial expressions as the group walks around the mounds of dirt; when the architects assemble in an elevated position to overlook the future development area, we find them looking down almost helplessly, as signaled by one of them scratching this head (see figure 14.1). Theirs is a significantly different experience from the impromptu family celebration we saw before. For the remainder of the film, Kahane no longer takes the viewer on location but only to the meetings in which models and blueprints are debated by the architects and the politicians. In the end, most of the innovative ideas and creative plans have been altered, reduced, or completely eliminated to meet the demands of the party functionaries. By showing the process of in all of its painstaking detail, Kahane allows the viewers a glimpse into the way politics permeated all aspects of East German life. Often, the demands were simply intended to showcase the influence of politics on everyday life in East Germany, as the ludicrous mandate to rename a

Figure 14.1 Perplexed architects on location, attempting to imagine innovative concepts for a suburban environment. DVD screen capture from *Die Architekten*.

sculpture from "Family in Stress" to "Family And Socialism" voiced in the meeting between the functionaries and the architects illustrates.

If this episode substantiates how building in East Germany had been institutionalized like other aspects of public life, it also positions itself into a long tradition of DEFA films about construction as part of the foundational myth of East Germany. Built from the rubble of Nazi Germany, the new nation was envisioned to be the "State of the Workers and Peasants," so East German cinema eagerly featured stories of construction workers, engineers, and political functionaries working as a collective to reach their common goal of constructing the buildings (and metaphorically working on building the nation) as their home. With a story about architects, a sofar largely neglected group in socialist cinema, Kahane expanded the array of narratives by directing attention to the significance of creativity and freedom in socialism.[15] The dreary tale of failure repositions the role of building again, away from being a signal of renewal and progress, as was the case in *Die Legende von Paul und Paula* (*The Legend of Paul and Paula*, Heiner Carow, 1973); instead, this story continues the monotony and anonymity already present in an earlier film that took place in the concrete suburbia of Berlin-Marzahn in Hermann Zschoches's 1983 *Insel der Schwäne* (*Island of Swans*). If seen in conjunction with the earlier films, *Die Architekten* signals how East German architecture coming to a standstill was one of the starkest symbols for the decline of East Germany.

Read in more general terms, Kahane aimed to have the architects represent East Germany's artists whose creativity and individualism were constantly stifled by a repressive adherence to decrees and directives forced onto them by continuous control, censorship, and a return to the old agenda.[16] Kahane comprised in the person of Daniel all the struggles: being torn between adaptation and noncompliance; hoping to help society progress by presenting radical and stimulating changes; and moreover, having to navigate the tricky situation to remain integrated in the system to have that chance to be effective in their work.

In *Die Architekten*, Daniel refuses to join SED after he is notified by a party functionary of his assignment to develop the design project, though he appears to be aware of the negative impact of his decision. In this situation, Daniel remains steadfast; later on, however, he agrees to make changes to his model when faced with the potential termination of his project. Once he learns about this decision, he makes an appointment with adult representatives from the Free German Youth (which was led by adults) in order to save his first real project. In the meeting Daniel formulates his reply in the idiomatic language generally used by functionaries in order to indicate his willingness to work within the regulative framework staked out by the party. Almost emotionless, he reads a statement in which he accepts the decision to cancel the project (acknowledging the ideological motivation) but appeals to the committee to put measures in place that will enable the success of future generations. What appears to be a resignation is in fact the opposite—it is

his way of relinquishing his individuality and signaling his cooperation with the party line.

Because Kahane no longer had to adhere to the rules and regulations imposed by politics once the Wall had come down, *Die Architekten* serves as a testament of art in between the systems and becomes a magnifying glass of an East Germany in the late 1980s that remained stuck in the sensibilities of the 1960s. At the time of its release in 1990, however, *Die Architekten* was outdated, depicting a barbaric political system that had suppressed creativity and torn apart families, but which had disappeared in a matter of months. Only 5,354 people bought tickets in 1990, a disappointing but not unexpected turnout for the film that would have sold-out theaters a year before.[17] After all, Kahane noted in an interview, "Who would have wanted to see a film which history had run roughshod over?"[18] It took almost 15 years for the film to be shown on German television—in a late-night slot on a regional channel, as Kahane has frequently pointed out, even though *Die Architekten* would have provided a counterpoint to the nostalgia television shows and feature film productions glorifying the East German past. Its breakthrough finally came with the 2005 retrospective "Rebels with a Cause" at the New York Museum of Modern Art, in which the film became one of 21 films from East Germany to be screened to an international audience. Since then, *Die Architekten* has turned into one of the centerpieces of East German cinema as the film that both ended an era and opened another one at the same time.

15

The *Wendeflicks*, Jörg Foth, and DEFA after Censorship: *Letztes aus der Da-Da-eR* (*Latest from the Da-Da-eR*, Jörg Foth, 1990)

An important day for East Germans was November 9, 1989. After massive demonstrations in the streets of their cities for democracy and freedom to travel, the SED declared in a television news conference that travel restrictions had been suspended. Only minutes later, thousands of East Berliners congregated at the crossing checkpoints and streamed into West Berlin as soon as border police opened the gates. This historic event, called *Wende* (turning point), would change East Germany forever. In less than a year, East Germany constituted itself into five states, held free and democratic elections, and eventually joined the West German Federal Republic of Germany on October 3, 1990. Four days later, Jörg Foth's film *Letztes aus der Da-Da-eR* (*Latest from the Da-Da-eR*) premiered at the Berlin cinema Babylon in the already unified Germany. Originally intended to be screened as a satirical and "uncompromising exposure of a bankrupt and ossified state" on this date—East Germany's forty-first anniversary—history had now turned *Letztes* into a swan song on a vanished country.[1] Now, more than 20 years later, watching the film can be a frustrating experience for contemporary German and international audiences as it requires viewers to be equipped with certain background knowledge to decode the plethora of visual information and pointed dialogue contained in the film.

Letztes follows the adventures of the two clowns Meh and Weh (played by the well-known East German cabaret artists Steffen Mensching and Hans-Eckhardt Wenzel) as they navigate through confusing landscapes that turn out to be East Germany at a time of chaos. During their odyssey, the clowns interact with East Germans and experience how the fall of the Wall has caused much of the population to embrace capitalism uncritically and to await German unification as inevitable final answer. Much as Meh and Weh try to make sense of their environment, the film's ten episodes reveal the angst and exasperation ensuing among those who were hoping for an independent, democratic East Germany to develop. Even though the film

was unable at the time of its release to do much more than to document an East Germany in disintegration, it captures the final moments of a country that has fallen apart beyond the willingness of its people to commit to it any longer, reflecting their "weariness of being strung along with empty promises."[2]

By "mapping a topography of pollution, oppression, imprisonment, surveillance and collaboration,"[3] director Jörg Foth reconciles pieces that leave a bleak legacy of East Germany at the turning point in 1990; these pieces, however, stand in stark contrast to the festive spirit that went along with the country preparing for its integration into a completely new political, historical, and cultural structure. *Letztes* reflects on this contradiction in a number of episodic skits. For example, the episode "A German Walpurgis Night" juxtaposes the critical voices of Meh and Weh at a bonfire with the euphoric chants and dances of East Germans bidding farewell to their past by burning red flags and shooting fireworks. Images of the faces of inebriated people are superimposed on the clowns wandering around the crowd, creating a mosaic of contrasts. In an ironic reversal of roles, the carefully enunciated speeches that the clowns attempt to give to the assembled crowds clash with songs about fun, drinking, and sex. Some of the masses ignore the words of caution and others confront the clowns aggressively. In the following episode, "A New Era," the life of the clowns is even threatened by the masses that chase them through the streets, chanting, "shoot the clowns." Meh and Weh barely escape. But when they stand safely in front of an apartment building decorated with German flags hung from balconies and German shepherd dogs barking at them from these balconies in the film's epilogue, they realize that the masses won.

The film's German title also serves as an ironic, and self-reflexive, comment: "*Letztes*" not only means "latest," as in its official English title, but also "last." Thus the film claims to look at a series of final events from the "DaDaeR." Here, the second part of the title functions as a portmanteau in German, blending the acronym for East Germany, DDR (Deutsche Demokratische Republik [German Democratic Republic]), with the European Dada art movement of the early twentieth century. In Germany, Dada manifested itself in the 1920s as an art form that often used artistic works as political and social statements intended to reject, or at least challenge, the established system. Choosing the title *Letztes aus der Da-Da-eR* thus raises the expectation that East Germany ought to be understood as an absurd political concept and not taken too seriously. At the same time, the title also pokes fun at the film itself, branding it as an absurd piece that defies a superficial reading and does not offer convenient viewing pleasure. Thus, one could certainly articulate the goal of the film as being "a left-wing critique of political developments in and around 1989."[4]

In the context of DEFA, DaDaeR takes on the third meaning of changes to the internal studio structure, and with it the emergence of the sofar-suppressed voices of a new, fourth generation of filmmakers. In 1988, a

group of young directors unsuccessfully requested to be granted a chance
to make films in an alternative studio within DEFA; the studio leadership
allowed the creation of the new production group "DaDaR" in the spring
of 1989, and the group eventually started on January 1, 1990.[5] In a studio
transitioning toward privatization, 12 filmmakers in this group—all belong-
ing to the so-called fourth generation of DEFA directors—began working
on new film projects in the hope that DEFA would continue to exist even in
a unified Germany.[6] Initially, their films were not intended to be only exper-
imental but rather to promote a new "artistic subjectivity," allowing direc-
tors to realize projects that would not have been possible in the rigid DEFA
structure.[7] Soon, however, it became clear that DEFA would be privatized
and sold, allowing the group to complete only one round of film projects.
These Wende flicks therefore captured the enthusiasm of their filmmakers
along with their disappointment in their fellow East German citizens, who
either embraced West German currency and its new buying power, left their
country in droves, or awaited unification instead of taking the chance to cre-
ate a democratic East Germany.[8] Looking at these films allows the unique
opportunity to capture the anxiety and frustrations experienced in a dissolv-
ing East Germany in dissolution.

For *Letztes aus der Da-Da-eR,* the first of the *Wendeflicks,* Jörg Foth
adapted the scenarios from pieces Steffen Mensching and Hans-Eckhardt
Wenzel had developed for a series of cabaret shows.[9] Between 1982 and
1989, the duo had performed a number of political shows entitled *Neues aus
der Da Da eR* (Last from the Da Da eR, 1982), *Altes aus der Da Da eR* (Old
news from the Da Da eR, 1988), and *Letztes aus der Da Da eR* (Latest from
the Da Da eR, 1989) that were well received with audiences because of their
acrimonious dialogues that mocked and attacked the political structures of
East Germany onstage. The duo had started their shows after the critical
singer and poet Wolf Biermann had been expatriated in 1976.[10] In 1982,
Mensching and Wenzel began to regularly use the clowns Meh and Weh
to satirize East German politics on a live stage, much like a court jester at
a royal court was allowed to criticize the ruler without fear of punishment.
Their combination of texts with their performance of clowns helped them
to avoid being banned, since it required the interplay of the dialogues, songs
with ambiguous lyrics, and the accompanying performance of gestures and
facial expression to achieve the desired outcome, and to create a censorious
code that East German audiences were able to decode.[11] All texts had to be
approved before an onstage performance, and when the censors criticized
a text passage for its ambiguity, Mensching and Wenzel reworked it and
replaced it with a different passage that was often even more critical but
got past the censorship.[12] The pleasure of the spectacle attending a play by
Mensching and Wenzel thus consisted of the successful decoding process
on the one hand, the audience's realization that the clowns had been able
to speak the truth without being arrested by East Germany's secret police
(Stasi) and of course the humorous touch brought to the play by the clown
characters.

Foth had already captured some of the work of Mensching and Wenzel in his 1989 short film *Tuba Wa Duo*, an 11 minute parody using the tuba as object to mock official East German rhetoric.[13] As his disappointment with the political developments grew, Foth visualized the satirical clown skits as ideal tools to bring attention to what he and others considered a missed chance for creating a democratic East Germany. The skits were taken straight out of the stage plays Mensching and Wenzel had performed in public despite their lyrics that sternly criticized politics, poked fun at party leaders and the secret police, and jibed at everyday problems such as the waiting lists for cars, lines at the meat counter, or the general shortage of commodities that created an active bartering culture. The opportunity to shoot a feature-length film permitted the director and his scriptwriters Mensching and Wenzel to build the plot around 11 political songs, making *Letztes* a musical film in the century-long tradition of German revue films to break "the resistance of […] DEFA against music films at the very last moment."[14] *Letztes* was the first music film since Werner Wallroth's 1983 *Zille und Ick* (Zille and Me), and for the first time in DEFA history a music film with a political agenda was directed against the nation's political leadership.[15]

In *Letztes*, Foth staged the songs in a variety of settings that complemented the message conveyed in the lyrics. In the scenario entitled "Acheron," Meh and Weh struggle to cross the river only to realize that their only option is a ferryboat taking them to the underworld. Instead of a "transition" (presumably of East Germany from communism into a democratic society) there is only the "downfall" of East German society caused by German unification and East Germans leaving for the West. Once more, the song lyrics help situate the dialogues of the clowns in the context of the mise-en-scène. First, Meh and Weh sing a shipyard workers' shanty whose text changes from the vocabulary of the working class (brothels, rum, parrots) to a musical message for a number of people who have relocated to the West (indicated by a list of places in West Germany: Bielefeld, Essen, Paderborn, Franconia) or who now, after the fall of the Wall, have taken the opportunity to travel abroad to swim in the Atlantic Ocean or see Rome. One can almost hear the bitterness in these lines about the fact that many East Germans gave up on their homeland and the chance to reinvent society but rather abandoned the ship East Germany to presumably "start from scratch."

Once in "Hell," the clowns also start searching for the princess Dulcinea of Toboso from Cervantes' novel *Don Quixote* (here a fantasy image of East Germany), but appear to be unable to locate it anywhere in the abandoned cement plant. Instead, the clowns sing a funeral hymn about the "fleeting goods time and money" with the name of the East German chemical plant "Buna" as background chorus—another symbol for a gradually faltering East German economy with companies being privatized or closed in preparation for the transition into the West German market economy. When Meh and Weh realize the futility of their quest for a new East Germany, they reminisce about the events of past decades when they were presumably not allowed to perform funny skits about the Head of State Security Erich Mielke;[16] they

then launch into a reckoning with East Germany as a police state that leads into another song lamenting ironically the ingratitude of the world as it summarizes East German politics in a few of its stanzas. Their accompanying dance around an illuminated communist star adorned with a life preserver hints at the pointless attempt to rescue East Germany as independent nation (see figure 15.1). When the clowns leave the factory along with the workers—a reference to East Germany as nation of workers and peasants— they all sing as they march along grown-over train tracks through a fenced-in fortified alleyway. The narrow path is heavily secured by a wall crowned with barbed wire and illuminated by floodlights reminding eerily of the border protection of the "death strip" separating all 856 miles of frontier between East and West Germany and encircling West Berlin at a length of 96 miles.[17] In another symbolic shot the camera pans 180 degrees along the crumbling wall, away from the marching masses into the empty space to reveal the same bleak and desolate environment to once more show the futility.

Only "A few seconds later," as the following chapter is titled, we encounter a final taking stock of life in the East. In a theater, a "Thank You" song by Meh and Weh is observed critically, first by a group of children, then by an audience made up entirely of members of the Stasi in dark suits and sunglasses, and finally by a mixed audience in an almost empty auditorium consisting of East Germans who remained. Afterward, the clowns return to

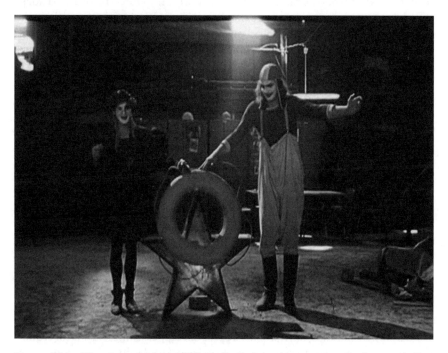

Figure 15.1 The clowns Meh and Weh symbolically trying to rescue the lost utopia East Germany. Screen capture from the DVD *Letztes aus der Da-Da-eR*.

the prison to play a skit about the rigged election results in East Germany with Meh doing a pantomime about a "lost vote" he put in the ballot box.[18] Times have changed, however, and at breakfast the following day, the prison guard has started to disassemble the ammunition for the gun she fired in the beginning of the film, resigned to the fact that East Germany is coming to an end.

In three more scenes and the epilogue, the clowns revisit similar issues that decry long waiting times for commodities, the willingness of the population to tolerate oppression without resistance (the slaughterhouse scene comparing East Germans with cows getting slaughtered), and the development of the SED as an oligarchy (the group of hunters shooting the zoo animals). The prevalence of political song as weapon not for but against the party thus attests that beginning with this film, DEFA cinema was no longer controlled by politics but developed into an authority able to exert political power.

Such a development was unthinkable just one year before the film's premiere. The Stasi had arrested Mensching and Wenzel in Hoyerswerda before a performance scheduled for the fortieth anniversary of East Germany on October 7, 1989, kept them overnight, and transported them out of the region, presumably to avoid an escalation between the demonstrators and security forces.[19] Only a few weeks later, the fall of the Wall allowed the duo to perform again without censorship or fear of any repercussions, and soon thereafter, they began to work with Foth on *Letztes*. In order to adapt the stage programs to the new reality of an East Germany in transition, the group wrote new passages set at various locations and added figures such as a mailman, a garbage truck worker, and a prison matron "to blend theatrical scenes and reality."[20] The casting for these roles was rather remarkable: Foth successfully won major celebrities to play in *Letztes*, with East German author Christoph Hein as garbage worker, West German actress Irm Hermann (who had reached world fame working with Rainer Werner Fassbinder) playing the prison matron, "She," and East Germany's popular sports icon, bicyclist Täve Schur, as mailman. *Letztes* received an additional, deeper layer of meaning with this cast. Hermann as prison guard adds to the value of the film as parable on East Germany; as the embodiment of West Germany she "imprisons" and controls the clowns. In the film's epilogue, we see her smile as she stands in a graveyard next to the headstone with the engraving "Good-bye" to not only indicate the end of the film but also to suggest the "passing" of East Germany after unification. For instance, celebrities such as Täve Schur had also disappeared from the public realm and turned into average citizens. In the new era, Schur still rides a bike, but now to deliver packages in his new job as mailman for the German postal service. He has turned into a buffoonish replica of himself in this apocalyptic scenario showing the loss of cultural East German memory.

In a similar manner, author Christoph Hein appears in *Letztes* as overqualified garbage man reciting verses by Friedrich Hölderlin, who wrote about Germany, politics, and the arts in the years following the French revolution.

When the truck disposes of the artistic "refuse" Meh and Weh in the episode "The Honor is Mine," Hölderlin's words fit the political situation of Germany in transition in an almost uncanny way, allowing Foth to create a multimedia tableau as comment on the prospects of East German arts: most of it will end up forgotten in history's garbage pile. Artists will stray around in a disoriented way like Meh and Weh climbing between the symbolic broken television sets and loose leaves of paper, even though they just decorated each other with a variety of awards during an official ceremony to celebrate the acceptance of one of them to the "Epidemic of Arts" in reference to East Germany's Academy of Arts, an institution representing the arts and advising the government or art-related matters.

Scenes such as these irritated East German critics and strained the comprehension of West German audiences, who were unable to uncover the deeper meaning of the film. On the other hand, East German audiences and West German critics praised this musical satire that painstakingly scrutinized East German politics.[21] Within the matter of a few months, however, this and the other *Wendeflicks* had lost most of their target audiences of critical-minded East Germans. The films disappeared from public discourse and were largely ignored for almost two decades.[22] Only after Foth toured the United States of America with *Letztes,* and when the *Wendeflicks* had a successful US DVD release in 2009, they started to reappear in Germany.[23] Twenty years later, the films are now beginning to find the following the group DaDaR would have wished for in 1990, explaining cinematically the turbulent times of the *Wende.*

APPENDIX

WATCHING DEFA FILMS (LEGALLY)

Reading about East German cinema is nice, but only half as fun without being able to watch the films for oneself. Luckily, nobody needs to rely on the written word, as DEFA films are easily accessible, even for audiences without any or only marginal knowledge of German. All of the films discussed in Part II of this book are available with subtitles in a convenient DEFA Box, available at the DEFA Film Library (https://defafilmlibrary.com/).

The DEFA Film Library at the University of Massachusetts Amherst holds not only the distribution rights to DEFA films in the United States of America and Canada, but has also taken on the commercial distribution of the films on DVD for these countries. At the time of publication, more than one hundred DEFA films have been subtitled, and are for sale on their website. The Film Library is also constantly releasing more films with English subtitles for home use, public libraries, educational institutions, and noncommercial screenings. They even rent out rare prints on 16 mm and 35 mm, and films not for sale otherwise (www.umass.edu/defa). At the time of this book going into print, no official streaming service is available yet.

For films not yet available from the DEFA Film Library, viewers need good mastery of German and access to a DVD/ Blu-ray player to be able to play discs from Europe. Those audiences have access to an amazing selection of hundreds of films available for purchase on the website of Icestorm Entertainment (www.icestorm.de/) and other online platforms or brick-and-mortar stores. For readers with a German IP address and a German residence, Icestorm also offers a growing library of video on demand as Icestorm.TV (www.icestorm.tv). Due to licensing issues, this service may not be available everywhere. None of the streaming videos and few of the DVDs have English subtitles. Some of the fairy tale films are also available in dubbed versions. For those with access to VCRs, preferably multisystem machines, searching for VHS tapes of DEFA films will yield treasures on auction platforms and other places selling used films. Some films were only released on VHS in the 1990s, and are not available on DVD at all.

NOTES

INTRODUCTION

1. For example, Sabine Hake, *German National Cinema*, 2nd ed. (New York: Routledge, 2008); Tim Bergfelder, Erica Carter, and Deniz Gokturk, eds. *The German Cinema Book* (London: British Film Institute, 2008); Stephen Brockman, *A Critical History of German Film* (Rochester, NY: Camden House, 2010); Terri Ginsberg and Andrea Mensch, eds. *A Companion to German Cinema* (Chichester: Wiley-Blackwell, 2012); and Jennifer Kapczynski and Michael Richardson, eds. *A New History of German Cinema* (Rochester, NY: Camden House, 2012).

2. Some books to start are Seán Allan and John Sandford, eds., *DEFA: East German Cinema 1946–1992* (Oxford: Berghahn, 1999); Leonie Naughton, *That Was the Wild East: Film Culture, Unification, and the "New" Germany* (Ann Arbor: University of Michigan Press, 2002); Joshua Feinstein, *The Triumph of the Ordinary: Depictions of Daily Life in the East German Cinema, 1949–1989* (Chapel Hill: University of North Carolina Press, 2001); Daniela Berghahn, *Hollywood behind the Wall: The Cinema of East Germany* (Manchester: Manchester University Press, 2005); and Anke Pinkert, *Film and Memory in East Germany* (Bloomington: Indiana University Press, 2008).

3. For two German-language treatments of the DEFA documentary genre, see Günter Jordan and Ralf Schenk, *Schwarzweiß und Farbe: DEFA-Dokumentarfilme 1946–1992* (Berlin: Jovis, 1996) and Tobias Ebbrecht, Hilde Hoffmann, and Jörg Schweinitz, eds., *DDR—Erinnern, Vergessen: Das visuelle Gedächtnis des Dokumentarfilms* (Marburg, Germany: Schüren, 2009).

4. Ralf Forster and Volker Petzold, *Im Schatten der DEFA: Private Filmproduzenten in der DDR* (Konstanz: UVK, 2010).

5. A good start into this genre would be Nora Alter, *Projecting History: German Nonfiction Cinema 1967–2000* (Ann Arbor: University of Michigan Press, 2003). Some of these films are available as bonus material or have been released separately on DVD by the DEFA Film Library at the University of Massachusetts at Amherst.

6. A selection of animated films is available on the DVD *Red Cartoons—Animated Films from East Germany* (First Run Features, 2010).

7. See Ralf Schenk and Sabine Scholze, *Die Trick-Fabrik: DEFA-Animationsfilme, 1955–1990* (Berlin: Bertz + Fischer, 2003).

1 EAST GERMAN CINEMA AS STATE INSTITUTION

1. Seán Allan, "DEFA: An Historical Overview," in *DEFA: East German Cinema, 1946–1992*, ed. Seán Allan and John Sandford (New York: Berghahn, 1999), 2.
2. Ibid., 3.
3. Quoted in ibid.
4. See also chapter 4 for a reading of *Die Mörder sind unter uns*, the first German postwar film.
5. Christiane Mückenberger, "Zeit der Hoffnungen 1946 bis 1949," in *Das zweite Leben der Filmstadt Babelsberg: DEFA 1946–1992*, ed. Ralf Schenk (Berlin: Henschel, 1994), 8–49.
6. Günter Jordan, *Film in der DDR: Daten Fakten Strukturen* (Potsdam: Filmmuseum Potsdam 2009), 33–34.
7. For example, the Free German Trade Union Federation (Freier Deutscher Gewerkschaftsbund) (FDBG), the Free German Youth (Freie Deutsche Jugend) (FDJ), and the Cultural Association of the GDR (Kulturbund der DDR) (KB). See Jordan, *Film in der DDR,*" 33–34.
8. For all of these and other dates, see Jordan *"Film in der DDR."*
9. Allan and Sanford, "DEFA: An Historical," 8.
10. See chapter 2 for a description of the production hierarchy that determined the fate of a film project.
11. Even DEFA stars were not spared. Manfred Krug, one of the most prominent East German actors, published his experiences with being blacklisted and his subsequent expatriation in his diary, *Abgehauen: Ein Mitschnitt und ein Tagebuch* (Düsseldorf: Econ, 1996).
12. DEFA-Kommissionssitzung October 3, 1950, Stiftung Archiv der Parteien und Massenorganisationen der DDR im Bundesarchiv (SAPMO) IV 2/906/208 (my translation). For more on the film, see also Deborah Vietor-Engländer, "Arnold Zweig, Lion Feuchtwanger und der Film Das Beil von Wandsbek: Was darf die Kunst und was darf der Präsident der Akademie der Künste? Ein politisches Lehrstück aus der DDR," in *Feuchtwanger und Film*, ed. Ian Wallace (New York: Peter Lang, 2009), 297–314.
13. Ralf Schenk, "Mitten im Kalten Krieg 1950 bis 1960," in *Das zweite Leben der Filmstadt Babelsberg: DEFA 1946–1992*, ed. Ralf Schenk (Berlin: Henschel, 1994), 50–157, quote on p. 70.
14. Jordan, *Film in der DDR,* 230–231.
15. See Schenk, "Mitten im Kalten," 86–99.
16. See also the discussion of the film *Berlin—Ecke Schönhauser* in chapter 3. While the idea of "freezes" and "thaw" periods in East German culture based on the political decisions of the Central Committee may seem to be an oversimplification of the rather complex structure and interaction of cinema and political life, it is nevertheless a useful concept to explain how critical films could be produced despite censorship during a period of "thaw," but then ended up becoming banned as a result of more strict censorship measures during a "freeze."
17. Schenk, "Mitten im Kalten," 132–138.
18. For more on the fate of the film *Die Schönste*, see also my essay "GDR Cinema as Commodity: Marketing DEFA Films since Unification," *German Studies Review* 36, no. 1 (2013): 61–78; for *Die Spielbankaffäre*, see also "Die gefährliche Farbe," *Der Spiegel* (44), 58–61.

19. Dagmar Schittly, *Zwischen Regie und Regime: Die Filmpolitik der SED im Spiegel der DEFA-Produktionen* (Berlin: Links, 2002), 93–94.

20. Schenk, "Mitten im Kalten," 151.

21. See also chapter 6, *Berlin—Ecke Schönhauser* for more on the film "tourism" between the sectors, and see chapter 2 for general information on the competition of DEFA cinema with West German films. For demographic information on East German audiences, see Elizabeth Prommer, *Kinobesuch im Lebenslauf* (Konstanz: UVK, 1999).

22. Dirk Jungnickel, "Produktionsbedingungen bei der Herstellung von Kinospielfilmen und Fernsehfilmen," in *Filmland DDR: Ein Reader zu Geschichte, Funktion, und Wirkung der DEFA*, ed. Harry Blunk and Dirk Jungnickel (Cologne: Wissenschaft und Politik, 1990), 47–58. See also chapter 2 in this book for more on KAGs.

23. See the discussion of *Das Kaninchen bin ich* in chapter 8.

24. *Heißer Sommer*, *Der schweigende Stern*, and *Apachen* discussed in chapters 7, 9, and 10 are three examples of DEFA's genre cinema.

25. A copy of the film was preserved by the director's wife, Evelyn Carow, and restored in 1987.

26. See also chapter 2 for more on DEFA stardom.

27. For DEFA cinema during this decade, see particularly Hans Joachim Meurer, *Cinema and National Identity in a Divided Germany, 1979–1989* (Lewiston, NY: Edwin Mellen Press, 2000).

28. Sabine Hake, *German National Cinema*, 2nd ed. (New York: Routledge, 2008).

29. See also the discussion of *Solo Sunny* in chapter 13.

30. Bärbel Dalichow, "Das letzte Kapitel 1989 bis 1993," in *Das zweite Leben der Filmstadt Babelsberg: DEFA 1946–1992*, ed. Ralf Schenk (Berlin: Henschel, 1994), 329.

31. See the discussion of *Die Architekten* and *Letztes aus der DaDaeR* in chapters 11 and 12 for more about the *Wendefilme*.

32. More on censorship can be found in chapter 2.

33. See chapter 5, *Die Geschichte vom Kleinen Muck*, for further information on the financing of children's films and fairy tales.

2 Reciprocities and Tensions: DEFA and the East German Entertainment Industry

1. See Ute Poiger, *Jazz, Rock, and Rebels: Cold War Politics and American Culture in a Divided Germany* (Berkeley: University of California Press, 2000), 85.

2. See Wolfgang Kohlhaase and Gerhard Klein, "DEFA: A Personal View," in *DEFA: East German Cinema, 1946–1992*, ed. Sean Allan and John Sandford (New York: Berghahn, 1999), 117–130.

3. Elizabeth Prommer, *Kinobesuch im Lebenslauf* (Konstanz: UVK Medien, 1999), 131–135.

4. Heinz Kersten, "Von Karl May bis Clara Zetkin: Was 1984 aus eigenen und fremden Ateliers in DDR-Kinos kommt," *Deutschland-Archiv* 3 (1984): 233.

5. For the problems of media research in East Germany, see Dieter Wiedemann, "Von den Schwierigkeiten der Medienforschung mit der Realität," *Funk und Fernsehen* 3 (1990): 343–356.



24. More about Staudte in chapters 4 and 5.
25. Sabine Hake, *German National Cinema*, 2nd ed. (New York: Routledge, 2008);
 Hans Joachim Meurer, *Cinema and National Identity in a Divided Germany
 1979–1989: The Split Screen* (Lewiston, NY: Edwin Mellen Press, 2000); and
 John Davidson and Sabine Hake, eds., *Take Two: Fifties Cinema in a Divided
 Germany* (New York: Berghahn, 2007).
26. Katie Trumpener, "DEFA: Moving Germany into Eastern Europe," in *Moving
 Images of East Germany: Past and Future of DEFA Film*, ed. Barton Byg and
 Betheny Moore (Washington DC: American Institute for Contemporary
 German Studies, 2002), 85–104.
27. See, for example, Dina Iordanova, *Cinema of the Other Europe* (London:
 Wallflower, 2003) and Mette Hjort and Duncan Petrie, *The Cinema of Small
 Nations* (Bloomington: Indiana University Press, 2007).
28. See Evan Torner's interview with DEFA director Jörg Foth about his interna-
 tional coproduction with a Vietnamese film studio at http://guyintheblackhat.
 wordpress.com/2011/09/22/apocalypse-hanoi-an-interview-with-jorg-foth-
 about-dschungelzeit-1988/.
29. Trumpener, "DEFA," 99. See also the discussion of *Das Kaninchen bin ich* in
 chapter 8.
30. Wieland Becker and Volker Petzold, *Tarkowski trifft King Kong* (Berlin: Vistas,
 2001).
31. Mariana Ivanova, "DEFA and East European Cinemas: Co-Productions,
 Transnational Exchange, and Artistic Collaborations," PhD diss. (Austin:
 University of Texas, 2011), 18.
32. See, for example, the discussion of the coproduced films *Der schweigende Stern*
 and *Apachen* in chapters 7 and 10.
33. Ownership of DEFA-produced films was granted to the DEFA-Stiftung and not
 to the former directors.
34. See http://www.defa.de/cms/DesktopDefault.aspx?TabID=1012 for more
 details on the various changes to the production structure.
35. The production collective was later renamed "artistic work groups" (KAG).
 These KAGs were supposed to become independent groups within the studio,
 a decision that was reverted after only two years in 1966. Only four KAGs
 remained, led by dramaturges and not film directors.
36. Dagmar Schittly, *Zwischen Regie und Regime: Die Filmpolitik der SED im Spiegel
 der DEFA-Produktionen* (Berlin: Links, 2002).
37. David Bathrick, *The Powers of Speech* (Lincoln: University of Nebraska Press,
 1995), 37.
38. The films by some directors, especially those made before 1965, or by directors
 whose topics were in line with the dogma of socialist realism, could be under-
 stood as auteurist. Some of these DEFA "auteurs" are Kurt Maetzig, Gerhard
 Klein, Slatan Dudow, and Wolfgang Staudte.
39. See especially the discussion of *Das Kaninchen bin ich* in chapter 8.
40. Prommer, *Kinobesuch*, 122–151.
41. Richard Dyer, *Heavenly Bodies: Film Stars and Society* (London: British Film
 Institute , 1986).
42. Harry Blunk and Dirk Jungnickel, "Aus Gesprächen der Herausgeber mit
 Armin Mueller-Stahl," in *Filmland DDR: Ein Reader zu Geschichte, Funktion*

und Wirkung der DEFA, ed. Harry Blunk and Dirk Jungnickel (Cologne: Wissenschaft und Politik, 1990), 63.

43. See Ingrid Poss and Peter Warnecke, *Spur der Filme: Zeitzeugen über die DEFA* (Berlin: Links, 2006), 171.

44. Stefan Soldovieri has explored this by looking at a 1962 East German book called *Our Filmstars (Unsere Filmsterne)* (Berlin: Junge Welt, 1962) in his essay "The Politics of the Popular: *Trace of the Stones* (1966/89) and the discourse on stardom in the GDR Cinema," in *Light Motives: German Popular Film in Perspective,* ed. Randal Halle and Margaret McCarthy (Detroit, MI: Wayne State University Press, 2003), 224.

45. In the 1950s and early 1960s, DEFA still encouraged the involvement of Western stars in their productions and made their participation widely known. For example, Stefan Soldovieri explains how, with the help of the French Pathé company, Yves Montand and Simone Signoret played in the Pathé-DEFA coproduction *Die Hexen von Salem (The Witches of Salem,* Raymon Rouleau, 1957), for which Signoret won a Best Actress Academy Award. Stefan Soldovieri, "Managing Stars: Manfred Krug and the Politics of Entertainment in GDR Cinema," in *Moving Images of East Germany: Past and Future of DEFA Film* (Washington, DC: AICGS, 2002), 59.

46. A similar approach has been taking place since 2006, when Icestorm Entertainment and the magazine *SuperIllu* started the marketing of DEFA films by adding the DVDs to the magazine and running accompanying stories about the actors in the magazine. See also chapter 3.

47. Soldovieri, "Managing Stars," 58.

48. http://www.filmstadt-quedlinburg.de/starpostkarten.php gives a good list of these postcards.

49. Claudia Fellmer, "Armin Mueller-Stahl: From East Germany to the West Coast," in *The German Cinema Book,* ed. Tim Bergfelder, Erica Carter, and Deniz Göktürk (London: British Film Institute , 2002), 96.

50. Soldovieri, "Managing Stars," 58–59.

51. Fellmer, "Armin Mueller-Stahl," 91.

52. Soldovieri, "Managing Stars," 63.

53. Harry Blunk, *Die DDR in ihren Spielfilmen* (Munich: Profil, 1984), 124.

54. Fellmer, "Armin Mueller-Stahl," 92.

55. Claudia Fellmer, The Communist Who Rarely Played a Communist: The Case of DEFA Star Erwin Geschonneck," in *Millennial Essays on Film and Other German Studies,* ed. Daniela Berghahn and Alan Bance (Oxford: Peter Lang, 2002), 41–62.

56. See chapter 7 for more details on Simon and how his previous role as communist leader Ernst Thälmann affected his role in the sci-fi film of 1960.

57. See also the documentary film *Der rote Elvis (The Red Elvis,* Leopold Grün, 2007).

58. See the analysis of *Apachen* in chapter 3 for more on the history of the red westerns and on Gojko Mitic.

59. "Die DEFA Indianerfilm," Filmportal, last accessed March 26, 2013, http://www.filmportal.de/thema/die-defa-indianerfilme.

60. Horst Claus, "DEFA—State, Studio, Style, Identity," in *The German Cinema Book,* ed. Tim Bergfelder, Erica Carter & Deniz Göktürk (London: British Film Institute, 2002), 139–147.

3 A Cultural Legacy: DEFA's Afterlife

1. The ideas for this chapter are based in part on research originally presented in two articles, "Emerging from the Niche: DEFA's Afterlife in Unified Germany," forthcoming in *Monatshefte* 105, no. 4 (Winter 2013), and "GDR Cinema as Commodity: Marketing DEFA Films since Unification," *German Studies Review* 36, no. 1 (2013): 61–78.
2. Stefan Haupt, *Urheberrecht und DEFA-Film* (Berlin: DEFA-Stiftung, 2005).
3. The concept of invented traditions was addressed by Eric Hobsbawm in a different context. See Eric Hobsbawm and Terence Granger, eds., *The Invention of Tradition* (Cambridge: Cambridge University Press, 1983).
4. "Filmpark Babelsberg," http://www.filmpark-babelsberg.de.
5. See chapter 5 for a discussion of this film and its significance for DEFA cinema. A photo of the gardens is stored at http://upload.wikimedia.org/wikipedia/commons/3/32/Filmpark_Babelsberg%2C_Der_kleine_Muck.jpg.
6. The museum is now a part of the film school Hochschule für Film und Fernsehen "Konrad Wolf," formerly East Germany's film school. The museum is not located near the school, but is housed in the historic Marstall building in the center of Potsdam.
7. For a brief timeline of the museum's history, see, for example, http://www.filmmuseum-potsdam.de/en/372-0.htm.
8. Videocassettes and recording equipment were generally unavailable to the East German public to prevent the unregulated dissemination of potential contraband.
9. In 2012, the contract was once again awarded to Progress (now owned by Icestorm Entertainment, the DEFA home video distributor), beating Studio Hamburg as competitor for the distribution rights.
10. From 2006 to 2012, the DEFA-Stiftung also operated a subsidiary company defa-spektrum for the distribution of reconstructed DEFA films and of new productions related to eastern German cinema that had been financially supported by the DEFA-Stiftung.
11. Dina Iordanova, *Cinema of the Other Europe* (London: Wallflower, 2003), 143–146.
12. Torsten Wahl, "DEFA-Filme als Renner der Videothek?" *Berliner Zeitung*, June 30, 1995, http://www.berliner-zeitung.de/archiv/bis-zum-jahresende-soll-progress-filmverleih-verkauft-sein—jubilaeumsnacht-im-kino—boerse—defa-filme-als-renner-der-videothek-,10810590,8971612.html.
13. See also note 7.
14. See chapters 7, 9, and 10 for analyses of DEFA's genre films.
15. For more on Kurt Maetzig and his role in DEFA, see chapters 7 and 8.
16. Susan Sontag, "Notes on 'Camp,'" in *Against Interpretation and Other Essays*, ed. Susan Sontag (New York: Farrar, 1967), 275–292.
17. Eric Hobsbawm, "Introduction: Inventing Traditions," in *The Invention of Tradition,* ed. Eric Hobsbawm and Terence Granger (Cambridge: Cambridge University Press, 1983), 4.
18. Manja Meister, email message to the author, August 2, 2011. Attendance figures and statistics provided. Meister was the former CEO of the now-defunct defa-spektrum.
19. "60 Jahre PROGRESS Film-Verleigh: Daten und Fakten," http://www.progress-film.de/de/progress/geschichte/documents/datenfakten.pdf.

20. Benedict Anderson, *Imagined Communities: Reflections on the Origin and Spread of Nationalism* (London: Verso, 2006).
21. For the concept of "poaching," see Henry Jenkins, *Textual Poachers: Television Fans and Participatory Culture*, updated ed. (New York: Routledge, 2013). For more detail on visual artist Matthias Fritsch, who tested the effect of Web 2.0 culture, see http://www.hfg-karlsruhe.de/~mfritsch/works/installation/technoviking-archiv/technoviking-archive.html. The original "Technoviking" video can be found at http://www.youtube.com/watch?v=_1nzEFMjkI4, and the video response by frischbeton, using *Heißer Sommer*, at http://www.youtube.com/watch?v=48dTH_pWtFA.
22. See chapter 9 for an analysis of *Heißer Sommer*.
23. See their fan website, http://www.dreihaselnuessefueraschenbroedel.de/.
24. For more details on Ludger Vollmer's opera, see http://www.operundtanz.de/archiv/2004/03/berichte-nordhausen.shtml.

Part II Freezes And Thaws: Canonizing DEFA

1. Frank-Burkhard Habel, *Das große Lexikon der DEFA-Spielfilme: Die vollständige Dokumentation aller DEFA-Spielfilme von 1946 bis 1993* (Berlin: Schwarzkopf & Schwarzkopf, 2001).
2. The slogan comes from the DVD distributor First Run Features marketing of the "Red Westerns," http://firstrunfeatures.com/defawesterns.html.

4 The Rubble Film, Wolfgang Staudte, and Postwar German Cinema: *Die Mörder sind unter uns* (*The Murderers Are among Us*, Wolfgang Staudte, 1946)

1. Kinematheksverbund, ed. *Die deutschen Filme. Deutsche Filmografie 1895–1998. Die Top 100*, CD-Rom (Frankfurt am Main: Deutsches Filminstitut, 1999).
2. The film does not clearly state this. Film scholar Robert Shandley has pointed out that the original script gives the father's communist affiliation as reason. See Shandley's *Rubble Films: German Cinema in the Shadow of the Third Reich* (Philadelphia, PA: Temple University Press, 2001), 134.
3. During the postwar time, interrogations by the Allies classified Germans into the categories of perpetrator, bystander, and victim. "Whitewashing" in this context meant to be acquitted of having been active in the Nazi system.
4. Peter Meyers, "Der DEFA-Film: *Die Mörder sind unter uns*," in *Nationalsozialismus und Judenverfolgung in DDR-Medien* (Berlin: Bundeszentrale für politische Bildung, 1997), 74.
5. See http://www.umass.edu/defa/filmtour/sjmurder.shtml#Commentary.
6. See chapter 1 for more information about this group of filmmakers.
7. See Christiane Mückenberger, "The Anti-Fascist Past in DEFA-Films," in *DEFA: East German Cinema, 1946–1992*, ed. Seán Allan and John Sandford (Oxford: Berghahn, 1999), 60.
8. Atina Grossmann notes how Soviets were eager to appear capable of getting services back in order in her 2007 book *Jews, Germans, and Allies* (Princeton: Princeton University Press).

9. Therefore, one should read Christiane Mückenberger's statement in "The Anti-Fascist Past in DEFA-Films" that "artists could develop their ideas without fear of censorship" (60) with caution.

10. The Soviet colonel Sergei Tulpanov, head of the SMAD propaganda department, stated these and other goals at the official ceremony for DEFA in May. Quoted by Seán Allan in "DEFA: An Historical Overview," in *DEFA: East German Cinema, 1946–1992*, ed. Seán Allan and John Sandford (Oxford: Berghahn, 1999), 3.

11. See also details of the film *Jakob der Lügner* in chapter 12.

12. See http://www.insidekino.de/DJahr/DDRAlltimeDeutsch.htm.

13. The idea of mourning as a necessary element of moving on is something Alexander and Margarete Mitscherlich bring up in their 1975 work *The Inability to Mourn: Principles of Collective Behavior* (New York: Grove, 1975).

14. Christiane Mückenberger, "Die ersten antifaschistischen DEFA-Filme der Nachkriegsjahre," in *Nationalsozialismus und Judenverfolgung in DDR-Medien*, ed. Bundeszentrale für politische Bildung (Bonn: Bundeszentrale für politische Bildung, 1977), 16.

15. For more on the German rubble film, see Shandley, *Rubble Films*; as well as Wilfried Wilms and William Rasch, eds. *German Postwar Films: Life and Love in Ruins* (New York: Macmillan, 2008).

16. See for instance Stefan Soldovieri, "Finding Navigable Waters: Inter-German Film Relations and Modernization in Two DEFA Barge Films of the 1950s," *Film History* 18, no. 1 (2006): 59–72.

17. "Des Müllers Lust," *Der Spiegel* Issue 50 (December 1951): 35.

18. During the shooting, the East German head of state, Walter Ulbricht, had summoned Minister of Culture Johannes R. Becher, DEFA's general director Albert Wilkening, and Staudte to request that the director replace the lead actress Helene Weigel. See "Mutter Blamage," *Der Spiegel* Issue 48 (November 1955): 54–55.

5 Fairy Tales and Children's Films as Eternal Blockbusters: *Die Geschichte vom Kleinen Muck* (*The Story of Little Mook*, Wolfgang Staudte, 1953)

1. http://www.insidekino.de/DJahr/DDRAlltimeDeutsch.htm lists this film as the most successful DEFA film ever in East Germany. For the import ban of East German films into West Germany, see chapter 2.

2. *Das Kalte Herz* (The Cold Heart, Michael Verhoeven, 1950) was the first one.

3. Marc Silberman, "The First DEFA Fairy Tales: Cold War Fantasies of the 1950s," in *Take Two: Fifties Cinema in Divided Germany*, ed. John Davidson and Sabine Hake (New York: Berghahn, 2007), 107.

4. Ibid., 108.

5. For reasons why West Germany relied on television, see ibid. Silberman also cites the data from a study about television programming in the 1950s by Bernhard Merkelbach and Dirk Stötzel, "Das Kinderfernsehen in der ARD in den 50er Jahren: Quantitative und qualitative Ergebnisse zum Programmangebot für Kinder," in *Fernsehen für Kinder: Vom Experiment zum Konzept. Programmstrukturen—Produkte—Präsentationsformen,* ed. Hans Dieter Erlinger, Bernhard Merkelbach, and Dirk Stötzel (Siegen: University of Siegen, 1990), 25.

6. Silberman, "The First DEFA Fairy Tales," 109.

7. See Joachim Giera, *Gedanken zu DEFA-Kinderfilmen* (Berlin: Betriebsakademie des VEB DEFA Studio für Spielfilme, 1982).

8. See chapter 2 for more details on the complicated political situation, the gray areas, and the ingenuity of film distributors when it came to matters of importing and exporting films between East and West Germany.

9. For more on the censorship of East German movies in West Germany, see Andreas Kötzing, "Zensur von DEFA Filmen in der Bundesrepublik," *Aus Politik und Zeitgeschichte*, nos. 1–2 (2009): 33–39.

10. Staudte had also directed DEFA's first feature *Die Mörder sind unter uns*, discussed in chapter 4, along with a number of other well-received projects.

11. For more on the failed project, see Werner Hecht, "Staudte verfilmt Brecht," in *Apropos: Film 2003*, ed. Ralf Schenk and Erika Richter (Berlin: Bertz, 2003), 8–23.

12. Sonja Fritzsche, "'Keep the Home Fires Burning': Fairy Tale Heroes and Heroines in an East German *Heimat*," *German Politics and Society* 30, no. 4 (2012): 50.

13. See chapter 2 for more about the international relations and coproductions of DEFA.

14. Silberman, "The First DEFA Fairy Tales," 107.

15. Qinna Shen, "Barometers of GDR Cultural Politics: Contextualizing the DEFA Grimm Adaptations," *Marvels & Tales: Journal of Fairy Tale Studies* 25, no. 1 (2011): 70.

16. For the educational aspects of DEFA fairytales and children's films, see Benita Blessing, "Happily Socialist Ever After? East German Children's Films and the Education of a Fairy Tale Land," *Oxford Review of Education* 36, no. 2 (2010): 233–248.

17. David Bathrick, *The Powers of Speech: The Politics of Culture in the GDR* (Lincoln: University of Nebraska Press, 1995), 167.

18. Jack Zipes, *The Enchanted Screen: The Unknown History of Fairy Tale Films* (New York: Routledge, 2010).

19. Silberman presents an extensive reading of *Muck* that illustrates how DEFA altered elements of the film to bring it in line with 1950s politics.

20. Ingelore König, Dieter Wiedemann, and Lothar Wolf, *Zwischen Marx und Muck* (Berlin: Henschel, 1996), 97.

21. Blessing, "Happily Socialist Ever After?" 240.

22. See Rosemary Creeser, "Cocteau for Kids: Rediscovering *The Singing, Ringing Tree*," in *Cinema and the Realms of Enchantment: Lectures, Seminars, and Essays by Marina Warner and Others*, ed. Duncan Petrie (London: British Film Institute, 1993), 111–124; http://3hfa.jimdo.com/; and Jim Morton's blog http://eastgermancinema.com/2011/12/23/the-golden-goose/.

6 The *Gegenwartsfilm*, West Berlin as Hostile Other, and East Germany as Homeland: The Rebel Film *Berlin—Ecke Schönhauser* (*Berlin Schönhauser Corner*, Gerhard Klein, 1957)

1. See also chapter 1.
2. See also chapter 2.

3. See Horst Claus, "Rebels with a Cause: The Development of the '*Berlin-Filme*' by Gerhard Klein and Wolfgang Kohlhaase," in *DEFA: East German Cinema, 1946–1992*, ed. Seán Allan and John Sandford (New York: Berghahn, 1999), 93–116.

4. These films are *Alarm im Zirkus* (1953), *Berliner Romanze* (1956), and *Berlin um die Ecke* (1965).

5. Wolfgang Kohlhaase mentions his and Klein's own experiences of going to West Berlin for these movies. See Wolfgang Kohlhaase and Gerhard Klein, "DEFA: A Personal View," in *DEFA: East German Cinema, 1946–1992*, ed. Seán Allan and John Sandford (New York: Berghahn, 1999), 117–130.

6. Matthias Judt, ed., *DDR-Geschichte in Dokumenten* (Berlin: Links, 1997), 545–546.

7. Ralf Schenk, ed., *Das zweite Leben der Filmstadt Babelsberg: DEFA 1946–1992* (Berlin: Henschel, 1994), 127.

8. See also chapter 1 for more on the historical events of June 17, 1953.

9. For a detailed account of these riots, see Ute Poiger, *Jazz, Rock, and Rebels: Cold War Politics and American Culture in a Divided Germany* (Berkeley: University of California Press, 2000).

10. The bikes also reference the genre of the prewar proletarian film, in particular Slatan Dudow's *Kuhle Wampe oder: Wem gehört die Welt* (*Kuhle Wampe: Or Who Owns the World?*, 1930) in which the bike becomes a symbol for the worker's movement.

7 The Birth of DEFA Genre Cinema, East German Sci-fi Films, New Technologies, and Coproduction with Eastern Europe: *Der schweigende Stern* (*Silent Star*, Kurt Maetzig, 1960)

1. Stefan Soldovieri, "Socialists in Outer Space: East German Film's Venusian Adventure," *Film History* 10 (1998): 382–398.

2. Kurt Maetzig, *Filmarbeit. Gespräche, Reden, Schriften*, ed. Günter Agde (Berlin: Henschel, 1987), 124.

3. Stanislav Lem, *Astronauci* (Warsaw: Czytelnik, 1951).

4. Soldovieri, "Socialists in Outer Space," 393.

5. "Bemerkungen zur Bearbeitung des Drehbuchs *Planet des Todes*," February 13, 1958, SAPMO: DR 117 1927, qtd. in Soldovieri, "Socialists in Outer Space," 393.

6. Michael Grisko. "Zwischen Sozialphilosophie und Actionfilm: Grenzen und Möglichkeiten des Science-Fiction Genres bei der DEFA," in *Apropos: Film 2002: Das Jahrbuch der DEFA-Stiftung*, ed. Ralf Schenk and Erika Richter (Berlin: Bertz, 2002), 112. See also chapter 1 in this book about the genre *Gegenwartsfilm*.

7. Stefan Soldovieri has meticulously researched and recorded the development of these collaborations in his aforementioned essay, "Socialists in Outer Space."

8. In the eyes of Detlef Kannapin, international solidarity is the main issue of DEFA sci-fi films. See Detlef Kannapin, "'Peace in Space': Die DEFA im Weltraum. Anmerkungen zu Fortschritt und Utopie im Filmschaffen der DDR," in *Zukunft im Film. Sozialwissenschaftliche Studien zu "Star Trek" und*

anderer Science Fiction, ed. Frank Hörnlein and Herbert Heinicke (Magdeburg: Scriptum, 2000), 55–70.

9. See Maetzig's remarks on the screenplay, cited in Soldovieri, "Socialists in Outer Space," 386.

10. Mariana Ivanova, "DEFA and East-European Cinemas: Co-Productions, Transnational Exchange and Artistic Collaborations," PhD diss., (The University of Texas at Austin, 2011), 117.

11. Soldovieri, "Socialists in Outer Space," 383.

12. DEFA produced a few sci-fi films set in the present and in the past, such as *Die Reise nach Kosmatom* (*The Journey to Kosmatom,* Manfred Gußmann and Janusz Star, 1961) and Frank Vogel's *Der Mann mit dem Objektiv* (*Man with the Objective,* 1961). For further information on defa-futurum, see Sonja Fritzsche, "East Germany's *Werkstatt Zukunft*: Futurology and the Science Fiction Films of *defa-futurum,*" *German Studies Review* 29, no. 2 (2006): 367–386.

13. For more on DEFA genre cinema, see Daniela Berghahn, *Hollywood Behind the Wall: The Cinema of East Germany* (Manchester: Manchester University Press, 2005), 39–43.

14. The film was not shot in 70 mm, as Stefan Soldovieri erroneously states ("Socialists in Outer Space," 382), but in 35 mm using the Totalvision lens from East Germany. DEFA only produced seven films in 70 mm format. *Der schweigende Stern* was not among them; two other sci-fi films, *Eolomea* and *Signale,* were. (See http://www.defa.de/cms/film-und-videoausgangsformate.) In fact, filming in 70 mm would have been rather useless, since only two movie theaters were able to play that format in 1962. See http://www.arsenal-berlin.de/de/kino-arsenal/programmarchiv/einzelansicht/article/590/2804//archive/2006/july.html.

15. The East German ministry was still called Ministry of Foreign Trade and German-German Trade (Ministerium für Außenhandel und Innerdeutschen Handel) in 1960. See "Innerzonenhandel: Rein und Raus," *Der Spiegel* 50 (December 7, 1960): 23–25. For this case, see also Soldovieri, "Socialists in Outer Space," 386.

16. Soldovieri, "Socialists in Outer Space," 387.

17. See chapter 1.

18. Intervision, officially called OIRT (Organisation Internationale de Radiodiffusion et de Télévision), did exist as a counter-organization to the Western European Eurovision. See Kenneth Harwood, "An Association of Soviet-Sphere Broadcasters: The International Radio and Television Organization," *Journal of Broadcasting and Electronic Media* 5, no. 1 (1960): 61–72.

19. Grisko, "Zwischen Sozialphilosophie," 112.

20. Sonja Fritzsche has noted how the later DEFA sci-fi films used the idea of East Germany as homeland in "A Natural and Artificial Homeland: East German Science-Fiction Film Responds to Kubrick and Tarkovsky," *Film & History: An Interdisciplinary Journal of Film and Television Studies* 40, no. 2 (Fall 2010): 80–101.

21. Frederic Jameson. "Science Fiction and the German Democratic Republic," *Science Fiction Studies* 11, no. 2 (July 1984): 194–199.

22. *Ernst Thälmann—Sohn seiner Klasse* (*Ernst Thälmann—Son of his Class,* Kurt Maetzig, 1954) and *Ernst Thälmann—Führer seiner Klasse* (*Ernst Thälmann—Leader of his Class,* Kurt Maetzig, 1955).

23. For instance, his 1946 documentary *Einheit SPD-KPD* (*Unity SPD-KPD*) depicted a very distorted view of the merger of the political parties that formed the SED.

24. See also Maetzig, *Filmarbeit*, and the discussion of Maetzig's film *Das Kaninchen bin ich* (*The Rabbit is Me*) in chapter 8 of this book.

25. Soldovieri, "Socialists in Outer Space," 386.

26. Berghahn, *Hollywood Behind the Wall*, 41.

27. Soldovieri, "Socialists in Outer Space," 394.

28. Burkhard Ciesla, "'Droht der Menschheit Vernichtung?' *Der schweigende Stern / First Spaceship on Venus*: Ein Vergleich," in *Apropos: Film 2002: Das Jahrbuch der DEFA-Stiftung*, ed. Ralf Schenk and Erika Richter (Berlin: Bertz, 2002), 121–136.

29. See Sebastian Heiduschke, "Communists and Cosmonauts in Mystery Science Theater 3000: De-Camping *First Spaceship on Venus / Silent Star*," in *The Peanut Gallery with Mystery Science Theater 3000: Essays on Film, Fandom, Technology and the Culture of Riffing*, ed. Robert Weiner and Shelley Barbra (Jefferson, NC: McFarland, 2011), 40–45.

30. See the *New York Times* DVD review at http://www.nytimes.com/2005/12/30/movies/30dvd.html?pagewanted=print&_r=0.

8 Film Censorship, the East German *Nouvelle Vague*, and the "Rabbit Films": *Das Kaninchen bin ich* (*The Rabbit Is Me*, Kurt Maetzig, 1965)

1. The interview can be found on the US DVD of *Das Kaninchen bin ich* released by First Run Features.

2. See also the case of Konrad Wolf's film *Sonnensucher* in the discussion of *Solo Sunny* in chapter 13.

3. See the discussion of *Letztes aus der Da-Da-eR* in chapter 15.

4. Katie Trumpener, "La guerre est finie: New Waves, Historical Contingency, and the GDR *Kaninchenfilme*," in *The Power of Intellectuals in Germany*, ed. Michael Geyer (Chicago: University of Chicago Press, 2001), 116.

5. For more on the West German "nouvelle vague" see, for example, Thomas Elsaesser, *New German Cinema: A History* (Basingstoke: Macmillan/British Film Institute , 1989) and Julia Knight, *New German Cinema: The Images of a Generation* (London: Wallflower, 2004).

6. Trumpener, "La guerre est finie," 126.

7. Günter Agde, ed., *Kahlschlag. Das 11. Plenum des ZK der SED. Studien und Dokumente*, 2nd ed. (Berlin: Aufbau, 2000).

8. See ibid., 303–309 for Maetzig's letter of apology.

9. See chapter 1 for a more extensive discussion of socialist realism as one of the guiding principles of DEFA film.

10. See, for example, Dagmar Schittly, *Zwischen Regie und Regime: Die Filmpolitik der SED im Spiegel der DEFA-Produktionen* (Berlin: Links, 2002), 129–132.

11. Joshua Feinstein, *The Triumph of the Ordinary: Depictions of Daily Life in the East German Cinema 1949–1989* (Chapel Hill: University of North Carolina Press, 2002), 163.

12. Stefan Soldovieri, "Censorship and the Law: The Case of *Das Kaninchen bin ich* (*I am the Rabbit*)," in *DEFA: East German Cinema 1946–1992*, ed. Seán Allan and John Sandford (New York: Berghahn, 1999), 146–163.

13. When Leonid Brezhnev reversed many of the liberal reform policies and returned to a politic of repression in the Soviet Union in 1964, East Germany followed suit. See also chapter 1 for the mirroring of Soviet policies in East Germany.

14. Soldovieri, "Censorship and the Law," 150–151.

15. Christiane Mückenberger, ed., *Prädikat: Besonders schädlich: Filmtexte* (Berlin: Henschel, 1990).

16. The novel never appeared in East Germany. Bieler published it under its original title *Maria Morzeck oder Das Kaninchen bin ich* (*Maria Morzedk or The Rabbit Is Me*) (Munich: Biederstein, 1969) after he had emigrated, first to Prague and then to West Germany.

17. See the interview with Maetzig on the US DVD of *Das Kaninchen bin ich*.

18. See chapter 2 for more on Eastern European influences in the 1960s.

19. See also the chapters 7, 9, and 10 on the genre films *Der schweigende Stern*, *Heißer Sommer*, and *Apachen*. Essentially, these productions became possible partly because of the building of the Berlin Wall.

20. Erika Richter, "Zwischen Mauerbau und Kahlschlag: 1961 bis 1965," in *Das zweite Leben der Filmstadt Babelsberg*, ed. Ralf Schenk (Berlin: Henschel, 1994), 171.

21. For an excerpt of a speech by East German head of state Walter Ulbricht in English translation, see http://germanhistorydocs.ghi-dc.org/ sub_document .cfm?document_id=927.

22. See also Feinstein, *The Triumph of the Ordinary*," 154–155.

23. Soldovieri, "Censorship and the Law," 150.

24. See Walter Ulbricht, "Schlußwort auf der 11: Tagung des ZK der SED 1965," in *Kahlschlag. Das 11. Plenum des ZK der SED. Studien und Dokumente*, 2nd ed., ed. Günter Adge (Berlin: Aufbau, 2000), 266–281.

25. Anke Pinkert, *Film and Memory in East Germany* (Bloomington: Indiana University Press, 2000), 180.

26. Gilles Deleuze, *Cinema 2: The Time-Image* (Minneapolis: University of Minnesota Press, 1989), 192–194.

27. See also the analysis of *Solo Sunny* in chapter 13.

28. See the discussion of *Letztes aus der Da-Da-eR* in chapter 15.

29. Daniela Berghahn, *Hollywood Behind the Wall: The Cinema of East Germany* (Manchester: Manchester University Press, 2005), 134–141.

30. See chapter 3.

9 RENEGADE FILMS, DEFA MUSICALS, AND THE GENRE CINEMA: *HEIßER SOMMER* (*HOT SUMMER*, JOACHIM HASLER, 1968)

1. See also chapter 2 for more details on the import of US and West German films. Other interesting sources are, for example, Hans Joachim Meurer, *Cinema and National Identity in a Divided Germany 1979–1989: The Split Screen* (Lewiston, NY: Edwin Mellen Press, 2000) and Rosemary Stott, *Crossing the Wall: The Western Feature Film Import in East Germany* (Oxford: Peter Lang, 2011).

2. See http://germanhistorydocs.ghi-dc.org/sub_document.cfm?document_ id=79 for an excerpt of the constitution in English translation. The entire constitution (in German) was reprinted in Volker Gransow and Konrad Jarausch, eds. *Die Deutsche Vereinigung: Dokumente zu Bürgerbewegung, Annäherung und Beitritt* (Cologne: Verlag Wissenschaft und Politik, 1991), 40–41.

3. See also the discussions of *Der schweigende Stern* and *Apachen* in this book.

4. See chapter 1 for details how an UFA style continued to exist in DEFA.

5. See the discussion of *Das Kaninchen bin ich* in chapter 8.

6. Helga Balach. *Wir tanzen um die Welt: Deutsche Revuefilme 1933–1945* (Munich: Hanser, 1979).

7. See also the discussion of *Die Mörder sind unter uns* in chapter 4.

8. See chapter 2 for more on these films.

9. Mary Wauchope, "The Other 'German' Cinema," in *Framing the Fifties: Cinema in a Divided Germany,* ed. John Davidson and Sabine Hake (New York: Berghahn, 2007), 220.

10. See the discussion of *Der schweigende Stern* in chapter 7 for more on the 70 mm format at DEFA.

11. The film continues to capture audiences time and again. It has been reviewed numerous times, and it appears on many blogs such as *Classic Forever,* http://classicforever.blogspot.com/2010/12/east-germanys-heier-sommer-aka.html; and *East German Cinema,* http://eastgermancinema.com /2011/12/29 /hot-summer/.

12. Andrea Rinke, "Eastside Stories: Singing and Dancing for Socialism," *Film History* 18 (2006): 73.

13. *East Side Story*, Dir. Dana Ranga, 1997.

14. Andrea Rinke, "Film Musicals in the GDR," in *Film's Musical Moments*, ed. Ian Conrich and Estelle Tincknell (Edinburgh: Edinburgh University Press, 2006), 190.

15. Johannes von Moltke has shown convincingly that the concept of the *Heimatfilm* also can be applied to DEFA cinema. See especially Chapter 7 entitled "Collectivizing the Local: DEFA and the Question of Heimat in the 1950s" in his monograph *No Place Like Home: Locations of Heimat in German Cinema* (Berkeley: University of California Press, 2005), 170–202.

16. See, for example, the discussion of *Das Kaninchen bin ich* in chapter 8.

17. For more about Gert Natschinski, see, for example, Manfred Haedler, "Der weiße Fleck: Musikfilm: Gespräche mit dem Regisseur Horst Bonnet und dem Komponisten Gerd Natschinski," in *Kino—und Fernseh-Almanach: Prisma 07,* ed. Horst Knietzsch (Berlin: Henschel, 1976), 64–80.

18. For more on the role of music in East Germany, the *Deutschlandtreffen* 1964, and the ban of "beat music" that was followed by a licensing requirement of bands after 1965, see, for example, Michael Rauhut, *Rock in der DDR* (Bonn: Bundeszentrale für politische Bildung, 2002).

19. Hans Helmut Prinzler, qtd. on http://www.hhprinzler.de/1965/06/findet-der-deutsche-film-bei-der-defa-statt/.

20. Rinke, "Film Musicals," 191.

21. See also the discussion of *Berlin—Ecke Schönhauser* in chapter 6.

10 More Genre Cinema, the "Red Western," and Stardom In East Germany: *Apachen* (*Apaches*, Gottfried Kolditz, 1973)

1. Thomas Schatz, *Hollywood Genres* (New York: Random House, 1981), 64.

2. Daniela Berghahn, *Hollywood behind the Wall: The Cinema of East Germany* (Manchester: Manchester University Press, 2005), 39.

3. See the statistics compiled at http://www.insidekino.de/DJahr /DDRAlltime Deutsch.htm.

4. See also chapter 1.
5. The story about the Apache tribe and their chief wraps up in *Ulzana* (Gottfried Kolditz, 1974).
6. Rex Strickland, "The Birth and Death of a Legend: The Johnson Massacre of 1837," *Arizona and the West* 18, no. 3 (1976): 257–286.
7. See also the analysis of *Der schweigende Stern* in chapter 7. For more on Welskopf-Henrich and her significance in East Germany, see Glenn Penny, "Red Power: Liselotte Welskopf-Henrich and Indian Activist Networks in East and West Germany," *Central European History* 41 (2008): 447–476.
8. See also the analysis of *Das Kaninchen bin ich* in chapter 8.
9. Berghahn, *Hollywood behind the Wall*, 39.
10. At this time, DEFA consisted of artistic work groups (*Künstlerische Arbeitsgruppe*, or KAG). Each group had a pool of directors, dramaturges, and technical personnel that would act as producers on films. The status and responsibilities of KAGs within DEFA changed multiple times throughout the studio history. Roter Kreis (Red Circle) was among four KAGs that remained after the changes of 1967, turned KAGs into groups led by a chief dramaturge. For a more detailed explanation of the KAG, see Mariana Ivanova, "DEFA and East European Cinemas: Co-Productions, Transnational Exchange and Artistic Collaborations," PhD Diss. (The University of Texas at Austin, 2011), 93–95.
11. Vera Dika, "An East German *Indianerfilm*: The Bear in Sheep's Clothing," *Jump Cut* 50 (2008), http://www.ejumpcut.org/archive/jc50.2008/Dika-indianer/index.html.
12. Ibid.
13. Andre Bazin. "The Western: Or the American Film Par Excellence," in *What is Cinema?* vol. 2, ed. and trans. Hugh Gray (Berkeley: University of California Press, 1971), 140.
14. Film scholar Katie Trumpener makes an important case for the proximity between DEFA and Eastern European Cinema in "DEFA: Moving Germany into Eastern Europe," in *Moving Images of East Germany: Past and Future of DEFA Film*, ed. Barton Byg and Betheny Moore (Washington DC: American Institute for Contemporary German Studies, 2002), 85–104.
15. Some East Germans mentioned rather ironically that after the building of the Berlin Wall, they also lived in some type of reservation—much like the Native Americans. See Friedrich von Borries and Jens-Uwe Fischer, *Sozialistische Cowboys: Der Wilde Western Ostdeutschlands* (Frankfurt am Main: Suhrkamp, 2008), 28.
16. Ivanova, "DEFA and East European Cinemas," 126–127.
17. In a question-and-answer session at the 2012 "Berlin and Beyond Film Festival" in San Francisco, German filmmaker Veit Helmer mentioned that he had grown up watching the West German westerns filmed in Yugoslavia and was deeply disappointed when he traveled to the "real" locations in the United States and realized they did not look at all like the places he knew from the films.
18. I am borrowing the word "twisted" from the US release of a box set of three *Indianerfilme* on DVD by First Run Features. "Turning the traditional [...] cowboy movies on their head" and "Westerns with a twist" were two of the catchphrases used to promote the set. See http://firstrunfeatures.com/defawesterns.html.
19. Trumpener, "DEFA," 96.

20. See Les Paul Robley, http://www.in70mm.com/news/2010/widescreen/index.htm
21. See "Eine Frage des Formats: DEFA 70," http://www.arsenal-berlin.de/de/kino-arsenal/programmarchiv/einzelansicht/article/590/2804 //archive/2006/july.html.
22. Charles Barr, "CinemaScope: Before and After," *Film Quarterly* 16, no. 4 (1963): 4–24.
23. See, for example, Peter Uwe Hohendahl, "Von der Rothaut zum Edelmenschen. Karl Mays Amerikaromane," in *Amerika in der deutschen Literatur: Neue Welt, Nordamerika, USA*, ed. Sigrid Bauschinger, Horst Denkler, and Wilfried Malsch (Stuttgart: Reclam, 1975), 229–245.
24. Jeffrey Sammons, *Ideology, Nemesis, Fantasy: Charles Sealsfield, Friedrich Gerstäcker, Karl May, and Other German Novelists of America* (Chapel Hill: University of North Carolina Press, 1998).
25. It is difficult to determine the exact number of tickets sold because Rialto did not keep statistics before Tobis Film was founded in 1970. The revenue for this film was nearly 6.5 million Deutsche Marks, according to Michael Petzel, *Karl May Filmbuch* (Bamberg: Karl-May-Verlag, 1998), 403.
26. Christian Heermann, *Old Shatterhand ritt nicht im Auftrag der Arbeiterklasse* (Dessau: Anhaltische Verlagsgesellschaft, 1995).
27. Borries and Fischer, *Sozialistische Cowboys*, 26.
28. Gerd Gemünden. "Between Karl May and Karl Marx. The DEFA *Indianerfilme* 1965–1983," in *Germans and Indians: Fantasies, Encounters, Projections*, ed. Colin Calloway, Gerd Gemünden, and Susanne Zantop (Lincoln: University of Nebraska Press, 2002), 244.
29. Borries and Fischer, *Sozialistische Cowboys*, 34.
30. For the notion of a void in the 1960s, see Rosemary Stott, "Entertained by the Class Enemy: Cinema Programming Policy in the German Democratic Republic," in *100 Years of European Cinema: Entertainment or Ideology?*, ed. Diana Holmes and Alison Smith (Manchester: Manchester University Press, 2000), 27–39.
31. Günter Agde, ed., *Kurt Maetzig—Filmarbeit: Gespräche, Reden, Schriften* (Berlin: Henschel, 1987), 285.
32. Peter Kenez, *Cinema and Soviet Society: From the Revolution to the Death of Stalin* (London: I. B. Tauris, 200), 93.

11 Gender, Class, and Sexuality: Ending Taboos in *Die Legende von Paul und Paula* (*The Legend of Paul and Paula*, Heiner Carow, 1973)

1. Zoe Ingalls, "Tender? Playful? Reflective? East German Cinema Comes to Light in Massachusetts," *The Chronicle of Higher Education* 46, no. 12 (November 12, 1999), B2.
2. Daniela Berghahn, *Hollywood Behind the Wall: The Cinema of East Germany* (Manchester: Manchester University Press, 2005), 200–201.
3. For more on *Gegenwartsfilme*, see the discussions of *Das Kaninchen bin ich* in chapter 8 and *Solo Sunny* in chapter 13, both examples of failed relationships.
4. Stephen Brockmann, *A Critical History of German Film* (Rochester, NY: Camden House, 2010), 263.
5. Frank Beyer's *Spur der Steine* (1965), for example, features a female engineer, Katie Klee.

6. See also *Solo Sunny* in chapter 13 for more on the genre of the DEFA women's film.

7. Berghahn, *Hollywood Behind the Wall*, 194.

8. Ibid., 195.

9. Helke Sander and Renée Schlesier, "*Die Legende von Paul und Paula*: Eine frauenverachtende Schnulze aus der DDR," *Frauen und Film* 2 (1974): 8–47.

10. Brockmann compares the bed scene to an LSD trip but later uncovers the political dimension of this scene; Brockmann, *A Critical History*, 266.

11. See http://www.spiegel.de/politik/deutschland/stichwort-veb-horch-und -guck-alias-stasi-a-78264.html. The contemporary films *Das Leben der Anderen* (*The Lives of Others*, Florian Henckel von Donnersmarck, 2006) and *Barbara* (Christian Petzold, 2012) show fictional stories of how the Stasi permeated and controlled life in East Germany.

12. Karin Hartewig, *Das Auge der Partei: Fotografie und Staatssicherheit* (Berlin: Links, 2004), 93.

13. Joshua Feinstein, *The Triumph of the Ordinary: Depictions of Daily Life in the East German Cinema 1949–1989* (Chapel Hill: University of North Carolina Press, 2002), 211–212.

14. Berghahn, *Hollywood Behind the Wall*, 197.

15. See also the discussion of *Solo Sunny* in chapter 13.

16. Paul Betts, *Within Walls: Private Life in the German Democratic Republic* (New York: Oxford University Press, 2010), 109.

17. Günter Gaus, *Wo Deutschland liegt. Eine Ortsbestimmung* (Hamburg: Hoffman und Campe, 1986), 119.

18. For more on the role of screen heroines, see Andrea Rinke, "Models or Misfits? The Role of Screen Heroines in GDR Cinema," in *Triangulated Visions: Women in Recent German Cinema*, ed. Ingeborg Majer O'Sickey and Ingeborg von Zadow (Albany: State University of New York Press, 1998), 207–218.

19. Andrea Rinke, "Sex and Subversion in GDR Cinema: The Legend of *Paul and Paula* (1973)," in *100 Years of European Cinema: Entertainment or Ideology?*, ed. Diana Holmes and Alison Smith (Manchester: Manchester University Press, 2001), 58–59.

20. The film marked the breakthrough for the Puhdys, who had covered mostly Western rock bands such as Deep Purple or Uriah Heep but needed German lyrics in order to be played on the radio and to receive concert requests. After *Paul und Paula*, the Puhdys became so famous in East Germany that they were allowed to travel internationally to play concerts. They survived unification and still tour Germany and play in front of large crowds. See http://www.mdr.de /fernsehen/ablage/riverboat/artikel25734.html.

21. See also the discussion of both films in chapters 13 and 14.

22. By that time, the actors who had played Paula (Angelica Domröse) and Paul (Winfried Glatzeder) had left East Germany to protest the expatriation of their colleague Wolf Biermann.

23. See chapter 3.

12　DEFA and the Holocaust, the Antifascist Legacy, and International Acclaim: *Jakob der Lügner* (*Jacob the Liar*, Frank Beyer, 1974)

1. For a concise but sometimes too cursory overview of the antifascist DEFA film, see Christiane Mückenberger, "The Antifascist Past in DEFA Films," in *DEFA:*

East German Cinema 1946–1992, ed. Seán Allan and John Sandford (Oxford: Berghahn, 1999), 58–76. Another useful treatment is available by Barton Byg, "The Antifascist Tradition and GDR Film," *Proceedings, Purdue University Fifth Annual Conference on Film* (West Lafayette, IN: Purdue University Press, 1980), 115–124.

2. For a detailed history of the ghetto, see Lucjan Dobroszycki, ed., *The Chronicle of the Lodz Ghetto, 1941–1944* (New Haven, CT: Yale University Press, 1987).

3. See chapter 1 for more on the historic events and their significance for DEFA cinema.

4. Sabine Hake, "Political Affects: Antifascism and the Second World War in Frank Beyer and Konrad Wolf," in *Screening War: Perspectives on German Suffering*, ed. Paul Cooke and Marc Silberman (Rochester, NY: Camden House, 2010), 103.

5. See also Joshua Feinstein, *The Triumph of the Ordinary: Depictions of Daily Life in the East German Cinema 1949–1989* (Chapel Hill: University of North Carolina Press, 2002), 26.

6. For a more historically balanced film about the "Red Orchestra," see *Die rote Kapelle* (*The Red Orchestra*, Stefan Roloff, 2004).

7. See the discussion of *Mörder* in this chapter.

8. Russel Lemmons, "'Great Truths and Minor Truths': Kurt Maetzig's Ernst Thälmann Films, the Antifascism Myth, and the Politics of Biography in the German Democratic Republic," in *Take Two: Fifties Cinema in Divided Germany*, ed. John E. Davidson and Sabine Hake (New York: Berghahn, 2007), 92.

9. Klaus Wischnewski, "Über Jakob und andere," *Film und Fernsehen* 2 (February 1975): 18–24.

10. See also Hake, "Political Affects," 119.

11. In his study of Konrad Wolf's *Mama, ich lebe*, Larson Powell brought up the use of intermediality, in particular, the interplay of sound and picture, to emphasize flashbacks in DEFA film: "*Mama, ich lebe*: Konrad Wolf's Intermedial Parable of Antifascism," in *Contested Legacies: Constructions of Cultural Heritage in the GDR*, ed. Matthew Philpotts and Sabine Rolle (Rochester, NY: Camden House, 2009), 63–75.

12. Frank Beyer, *Wenn der Wind sich dreht* (Munich: Econ, 2001), 189. See also chapter 1 for DEFA's 1970s competition with cinema imports and television.

13. For an interesting article on Rühmann's role after the war, see "Ballade vom Mitläufer," *SPIEGEL* December 1960, 60–61. For more on the actor before, during, and after the war, see Stephen Lowry, "Heinz Rühmann: The Archetypal German," in *The German Cinema Book*, ed. Tim Bergfelder, Erica Carter, and Deniz Göktürk (London: British Film Institute, 2002), 81–89.

14. Movie critic John Simon complains about the dubbing of Brodsky's dialogue in his review "Well-intentioned, Ill-conceived," *New York Magazine*, May 9, 1977, 71–72.

15. See also the discussion of *Das Kaninchen bin ich* in this chapter.

16. Ralf Schenk, "Damit Lebe Ich Bis Heute: Ein Gespräch Mit Frank Beyer," in *Regie: Frank Beyer*, ed. Ralf Schenk (Berlin: Hentrich, 1995), 72–75.

17. The film premiered on DFF 1, a channel that at this time was slowly making transition to full color channel. Many programs were still broadcast in black and white, and most television sets in East Germany were not capable of receiving color pictures. The second East German channel, DFF 2, had already been

broadcasting in color for a number of years at that time. Color television sets were available, but rather expensive, often costing the equivalent of a worker's annual salary.

18. See Jennifer Bjornstad, "From East Berlin to Hollywood: Literary Resistance in Jurek Becker's *Jakob der Lügner,*" *Journal of the Midwest Modern Language Association* 41, no. 1 (2008): 56–66.
19. Ibid., 56.
20. Sabine Hake, *German National Cinema*, 2nd ed. (New York: Routledge, 2008), 127–153.

13 THE WOMEN'S FILM, KONRAD WOLF, AND DEFA AFTER THE "BIERMANN AFFAIR": *SOLO SUNNY* (KONRAD WOLF, 1980)

1. See Kohlhaase's remark about the film at http://www.progress film.de/film _doks/sonstige_pdfs/f-solosunny-sp.pdf.
2. Alexander Haeder and Ulrich Wüst, *Prenzlauer Berg: Besichtigung einer Legende* (Berlin: Edition Q, 1994).
3. Heinz Kersten, "Der Tagesspiegel," March 3,1980, accessed October 2, 2012, qtd. in *Solo Sunny* (n.d.), *Progress Film-Verleih,* http://www.progress-film.de /film_doks/sonstige_pdfs/f-solosunny-sp.pdf.
4. Andrea Rinke, "From Models to Misfits: Women in DEFA Films of the 1970s and 1980s," in *DEFA: East German Cinema, 1946–1992,* ed. Seán Allan and John Sandford (New York: Berghahn, 1999), 201
5. Ibid., 201.
6. Christiane Lemke, "Social Change and Women's Issues in the GDR: Problems of Leadership Positions," in *Studies in GDR Culture and Society 2,* ed. Christine Cosentino et al. (Washington DC: University Press of America, 1982), 252.
7. Miriam Hansen, "*Frauen und Film* and Feminist Film Culture in West Germany," in *Gender and German Cinema: Feminist Interventions. Volume II; German Film History/ German History on Film,* ed. Sandra Frieden et al. (Oxford: Berg, 1993), 293–298.
8. Rosemary Stott, "'Letting the Genie out the Bottle': DEFA Film-Makers and *Film und Fernsehen,*" in *DEFA: East German Cinema, 1946–1992,* ed. Seán Allan and John Sandford (Oxford: Berghahn, 1999), 49.
9. Rinke, "From Models to Misfits," 185.
10. See, for example, Barbara Holland-Cunz, *Die alte neue Frauenfrage* (Frankfurt am Main: Suhrkamp, 2003) and Herta Kuhrig, "*Mit den Frauen—Für die Frauen:* Frauenpolitik und Frauenbewegung in der DDR," in *Geschichte der deutschen Frauenbewegung,* 5th ed., ed. Florence Hervé (Köln: PapyRossa, 1995), 209–248.
11. The East German parliament (*Volkskammer*) usually consisted of only 24–32% of female politicians, and not a single woman ever held a leading function in the SED *politburo.*
12. Joshua Feinstein, *The Triumph of the Ordinary: Depictions of Daily Life in the East German Cinema 1949–1989* (Chapel Hill: University of North Carolina Press, 2002), 220.
13. Gisela Bahr, "Film and Consciousness: The Depiction of Women in East German Movies," in *Gender and German Cinema: Feminist Interventions. Volume. I;*

Gender and Representation in New German Cinema, ed. Sandra Frieden et al. (Providence, RI: Berg, 1993), 125–140.

14. Anthony Coulson, "Paths of Discovery: The Films of Konrad Wolf," in *DEFA: East German Cinema, 1946–1992*, ed. Seán Allan and John Sandford (New York: Berghahn, 1999), 164.

15. Coulson ("Paths of Discovery," 164–165) splits Wolf's films into one group about exploring the rise of fascism and a second group of films about the war-times. Marc Silberman chooses different categories altogether in "Remembering History: The Filmmaker Konrad Wolf," *New German Critique* 49 (Winter 1990): 163–191.

16. Barton Byg, "Generational Conflict and Historical Continuity in GDR Film," in *Framing the Past: The Historiography of German Cinema and Television*, ed. Bruce Murray and Chistopher J. Wickham (Carbondale: Southern Illinois University Press, 1992), 200.

17. Silberman, "Remembering History," 165–166.

18. See also Seán Allan, "'Ich denke, sie machen meistens nackte Weiber': Kunst und Künstler in Konrad Wolfs *Goya* (1971) und *Der nackte Mann auf dem Sportplatz* (1974)," in *Von der Vision zur Realität: Film im Sozialismus—die DEFA*, ed. Frank Stern and Barbara Eichinger (Vienna: Mandelbaum, 2009), 342–367.

19. Coulson, "Paths of Discovery," 165.

20. See the documentary *Solo für Sanije: Die wahre Geschichte der "Solo Sunny"* (*Solo for Sanije: The True Story of "Solo Sunny"*), Alexandra Czok, 2008.

21. A DEFA film that addressed life in these juvenile detention centers was Helmut Dziuba's *Jana und Jan* (1992). See also my essay "Love behind Double Walls: Helmut Dziuba's *Jana and Jan* about Youth Love in an East German Workshop for Juvenile Delinquents" (Amherst: DEFA Film Library, 2009) as part of the bonus material on the US DVD release of that film.

22. See Tamara Bartlitz's transcript of her interview with Alexandra Czok at http://www.ad-hoc-news.de/sanije-ddp-wortlautinterview-wiederholung-vom-samstag—/de/Politik/ 20494122.

23. Jutta Voigt is, however, listed as a "consultant" in the film credits.

24. See "Solo Sunny," *Filmtipp*, date accessed October 2, 2012, http://www.dieterwunderlich.de/Wolf-solo-Sunny.htm.

25. Silberman, "Remembering History," 183.

26. For Geick's filmography, see http://www.filmportal.de/en/node/1086391.

27. Silberman, "Remembering History," 183.

28. Wolfgang Kohlhaase points this out in Christoph Wende's 2003 documentary *Auf den Spuren von "Solo Sunny" und Konrad Wolf* (*Looking for Solo Sunny and Konrad Wolf*).

29. See "Sunnys Solo—anregend wie am ersten Tag," *blogsgesang* (blog), last modified October 2, 2012, http://www.blogsgesang.de/2012/03/10/sunnys-solo-anregend-wie-am-ersten-tag.

30. Stefan Zahlmann, "Vom Wir zum Ich: Körper und Konfliktkultur im Spielfilm der DDR seit den 1960er Jahren," in *Körper mit Geschichte: Der menschliche Körper als Ort der Selbst—und Weltdeutung*, ed. Clemens Wischermann and Stefan Haas (Stuttgart: Franz Steiner, 2000), 309–336.

31. See the list of leading US reviewers at http://www.metacritic.com/movie/summer-in-berlin/critic-reviews. Only a few reviewers, even in Germany, had the necessary film knowledge to make this connection.

14 Passed by History: Dystopia, Parable, and Bookend: *Die Architekten* (*The Architects*, Peter Kahane, 1990)

1. See also the discussion of *Die Mörder sind unter uns* in chapter 4.
2. Kahane's debut film, *Weiberwirtschaft*, was produced for television in 1983 when he was over 30 years old.
3. Peter Kahane, "Interview 1993," in *DEFA NOVA: Nach wie vor? Versuch einer Spurensicherung*, ed. Dietmar Hochmuth (Berlin: Freunde der deutschen Kinemathek, 1993), 115. (My translation.)
4. Ingrid Poss and Peter Warnecke, *Spur der Filme: Zeitzeugen über die DEFA* (Berlin: Links, 2006), 462.
5. Ibid., 462.
6. See chapter 2 for more on the censoring mechanisms at DEFA.
7. Laura McGee, "'Ich wollte ewig einen richtigen Film machen! Und als es soweit war, konnte ich's nicht!' The End Phase of the GDR in Films by DEFA Nachwuchsregisseure," *German Studies Review* 26, no. 2 (May 2003): 323.
8. See the minutes of the discussion about the screenplay (stored at the Bundesarchiv in Berlin) with the East German Minister of Culture Horst Pehnert, Golde, and his cohead Rudolf Jürschik that took place on May 5, 1989. BArch DR 117 (III) 3391.
9. One of the many books about this time is by Mary Fulbrook, *Anatomy of a Dictatorship: Inside the GDR, 1949–89* (Oxford: Oxford University Press, 1995).
10. "'Laßt die Leute raus.' Die Nacht in der die Berliner Mauer brach," *Der Spiegel* 46 (November 1989), 28–30.
11. Laura McGee mentions this unpublished interview with Peter Kahane in "Ich wollte," 323.
12. Also in Schenk's interview with Peter Kahane on the US DVD.
13. McGee, "Ich wollte," 324.
14. For more on buildings as symbols of progress, see also the discussion of *Die Legende von Paul und Paula* in chapter 11.
15. As Seán Allan points out in his essay "1989 and the *Wende* in East German Cinema: Peter Kahane's *Die Architekten* (1990), Egon Günther's *Stein* (1991) and Jörg Foth's *Letztes aus der Da Da* eR (1990)," Lothar Warneke's film *Unser kurzes Leben* (Our Short Life, 1981) features a female architect who also fails with her architectural vision.
16. Kahane makes the comparison between architects and filmmakers in the interview with Schenk on the US DVD.
17. According to data by the FFA, quoted in Richard Oehmig, *"Überholt" von der Geschichte? Drei Defa-Spielfilme im Blickpunkt*, Masters Thesis, Humboldt University Berlin, 2008, 58.
18. In Schenk's interview on the DVD.

15 The *Wendeflicks*, Jörg Foth, and DEFA after Censorship: *Letztes aus der Da-Da-eR* (*Latest from the Da-Da-eR*, Jörg Foth, 1990)

1. Reinhild Steingröver, "On Fools and Clowns: Generational Farewell in Two Final DEFA Films: Egon Günther's *Stein* and Jörg Foth's *Letztes aus der DaDaeR*," *German Quarterly* 78, no. 4 (2005): 458.

2. Ibid., 445.

3. Ibid.

4. Seán Allan, "1989 and the *Wende* in East German Cinema: Peter Kahane's *Die Architekten* (1990), Egon Günther's *Stein* (1991) and Jörg Foth's *Letztes aus der Da Da eR* (1990)," in *1949/1989: Cultural Perspectives on Divisions in East and West*, ed. Clare Flanagan and Stuart Taberner (Amsterdam: Rodopi, 2000), 242.

5. See Reinhild Steingrövern, "2 February 1988: Last Generation of DEFA Directors Calls in Vain for Reform," in *A New History of German Cinema*, ed. Jennifer M. Kapczynski and Michael E Richardson (Rochester, NY: Camden House, 2012), 497–501.

6. For a detailed account of the fourth generation, see Laura McGee, "Revolution in the Studio? The DEFA's Fourth Generation of Film Directors and Their Reform Efforts in the Last Decade of the GDR," *Film History*, 15 (2003) 444–464.

7. See Jörg Foth, "Forever Young," in *Filmland DDR*, ed. Harry Blunck and Dirk Jungnickel (Cologne: Wissenschaft und Politik, 1990), 97.

8. The term *Wende* Flicks was coined in the United States, when the DEFA Film Library took on the project to release the series of films. For a list of film titles, see http://www.umass.edu/defa/wende_flicks_collection.shtml.

9. For a detailed analysis of the cabaret of Wenzel and Mensching, see David Robb, *Zwei Clowns im Lande des verlorenen Lachens: Das Liedertheater Wenzel & Mensching* (Berlin: Links, 1998).

10. See chapter 1 for more information on the consequences of Biermann's send-off for East Germany's cultural landscape.

11. Robb, *Zwei Clowns*, 7.

12. Ibid., 159–160.

13. The short film is included as bonus material on the US DVD release of *Letztes*.

14. Hiltrud Schulz, interview with Jörg Foth, *Latest from the Da-Da-eR* (Amherst, MA: DEFA Film Library), 11. DVD.

15. For more information on the tradition of DEFA musical films, see the discussion of the film *Heißer Sommer* in chapter 9.

16. Robb, *Zwei Clowns*, 48–49.

17. See, for example, Gordon Rottman, *The Berlin Wall and the Intra-German Border 1961–89* (New York: Osprey, 2008).

18. The German *Stimme* is both used for "vote" and "voice." In East German elections, the citizens approved the national front, an alliance of parties and mass organizations lead by the communist party. Voters were able to check boxes with only "Yes" for approval or "No" for disapproval. The official results usually reported approval rates of close to 100 percent, suggesting that participation in these elections did not matter.

19. See David Robb's introductory essay "Wenzel, Mensching and the *Latest from the Da-Da-R*," in *Latest from the Da-Da-eR* (Amherst: DEFA Film Library, 2009), 2. DVD.

20. Schulz, *Latest from the Da-Da-eR*, 5.

21. Ibid., 9.

22. Ibid. Foth mentions an initial euphoric reception with movie theater audiences clapping throughout the screenings of his film, but nothing happened with the films afterward, until the director was invited to tour the United States of

America. Afterward, *Letztes* also was played again in Germany, and is now marketed there as well.

23. See chapter 3 for more information on the current distribution of DEFA films. Because no German distributor was interested in the home video rights, Hans-Eckhardt Wenzel founded his own label "Matrosenblau" to sell the film. See http://www.tmdb.de/de/marke/MATROSENBLAU,DE30779314.html.

BIBLIOGRAPHY

The following bibliography is intended to allow quick access to essential works referenced in this book, and to point out additional resources that could be useful for the further study of DEFA cinema. For easier access each part has been divided into English and German language resources. Some works appear in more than one category.

EAST GERMAN FILM HISTORY
German-Language Resources

Agde, Günter, and Christiane Mückenberger. *Sie Sehen Selbst, Sie Hören Selbst. Die DEFA von Ihren Anfängen Bis 1949.* Marburg, Germany: Hitzeroth, 2000.

Becker, Wieland, and Volker Petzold. *Tarkowski trifft King Kong.* Berlin: Vistas, 2001.

Beutelschmidt, Thomas. *Sozialistische Audiovision: Zur Geschichte der Medienkultur in der DDR.* Potsdam: Verlag für Berlin Brandenburg, 1995.

Blunk, Harry. *Die DDR in ihren Spielfilmen.* Munich: Profil, 1984.

Harry, Blunk, and Dirk Jungnickel. "Aus Gesprächen der Herausgeber mit Armin Mueller-Stahl." In *Filmland DDR: Ein Reader zu Geschichte, Funktion und Wirkung der DEFA,* edited by Harry Blunk and Dirk Jungnickel, 59–70. Cologne: Wissenschaft und Politik, 1990.

Blunk, Harry, and Dirk Jungnickel, eds. *Filmland DDR: Ein Reader Zu Geschichte, Funktion Und Wirkung Der DEFA.* Cologne, Germany: Wissenschaft und Politik, 1990.

Dalichow, Bärbel. "Das letzte Kapitel 1989 bis 1993." In *Das zweite Leben der Filmstadt Babelsberg: DEFA 1946–1992,* edited by Ralf Schenk, 328–353. Berlin: Henschel, 1994.

Ebbrecht, Tobias, Hilde Hoffmann, and Jörg Schweinitz, eds. *DDR Erinnern Vergessen—Das visuelle Gedächtnis des Dokumentarfilms.* Marburg, Germany: Schüren, 2009.

Eckert, Stefanie. *Das Erbe der DEFA: Die fast unendliche Geschichte einer Stiftungsgründung.* Berlin: DEFA-Stiftung, 2008.

Eichinger, Barbara, and Frank Stern, eds. *Film Im Sozialismus—Die DEFA.* Vienna, Austria: Mandelbaum, 2009.

Finke, Klaus, ed. *DEFA-Film als nationales Kulturerbe?* Berlin: Vistas, 2001.

Forster, Ralf, and Volker Petzold. *Im Schatten der DEFA: Private Filmproduzenten in der DDR.* Konstanz: UVK, 2010.

"Die gefährliche Farbe." *Der Spiegel* 44 (October 1957), 58–61.

Geiss, Axel, ed. *Filmstadt Babelsberg: Zur Geschichte des Studios und seiner Filme.* Potsdam: Nicolaische Verlagsbuchhandlung, 1994.

————. *Repression und Freiheit: DEFA-Regisseure zwischen Fremd—und Selbstbestimmung.* Potsdam: Brandenburgische Landeszentrale für politische Bildung, 1997.

Gersch, Wolfgang. *Geschichte der nicht wahrgenommenen Möglichkeiten oder wie 1990 das Ende der DEFA begann. Ein persönlicher Bericht.* Berlin: DEFA-Stiftung, 2011.

————. *Szenen eines Landes: Die DDR und ihre Filme.* Berlin: Aufbau, 2006.

Giesenfeld, Günter, ed. *Der DEFA-Film: Erbe oder Episode?* Marburg, Germany: Schüren, 1993.

Habel, Frank-Burkhard. *Was ich von der DEFA wissen sollte.* Berlin: DEFA-Stiftung, 2008.

Haupt, Stefan. *Urheberrecht und DEFA-Film.* Berlin: DEFA-Stiftung, 2005.

Holzweißig, Gunter. *Die schärfste Waffe der Partei. Eine Mediengeschichte der DDR.* Cologne: Böhlau, 2002.

Jacobsen, Wolfgang. *Babelsberg: Das Filmstudio (1912–1995).* Berlin: Argon, 1994.

Jacobsen, Wolfgang, Anton Kaes, and Hans Helmut Prinzler, eds. *Geschichte des Deutschen Films.* Stuttgart: Metzler 1993.

Jordan, Günter. *Film in der DDR: Daten Fakten Strukturen.* Potsdam: Filmmuseum Potsdam, 2009.

Jordan, Günter, and Ralf Schenk. *Schwarzweiß und Farbe: DEFA-Dokumentarfilme 1946–1992.* Berlin: Jovis, 1996.

Jungnickel, Dirk. "Produktionsbedingungen bei der Herstellung von Kinospielfilmen und Fernsehfilmen." In *Filmland DDR: Ein Reader zu Geschichte, Funktion, und Wirkung der DEFA*, edited by Harry Blunk and Dirk Jungnickel, 47–58. Cologne: Wissenschaft und Politik, 1990.

Kersten, Heinz. "Von Karl May bis Clara Zetkin: Was 1984 aus eigenen und fremden Ateliers in DDR-Kinos kommt." *Deutschland-Archiv* 3 (1984): 233–235.

Krug, Manfred. *Abgehauen: Ein Mitschnitt und ein Tagebuch.* Düsseldorf: Econ, 1996.

Mückenberger, Christiane. "Zeit der Hoffnungen 1946 bis 1949." In *Das zweite Leben der Filmstadt Babelsberg: DEFA 1946–1992*, edited by Ralf Schenk, 8–49. Berlin: Henschel, 1994.

Mühl-Benninghaus, Wolfgang, ed. *Drei mal auf Anfang: Fernsehunterhaltung in Deutschland.* Berlin: Vistas, 2006.

Pflaum, Hans Günther, and Hans Helmut Prinzler. *Film in Der Bundesrepublik Deutschland: Der Neue Deutsche Film. Von Den Anfängen Bis Zur Gegenwart. Ein Handbuch: Mit Einem Exkurs Über Das Kino Der DDR.* New edition. Munich: Hanser, 1992.

Poss, Ingrid, and Peter Warnecke. *Spur der Filme: Zeitzeugen über die DEFA.* Berlin: Links, 2006.

Prommer, Elizabeth. *Kinobesuch im Lebenslauf.* Konstanz: UVK, 1999.

Schenk, Ralf, ed. *Das zweite Leben der Filmstadt Babelsberg: DEFA 1946–1992.* Berlin: Henschel, 1994.

Schenk, Ralf. "Ich fürchte mich vor gar nichts mehr." *Berliner Zeitung.* August 19, 2010, last accessed March 26, 2013, http://www.berliner-zeitung.de/archiv /ralf-schenk-ueber-den-berliner-filmkaufmann-erich-mehl–sein-husaren-stueck-und-die-liebe-zum—untertan—ich-fuerchte-mich-vor-gar-nichts-mehr,10810590,10737218.html.

————. "Kino in der DDR." *Filmportal,* last accessed March 26, 2013, http://www
.filmportal.de/thema/kino-in-der-ddr.

————. "Mitten im Kalten Krieg 1950 bis 1960." In *Das zweite Leben der Filmstadt
Babelsberg: DEFA 1946–1992,* edited by Ralf Schenk, 50–157. Berlin: Henschel,
1994.

Schenk, Ralf, and Sabine Scholze. *Die Trick-Fabrik: DEFA-Animationsfilme, 1955–
1990.* Berlin: Bertz + Fischer, 2003.

Schittly, Dagmar. *Zwischen Regie und Regime: Die Filmpolitik der SED im Spiegel
der DEFA-Produktionen.* Berlin: Links, 2002.

Schulz, Günter. *Ausländische Spiel: Und abendfüllende Dokumentarfilme in den
Kinos der SBZ/DDR 1945–1966.* Berlin: Bundesarchiv-Filmarchiv, 2001.

Steinmetz, Rüdiger, and Reinhold Viehoff, eds. *Deutsches Fernsehen Ost: Eine
Programmgeschichte des DDR-Fernsehens.* Berlin: VBB, 2008.

Vietor-Engländer, Deborah. "Arnold Zweig, Lion Feuchtwanger und der Film Das
Beil von Wandsbek: Was darf die Kunst und was darf der Präsident der Akademie
der Künste? Ein politisches Lehrstück aus der DDR." In *Feuchtwanger und Film,*
edited by Ian Wallace, 297–314. New York: Peter Lang, 2009.

Wahl, Torsten. "DEFA-Filme als Renner der Videothek?" *Berliner Zeitung,* June 30,
1995, http://www.berliner-zeitung.de/archiv/bis-zum-jahresende-soll-progress
-filmverleih-verkauft-sein—jubilaeumsnacht-im-kino—boerse—defa-filme-als
-renner-der-videothek-,10810590,8971612.html.

Wedel, Michael, Barton Byg, Andy Räder, Sky Arndt-Briggs, and Evan Torner, eds.
*DEFA International: Grenzüberschreitende Filmbeziehungen Vor Und Nach Dem
Mauerbau.* Wiesbaden, Germany: Springer VS, 2013.

Wiedemann, Dieter. "Von den Schwierigkeiten der Medienforschung mit der
Realität." *Funk und Fernsehen* 3 (1990): 343–356.

Wolf, Dieter. "Die DEFA-Spielfilmproduktion Unter Den Bedingungen Staatlicher
Finanzierung Und Kontrolle. Zur Arbeit Und Organisation Der DEFA-
Dramaturgie." In *Politik Und Mythos—Kader, Arbeiter Und Aktivisten Im DEFA-
Film,* edited by Klaus Finke, 112–138. Oldenburg: BIS, 2002.

English-Language Resources

Allan, Seán. "DEFA: An Historical Overview." In *DEFA: East German Cinema, 1946–
1992,* edited by Seán Allan and John Sandford, 1–21. Oxford: Berghahn, 1999.

Allan, Seán , and John Sandford, eds. *DEFA: East German Cinema 1946–1992.*
Oxford: Berghahn, 1999.

Alter, Nora. *Projecting History: German Nonfiction Cinema 1967–2000.* Ann Arbor,
MI: University of Michigan Press, 2003.

Anderson, Benedict. *Imagined Communities: Reflections on the Origin and Spread of
Nationalism.* London: Verso, 2006.

Bathrick, David. "From UFA to DEFA: Past as Present in Early GDR Films." In
Contentious Memories: Looking Back at the GDR, edited by Jost Hermand and
Marc Silberman, 169–188. New York: Peter Lang, 2000.

Bathrick, David. *The Powers of Speech: The Politics of Culture in the GDR.* Lincoln:
University of Nebraska Press, 1995.

Berghahn, Daniela. *Hollywood Behind the Wall: The Cinema of East Germany.*
Manchester: Manchester University Press, 2005.

Bock, Hans-Michael, and Tim Bergfelder, eds. *The Concise Cinegraph.* New York:
Berghahn, 2009.

Brockmann, Stephen. *A Critical History of German Film*. Rochester, NY: Camden House, 2010.

Byg, Barton. "Generational Conflict and Historical Continuity in GDR Film." In *Framing the Past: The Historiography of German Cinema and Television*, edited by Bruce Murray and Christopher J. Wickham, 197–219. Carbondale: Southern Illinois University Press, 1992.

Claus, Horst. "DEFA: State, Studio, Style, Identity." In *The German Cinema Book*, edited by Tim Bergfelder, Erica Carter, and Deniz Göktürk, 130–147. London: British Film Institute, 2002.

Davidson, John, and Sabine Hake, eds. *Take Two: Fifties Cinema in a Divided Germany*. New York: Berghahn, 2007.

Feinstein, Joshua. *The Triumph of the Ordinary: Depictions of Daily Life in the East German Cinema, 1949–1989*. Chapel Hill: University of North Carolina Press, 2001.

Flanagan, Clare, and Stuart Taberner, eds. *1949/1989: Cultural Perspectives on Division and Unity in East and West*. Amsterdam: Rodopi, 2000.

Hake, Sabine. *German National Cinema*. 2nd ed. New York: Routledge, 2008.

Heiduschke, Sebastian. "Emerging from the Niche: DEFA Afterlife in Unified Germany." *Monatshefte* 105, no. 4 (Winter 2013): forthcoming.

———. "GDR Cinema as Commodity: Marketing DEFA Films since Unification." *German Studies Review* 36, no. 1 (2013): 61–78.

Hjort, Mette, and Duncan Petrie. *The Cinema of Small Nations*. Bloomington: Indiana University Press, 2007.

Iordanova, Dina. *Cinema of the Other Europe*. London: Wallflower, 2003.

Kohlhaase, Wolfgang, and Gerhard Klein. "DEFA: A Personal View." In *DEFA: East German Cinema, 1946–1992*, edited by Seán Allan and John Sandford, 117–130. New York: Berghahn, 1999.

Meurer, Hans Joachim. *Cinema and National Identity in a Divided Germany, 1979–1989: The Split Screen* Lewiston, NY: Edwin Mellen Press, 2000.

Naughton, Leonie. *That Was the Wild East: Film Culture, Unification, and the "New" Germany*. Ann Arbor, MI: University of Michigan Press, 2002.

Pflaum, Hans Günther, and Hans Helmut Prinzler. *Cinema in the Federal Republic of Germany. The New German Film. Origins and Present Situation. With A Section on GDR Cinema. A Handbook*. Munich: Inter Nationes, 1993.

Pinkert, Anke. *Film and Memory in East Germany*. Bloomington: Indiana University Press, 2008.

Silberman, Marc, and Henning Wrage, eds. *DEFA at the Crossroads of East German and International Film Culture: A Companion*. Berlin: De Gruyter, forthcoming.

Silberman, Marc. *German Cinema: Texts in Context*. Detroit: Wayne State University Press, 1995.

———. "Learning from the Enemy: DEFA-French Co-productions of the 1950s." *Film History: An International Journal* 18, no. 1 (2006): 21–45.

Stott, Rosemary. *Crossing the Wall: The Western Feature Film Import in East Germany*. Oxford: Peter Lang, 2012.

Torner, Evan. "Apocalypse Hanoi: An Interview with Jörg Foth about Dschungelzeit (1988)." http://guyintheblackhat.wordpress.com/2011/09/22/apocalypse-hanoi-an-interview-with-jorg-foth-about-dschungelzeit-1988/.

Trumpener, Katie. "Old movies: Cinema as Palimpsest in GDR Fiction." *New German Critique* 82 (Winter 2001): 39–76.

THE RUBBLE FILM, WOLFGANG STAUDTE, AND POSTWAR GERMAN CINEMA: *DIE MÖRDER SIND UNTER UNS*

German-Language Resources

Becker, Wolfgang, and Norbert Schöll. *In jenen Tagen...wie der deutsche Nachkriegsfilm die Vergangenheit bewältigte.* Opladen: Leske and Budrich, 1995.

Grisko, Michael. *Nachdenken über Wolfgang Staudte—Eine Dokumentation zur Veranstaltung im Filmmuseum Potsdam zum 100. Geburtstag.* Siegen: Carl Böschen Verlag, 2008.

Habel, Frank-Burkhard .*Das große Lexikon der DEFA-Spielfilme: Die vollständige Dokumentation aller DEFA-Spielfilme von 1946 bis 1993.* Berlin: Schwarzkopf & Schwarzkopf, 2001.

Hecht, Werner. "Staudte verfilmt Brecht." In *Apropos: Film 2003*, edited by Ralf Schenk and Erika Richter, 8–23. Berlin: Bertz, 2003.

Kannapin, Detlef. *Dialektik der Bilder. Der Nationalsozialismus im deutschen Film. Ein Ost-West-Vergleich.* Berlin: Dietz, 2006.

———. "Was hat Zarah Leander mit der DEFA zu tun? Die Nachwirkungen des NS-Films im DEFA-Schaffen—Notwendige Anmerkungen für eine neue Forschungsperspektive," in *Apropos: Film 2005,* edited by Ralf Schenk, Erika Richter, and Claus Löser, 188–209. Berlin: Bertz, 2005.

Kinematheksverbund, ed. *Die deutschen Filme. Deutsche Filmografie 1895–1998. Die Top 100*, CD-Rom. Frankfurt am Main: Deutsches Filminstitut, 1999.

Kober, Anne. *Die Antifaschismusthematik der DEFA—eine Kultur—und Filmhistorische Analyse.* Marburg, Germany: Schüren 2008

Meyers, Peter. "Der DEFA-Film: "Die Mörder sind unter uns.'" In *Nationalsozialismus und Judenverfolgung in DDR-Medien*, 71–83. Berlin: Bundeszentrale für politische Bildung, 1997.

Mückenberger, Christiane. "Die ersten antifaschistischen DEFA-Filme der Nachkriegsjahre." In *Nationalsozialismus und Judenverfolgung in DDR-Medien*, edited by Bundeszentrale für politische Bildung, 15–17. Bonn: Bundeszentrale für politische Bildung, 1997.

Seeßlen, Georg. "Faschismus, Krieg und Holocaust im deutschen Nachkriegsfilm," in *Apropos: Film 2000*, edited by Ralf Schenk and Erika Richter, 254–288. Berlin: Das Neue Berlin, 2000.

English-Language Resources

Bathrick, David. "From UFA to DEFA: Past as Present in Early GDR Films." In *Contentious Memories. Looking Back at the GDR*, edited by Jost Hermand and Marc Silberman, 169–188. New York: Peter Lang, 2000.

Berghahn, Daniela: "Liars and Traitors: Unheroic Resistance in Antifascist DEFA Films." In *Millennial Essays on Film and Other German Studies*, edited by Daniela Berghahn and Alan Bance, 23–39. Oxford: Peter Lang, 2002.

Brockmann, Stephen. *A Critical History of German Film.* Rochester, NY: Camden House, 2010.

Byg, Barton. "The Antifascist Tradition and GDR Film." In *Proceedings, Purdue University Fifth Annual Conference on Film*, 115–124. West Lafayette, IN: Purdue University Press, 1980.

Carter, Erica. "Die Mörder Sind Unter Uns/ The Murderers Are Among Us." In *The Cinema of Germany*, edited by Joseph Garncarz and Annemone Ligensa, 108–117. London and New York: Wallflower, 2012.

Fisher, Jaimey. "Who's Watching the Rubble-Kids? Youth, Pedagogy and Politics in Early DEFA Films." *New German Critique* 82 (Winter 2001): 91–125.

Grossmann, Atina. *Jews, Germans, and Allies*. Princeton: Princeton University Press, 2007.

Hoffgen, Maggie. *Studying German Cinema*. Leighton Buzzard, UK: Auteur, 2009.

Lemmons, Russel. "'Great Truths and Minor Truths': Kurt Maetzig's Ernst Thälmann Films, the Antifascism Myth, and the Politics of Biography in the German Democratic Republic." In *Take Two: Fifties Cinema in Divided Germany*, edited by John E. Davidson and Sabine Hake, 91–105. New York: Berghahn, 2007.

Mückenberger, Christiane. "The Anti-Fascist Past in DEFA Films." In *DEFA: East German Cinema 1946–1992*, edited by Seán Allan and John Sandford, 58–76. Oxford: Berghahn, 1999.

Pinkert, Anke. "Can Melodrama Cure? War Trauma and Crisis of Masculinity in Early DEFA Film." *Seminar: A Journal of Germanic Studies* 44, no. 1 (2008): 118–136.

———. *Film and Memory in East Germany*. Bloomington: Indiana University Press, 2008.

Reimer, Robert. *Nazi-Retro Film: How German Narrative Cinema Remembers the Past*. Woodbridge, CT: Twayne, 1992.

Reimer, Robert, and Reinhard Zachau. *German Culture through Film: An Introduction to German Cinema*. Newburyport, MA: Focus, 2005.

Rinke, Andrea. "Models or Misfits? The Role of Screen Heroines in GDR Cinema." In *Triangulated Visions: Women in Recent German Cinema*, edited by Ingeborg Majer O'Sickey and Ingeborg von Zadow, 207–218. Albany: State University of New York Press, 1998.

Shandley, Robert. *Rubble Films: German Cinema in the Shadow of the Third Reich*. Philadelphia, PA: Temple University Press, 2010.

Soldovieri, Stefan. "Finding Navigable Waters: Inter-German Film Relations and Modernization in Two DEFA Barge Films of the 1950s." *Film History* 18, no. 1 (2006): 59–72.

von Moltke, Johannes. *No Place Like Home: Locations of Heimat in German Cinema*. Berkeley: University of California Press, 2005.

Wilms, Wilfried, and William Rasch, eds. *German Postwar Films: Life and Love in Ruins*. New York: Macmillan, 2008.

FAIRY TALES AND CHILDREN'S FILMS AS ETERNAL BLOCKBUSTERS: *DIE GESCHICHTE VOM KLEINEN MUCK*

German-Language Resources

Elstermann, Knut. *Früher war ich Filmkind: Die DEFA und ihre jüngsten Darsteller*. Berlin: Das Neue Berlin, 2011.

Felsmann, Klaus-Dieter. "Eine feste Bank: DEFA-Kinderfilme in 25 Berlinale-Jahren." In *Apropos: Film 2002*, edited by Ralf Schenk and Erika Richter, 190–198. Berlin: Bertz, 2002.

Felsmann, Klaus-Dieter, and Bernd Sahling. *Deutsche Kinderfilme aus Babelsberg: Werkstattgespräche und Rezeptionsräume*. Berlin: DEFA-Stiftung, 2010.

Giera, Joachim. *Gedanken zu DEFA-Kinderfilmen*. Berlin: Betriebsakademie des VEB DEFA Studio für Spielfilme, 1982.

Hamisch, Siegfried. "Es War Einmal…Märchen Und Märchenverfilmung Im DEFA-Film Und in Filmen Des Fernsehens Der DDR." In *Prisma—Kino—Und Fernseh-Almanach*, edited by Horst Knietzsch, 79–93. Berlin: Henschel, 1985.

König, Ingelore, Dieter Wiedemann, and Lothar Wolf. *Zwischen Marx und Muck*. Berlin: Henschel, 1996.

Merkelbach, Bernhard, and Dirk Stötzel. "Das Kinderfernsehen in der ARD in den 50er Jahren: Quantitative und qualitative Ergebnisse zum Programmangebot für Kinder." In *Fernsehen für Kinder: Vom Experiment zum Konzept. Programmstrukturen—Produkte—Präsentationsformen*, edited by Hans Dieter Erlinger, Bernhard Merkelbach, and Dirk Stötzel, 21–52. Siegen: University of Siegen, 1990.

English-Language Resources

Bathrick, David. *The Powers of Speech: The Politics of Culture in the GDR*. Lincoln: University of Nebraska Press, 1995.

Blessing, Benita. "Happily Socialist Ever After? East German Children's Films and the Education of a Fairy Tale Land." *Oxford Review of Education* 36, no. 2 (2010): 233–248.

Creeser, Rosemary. "Cocteau for Kids: Rediscovering *The Singing, Ringing Tree*." In *Cinema and the Realms of Enchantment: Lectures, Seminars, and Essays by Marina Warner and Others*, edited by Duncan Petrie, 111–124. London: British Film Institute, 1993.

Fritzsche, Sonja. " 'Keep the Home Fires Burning': Fairy Tale Heroes and Heroines in an East German 'Heimat.' " *German Politics and Society* 30, no. 4 (2012): 45–72.

Kohlhaase, Wolfgang, and Gerhard Klein. "DEFA: A Personal View." In *DEFA: East German Cinema, 1946–1992*, edited by Seán Allan and John Sandford, 117–130. New York: Berghahn, 1999.

Shen, Qinna. "Barometers of GDR Cultural Politics: Contextualizing the DEFA Grimm Adaptations." *Marvels & Tales: Journal of Fairy Tale Studies* 25, no. 1 (2011): 70–95.

Silberman, Marc. "The First DEFA Fairy Tales: Cold War Fantasies of the 1950s." In *Take Two: Fifties Cinema in Divided Germany*, edited by John Davidson and Sabine Hake, 106–119. New York: Berghahn, 2007.

———. *German Cinema: Texts in Context*. Detroit: Wayne State University Press, 1995.

Zipes, Jack. *The Enchanted Screen: The Unknown History of Fairy Tale Films*. New York: Routledge, 2010.

THE *GEGENWARTSFILM*, WEST BERLIN AS HOSTILE OTHER, AND EAST GERMANY AS HOMELAND: BERLIN ECKE SCHÖNHAUSER

German-Language Resources

Aurich, Rolf. "Geteilter Himmel ohne Sterne". In *Kalter Krieg: 60 Filme aus Ost und West. Internationale Filmfestspiele Berlin/Retrospektive*, edited by Helga Belach and Wolfgang Jacobsen, 18–44. Berlin: Stiftung Deutsche Kinemathek, 1991.

Felix, Jürgen. "Die 'Halbstarken'-Filme: Vorbilder Und Nachbilder. 'Berlin-Ecke Schönhauser' Gerhard Klein, DEFA 1957." In *Positionen Deutscher Filmgeschichte: 100 Jahre Kinematographie*, edited by Michael Schaudig, 322–324. Munich: Diskurs, 1996.

Gehler, Fred. "Der liebe Gott in Berlin. Anmerkungen zu Gerhard Klein 1920–1970," in *Apropos: Film 2005*, edited by Ralf Schenk, Erika Richter, and Claus Löser, 31–41. Berlin: Bertz, 2005.

Judt, Matthias, ed. *DDR-Geschichte in Dokumenten*. Berlin: Links, 1997.

Lindenberger, Thomas. *Massenmedien im Kalten Krieg: Akteure, Bilder, Resonanzen*. Cologne: Böhlau, 2006.

English-Language Resources

Claus, Horst. "Rebels with a Cause: The Development of the *'Berlin-Filme'* by Gerhard Klein and Wolfgang Kohlhaase." In *DEFA: East German Cinema, 1946–1992*, edited by Seán Allan and John Sandford, 93–116. New York: Berghahn, 1999.

Feinstein, Joshua. *The Triumph of the Ordinary: Depictions of Daily Life in the East German Cinema, 1949–1989*. Chapel Hill: University of North Carolina Press, 2001.

Heiduschke, Sebastian. "Cold War Envoys or German Cinematic Responses? Teenage Rebellion, Authority, and Mobility in The Wild One (USA, 1953), Die Halbstarken (West Germany, 1956) and Berlin— Ecke Schönhauser (East Germany, 1957)." *Seminar* 49, no. 3 (September 2013): Forthcoming.

Lindenberger, Thomas. "Home Sweet Home: Desperately Seeking Heimat in Early DEFA Films." *Film History: An International Journal* 18, no. 1 (2006): 46–58.

Poiger, Ute. *Jazz, Rock, and Rebels: Cold War Politics and American Culture in a Divided Germany*. Berkeley: University of California Press, 2000.

Urang, John Griffith. "Realism and Romance in the East German Cinema, 1952–1962." *Film History: An International Journal* 18, no. 1 (2006): 88–103.

von Moltke, Johannes. *No Place Like Home: Locations of Heimat in German Cinema*. Berkeley: University of California Press, 2005.

THE BIRTH OF DEFA GENRE CINEMA, EAST GERMAN SCI-FI FILMS, NEW TECHNOLOGIES, AND COPRODUCTION WITH EASTERN EUROPE: *DER SCHWEIGENDE STERN*

German-Language Resources

Agde, Günter, ed. *Kurt Maetzig: Filmarbeit: Gespräche, Reden, Schriften*. Berlin: Henschel, 1987.

Byg, Barton. "DEFA Und Osteuropäisches Kino. Das East German Summer Film Institute 2003." In *Apropos: Film 2003*, edited by Ralf Schenk and Erika Richter, 320–322. Berlin: Bertz, 2003.

Ciesla, Burkhard. "'Droht der Menschheit Vernichtung?' *Der schweigende Stern / First Spaceship on Venus*: Ein Vergleich." In *Apropos: Film 2002*, edited by Ralf Schenk and Erika Richter, 121–136. Berlin: Bertz, 2002.

Filipovic, Andreas. "Filmbeziehungen Zweier Länder, Die Nicht Mehr Sind— Jugoslawien Und Die DDR." In *Film Im Sozialismus—Die DEFA*, edited by

Barbara Eichinger and Frank Stern, 236–256. Vienna, Austria: Mandelbaum, 2009.

Grisko, Michael. "Zwischen Sozialphilosophie und Actionfilm: Grenzen und Möglichkeiten des Science-Fiction Genres bei der DEFA." In *Apropos: Film 2002: Das Jahrbuch der DEFA-Stiftung*, edited by Ralf Schenk and Erika Richter, 108–120. Berlin: Bertz, 2002.

Kannapin, Detlef. " 'Peace in Space': Die DEFA im Weltraum. Anmerkungen zu Fortschritt und Utopie im Filmschaffen der DDR." In *Zukunft im Film. Sozialwissenschaftliche Studien zu "Star Trek" und anderer Science Fiction*, edited by Frank Hörnlein and Herbert Heinicke, 55–70. Magdeburg: Scriptum, 2000.

Schenk, Ralf. *DEFA 70: Technik, Kunst und Politik—Das 70-mm-Kino in der DDR*. Marburg, Germany: Schüren, 2012.

———. "Technik, Kunst Und Politik. Die DDR Und Das 70-mm-Kino—Eine Geschichte Aus Ferner Vergangenheit." In *Die Bedeutung Der Unterhaltungsmedien Für Die Konstruktion Des Politikbildes*, edited by Klaus-Dieter Felsmann, 189–198. Munich: Kopaed, 2010.

English-Language Resources

Fritzsche, Sonja. "East Germany's *Werkstatt Zukunft*: Futurology and the Science Fiction Films of *defa-futurum*." *German Studies Review* 29, no. 2 (2006): 367–386.

———. "A Natural and Artificial Homeland: East German Science-Fiction Film Responds to Kubrick and Tarkovsky." *Film & History: An Interdisciplinary Journal of Film and Television Studies* 40, no. 2 (Fall 2010): 80–101.

Hayward, Philip, and Natalie Lewandowski. "Sounds of the Silent Star: The Context, Score and Thematics of the 1960 Film Adaptation of Stanislaw Lem's Novel Astronauci." *Science Fiction Film and Television* 3, no. 2 (2010): 183–200.

Heiduschke, Sebastian. "Communists and Cosmonauts in Mystery Science Theater 3000: De-Camping *First Spaceship on Venus / Silent Star*." In *The Peanut Gallery with Mystery Science Theater 3000: Essays on Film, Fandom, Technology and the Culture of Riffing*, edited by Robert Weiner and Shelley Barbra, 40–45. Jefferson, NC: McFarland, 2011.

Ivanova, Mariana. "DEFA and East-European Cinemas: Co-Productions, Transnational Exchange, and Artistic Collaborations." PhD diss., University of Texas, Austin, 2011.

Jameson, Frederic. "Science Fiction and the German Democratic Republic." *Science Fiction Studies* 11, no. 2 (July 1984): 194–199.

Lemmons, Russel. " ' Great Truths and Minor Truths': Kurt Maetzig's Ernst Thälmann Films, the Antifascism Myth, and the Politics of Biography in the German Democratic Republic." In *Take Two: Fifties Cinema in Divided Germany*, edited by John E. Davidson and Sabine Hake, 91–105. New York: Berghahn, 2007.

Trumpener, Katie. "DEFA: Moving Germany into Eastern Europe." In *Moving Images of East Germany: Past and Future of DEFA Film*, edited by Barton Byg and Betheny Moore, 85–104. Washington DC: American Institute for Contemporary German Studies, 2002.

Soldovieri, Stefan. "Socialists in Outer Space: East German Film's Venusian Adventure." *Film History* 10 (1998): 382–398.

Stott, Rosemary. "Continuity and Change in GDR Cinema Programming Policy 1979–1989: The Case of the American Science Fiction Import." *German Life and Letters* 55, no. 1 (January 2002): 91–99.

FILM CENSORSHIP, THE EAST GERMAN *NOUVELLE VAGUE*, AND THE "RABBIT FILMS": *DAS KANINCHEN BIN ICH*

German-Language Resources

Adge, Günter. *Die langen Schatten danach—Texte nichtrealisierte Filme der DEFA 1965/1966.* Berlin: DEFA-Stiftung, 2011.

———, ed. *Kahlschlag. Das 11. Plenum des ZK der SED. Studien und Dokumente.* 2nd ed. Berlin: Aufbau, 2000.

———, ed. *Kurt Maetzig: Filmarbeit: Gespräche, Reden, Schriften.* Berlin: Henschel, 1987.

Bieler, Manfred. *Maria Morzeck oder Das Kaninchen bin ich (Maria Morzedk or The Rabbit Is Me).* Munich: Biederstein, 1969.

Finke, Klaus. *Politik und Film in der DDR: Zum heroischen Selbstbild des Kommunismus im DEFA-Film.* Oldenburg: BIS, 2008.

Günther, Beate. *Leitbilder richtigen Lebens—Politischer Diskurs und filmische Darstellung in DEFA-Gegenwartsfilmen der 1960er Jahre. Filmanalyse am Beispiel von Frauenrollen und Geschlechterbeziehungen.* Berlin: Trafo, 2008.

Habel, Frank-Burkhard. *Zerschnittene Filme. Zensur im Kino.* Leipzig: Kiepenheuer, 2003.

Harhausen, Ralf. *Alltagsfilm in der DDR—Die "Nouvelle Vague" der DEFA.* Marburg, Germany: Tectum, 2007.

Mückenberger, Christiane, ed. *Prädikat: Besonders schädlich: Filmtexte.* Berlin: Henschel, 1990.

Richter, Erika. "Zwischen Mauerbau und Kahlschlag: 1961 bis 1965." In *Das zweite Leben der Filmstadt Babelsberg,* edited by Ralf Schenk, 158–211. Berlin: Henschel, 1994.

Ulbricht, Walter. "Schlußwort auf der 11: Tagung des ZK der SED 1965." In *Kahlschlag. Das 11. Plenum des ZK der SED. Studien und Dokumente,* 2nd ed., edited by Günter Adge, 266–281. Berlin: Aufbau, 2000.

English-Language Resources

Berghahn, Daniela. "Censorship in GDR Cinema: The Case of 'Spur Der Steine.'" In *From Classical Shades to Vickers Victourious: Shifting Perspectives in British German Studies,* edited by Steve Giles and Peter Graves, 183–198. Bern: Peter Lang, 1999.

———. "The Forbidden Films: Film Censorship in the Wake of the Eleventh Plenum." In *100 Years of European Cinema: Entertainment or Ideology,* edited by Diana Holmes and Alison Smith, 40–45. Manchester: Manchester University Press, 2000.

Elsaesser, Thomas. *New German Cinema: A History.* Basingstoke: Macmillan/British Film Institute, 1989.

Feinstein, Joshua. *The Triumph of the Ordinary: Depictions of Daily Life in the East German Cinema, 1949–1989.* Chapel Hill: University of North Carolina Press, 2001.

Heiduschke, Sebastian. "'Das Ist Die Mauer, Die Quer Durchgeht. Dahinter Liegt Die Stadt Und Das Glück:' DEFA Directors and Their Criticism of the Berlin Wall." *Colloquia Germanica* 40, no. 1 (2007): 37–50.

Knight, Julia. *New German Cinema: The Images of a Generation*. London: Wallflower, 2004.

Pinkert, Anke. *Film and Memory in East Germany*. Bloomington: Indiana University Press, 2008.

Rinke, Andrea. "Models or Misfits? The Role of Screen Heroines in GDR Cinema." In *Triangulated Visions: Women in Recent German Cinema*, edited by Ingeborg Majer O'Sickey and Ingeborg von Zadow, 207–218. Albany: State University of New York Press, 1998.

Soldovieri, Stefan. "Censorship and the Law: The Case of *Das Kaninchen bin ich (I am the Rabbit)*." In *DEFA: East German Cinema 1946–1992*, edited by Seán Allan and John Sandford, 146–163. New York: Berghahn, 1999.

Trumpener, Katie. "La guerre est finie: New Waves, Historical Contingency, and the GDR *Kaninchenfilme*." In *The Power of Intellectuals in Germany*, edited by Michael Geyer, 113–147. Chicago: University of Chicago Press, 2001.

Renegade Films, DEFA Musicals, and the Genre Cinema: *Heißer Sommer* (*Hot Summer*, Joachim Hasler, 1968)

German-Language Resources

Agde, Günter. "DEFA-Filmexperiment mit einer Oper." *Filmblatt* 15, no. 43 (2010): 18–22.

———. "Filmmusik Im Zwiespalt." *Filmblatt* 15, no. 43 (2010): 13–18.

Berg, Michael, Nina Noeske, and Albrecht von Massow, eds. *Zwischen Macht und Freiheit. Neue Musik in der DDR*. Cologne: Böhlau, 2004.

Haedler, Manfred. "Der weiße Fleck: Musikfilm: Gespräche mit dem Regisseur Horst Bonnet und dem Komponisten Gerd Natschinski." In *Kino—und Fernseh-Almanach: Prisma 07*, edited by Horst Knietzsch, 64–80. Berlin: Henschel, 1976.

Tischer, Matthias. *Komponieren für und wider den Staat: Paul Dessau in der DDR*. Cologne: Böhlau, 2009.

———, ed. *Musik in der DDR: Beiträge zu den Musikverhältnissen eines verschwundenen Staates*. Berlin: Kuhn, 2005.

Trültzsch, Sascha, and Thomas Wilke, eds. *Heißer Sommer—Coole Beats—zur populären Musik und ihren medialen Repräsentation in der DDR*. Bern: Peter Lang, 2010.

English-Language Resources

Bahr, Gisela. "Film and Consciousness: The Depiction of Women in East German Movies." In *Gender and German Cinema: Feminist Interventions. Volume. I: Gender and Representation in New German Cinema*, edited by Sandra Frieden, Richard W. McCormick, Vibeke R. Peterson, and Laurie Melissa Vogelsang, 125–140. Providence, RI: Berg, 1993.

Buehler, James, Carol Flynn, and David Neumeyer, eds. *Music and Cinema*. Hanover, NH: University of New England Press, 2000.

Raundalen, Jon. "A Communist Takeover in the Dream Factory: Appropriation of Popular Genres by the East German Film Industry." *Slavonica* 11, no.1 (April 2005): 69–86.

Rinke, Andrea. "Eastside Stories: Singing and Dancing for Socialism." *Film History* 18 (2006): 73–87.

———. "Film Musicals in the GDR." In *Film's Musical Moments,* edited by Ian Conrich and Estelle Tincknell, 183–195. Edinburgh: Edinburgh University Press, 2006.

The "Red Western," and Stardom in East Germany: *Apachen*

German-Language Resources

Bergemann, Sandra. *Gesichter der DEFA: Große Schauspieler und ihre Filme mit Kurzbiographien und Filmographien.* Heidelberg: Braus, 2008.

Bluhm, Heiko. *Manfred Krug: Seine Filme—sein Leben.* Munich: Heyne, 1993.

Engelke, Henning, and Simon Kopp. "Der Western Im Osten. Genre, Zeitlichkeit Und Authentizität Im DEFA-Und Im Hollywood-Western." *Zeithistorische Forschungen/Studies in Contemporary History* 1, no. 2 (2004). Accessed April 29, 2013. http://www.zeithistorische-forschungen.de/16126041-Engelke-Kopp-2-2004.

Habel, Frank-Burkhard. *Gojko Mitic, Mustangs, Marterpfähle: Die DEFA-Indianerfilme, das große Buch für Fans.* Berlin: Schwarzkopf & Schwarzkopf, 1997.

Habel, Frank-Burkhard, and Volker Wachtel. *Das große Lexikon der DDR-Stars.* Berlin: Schwarzkopf & Schwarzkopf, 2002.

Heermann, Christian. *Old Shatterhand ritt nicht im Auftrag der Arbeiterklasse.* Dessau: Anhaltische Verlagsgesellschaft, 1995.

von Borries, Friedrich, and Jens-Uwe Fischer. *Sozialistische Cowboys: Der Wilde Western Ostdeutschlands.* Frankfurt am Main: Suhrkamp, 2008.

Wolf, Alex. *Gojko Mitic: Erinnerungen.* Frankfurt: Ullstein, 1996.

English-Language Resources

Broe, Dennis. "Have Dialectic, Will Travel. The GDR *Indianerfilme* as Critique and Radical Imaginary." In *A Companion to German Cinema,* edited by Terri Ginsberg and Andrea Mensch, 27–54. Chichester: Wiley-Blackwell, 2012.

Dika, Vera. "An East German *Indianerfilm*: The Bear in Sheep's Clothing." *Jump Cut* 50 (2008), http://www.ejumpcut.org/archive/jc50.2008/Dika-indianer/index.html.

Fellmer, Claudia. "Armin Mueller-Stahl: From East Germany to the West Coast." In *The German Cinema Book,* edited by Tim Bergfelder, Erica Carter, and Deniz Göktürk, 90–97. London: British Film Institute , 2002.

———. "The Communist Who Rarely Played a Communist: The Case of DEFA Star Erwin Geschonneck." In *Millennial Essays on Film and Other German Studies,* edited by Daniela Berghahn and Alan Bance, 41–62. Oxford: Peter Lang, 2002.

———. "Stars in East German Cinema." PhD thesis, University of Southampton, 2002.

Gemünden, Gerd. "Between Karl May and Karl Marx: The DEFA *Indianerfilme* 1965–1983." In *Germans and Indians: Fantasies, Encounters, Projections*, edited by Colin Calloway, Gerd Gemünden, and Susanne Zantop, 243–256. Lincoln: University of Nebraska Press, 2002.

Kencz, Peter. *Cinema and Soviet Society: From the Revolution to the Death of Stalin.* London: I. B. Tauris, 2001.

Ligensa, Annemone. "Der Schatz Im Silbersee/ The Treasure of Silver Lake and Die Söhne Der Großen Bärin/ The Sons of Great Bear." In *The Cinema of Germany*, edited by Joseph Garncarz and Annemone Ligensa, 138–147. London and New York: Wallflower, 2012.

Penny, Glenn. "Red Power: Liselotte Welskopf-Henrich and Indian Activist Networks in East and West Germany." *Central European History* 41 (2008): 447–476.

Soldovieri, Stefan. "The Politics of the Popular: *"Trace of the Stones"* (1966/89) and the discourse on stardom in the GDR Cinema." In *Light Motives: German Popular Film in Perspective*, edited by Randal Halle and Margaret McCarthy, 220–236. Detroit, MI: Wayne State University Press, 2003.

Stott, Rosemary. "Entertained by the Class Enemy: Cinema Programming Policy in the German Democratic Republic." In *100 Years of European Cinema: Entertainment or Ideology?*, edited by Diana Holmes and Alison Smith, 27–39. Manchester: Manchester University Press, 2000.

GENDER, CLASS, AND SEXUALITY: ENDING TABOOS IN *DIE LEGENDE VON PAUL UND PAULA*

German-Language Resources

Bundeszentrale für politische Bildung, ed. *Frauenbilder in den DDR Medien.* Bonn: Bundeszentrale für politische Bildung, 1996.

Glatzeder, Winfried, and Manuela Runge. *Winfried Glatzeder—Paul und Ich.* Berlin: Aufbau, 2008.

Harhausen, Ralf. *Alltagsfilm in der DDR—Die "Nouvelle Vague" der DEFA.* Marburg, Germany: Tectum, 2007.

Hartewig, Karin. *Das Auge der Partei: Fotografie und Staatssicherheit.* Berlin: Links, 2004.

Sander, Helke, and Renée Schlesier. "*'Die Legende von Paul und Paula'*: Eine frauen- verachtende Schnulze aus der DDR." *Frauen und Film* 2 (1974): 8–47.

Sell, Katrin. *Frauenbilder im DEFA-Gegenwartskino: Exemplarische Untersuchungen zur Filmischen Darstellung der Figur der Frau im DEFA-Film der Jahre 1949– 1970.* Marburg, Germany: Tectum, 2009.

Zahlmann, Stefan. "Geregelte Identität. Männlichkeitskonzepte Und Partnerschaft Im Spielfilm Der DDR." In *Mann Bilder: Ein Lese- Und Quellenbuch Zur Historischen Männerforschung*, edited by Wolfgang Schmale, 221–266. Berlin: Arno Spitz, 1998.

English-Language Resources

Bahr, Gisela. "Film and Consciousness: The Depiction of Women in East German Movies." In *Gender and German Cinema: Feminist Interventions. Volume. I: Gender and Representation in New German Cinema*, edited by Sandra Frieden,

Richard W. McCormick, Vibeke R. Peterson, and Laurie Melissa Vogelsang, 125–140. Providence, RI: Berg, 1993.

Betts, Paul. *Within Walls: Private Life in the German Democratic Republic*. New York: Oxford University Press, 2010.

Brockmann, Stephen. *A Critical History of German Film*. Rochester, NY: Camden House, 2010.

Dennis, David Brandon. "*Coming Out* into Socialism: Heiner Carow's Third Way." In *A Companion to German Cinema*, edited by Terri Ginsberg and Andrea Mensch, 55–81. Chichester: Wiley-Blackwell, 2012.

Dolling, Irene. "'We All Love Paula but Paul is More Important to Us': Constructing a 'Socialist Person' Using the 'Femininity' of a Working Woman." *New German Critique* 82 (Winter 2001): 77–90.

Mühl-Benninghaus, Wolfgang. "Die Legende Von Paul Und Paula/ The Legend of Paul and Paula." In *The Cinema of Germany*, edited by Joseph Garncarz and Annemone Ligensa, 168–175. London and New York: Wallflower, 2012.

Naughton, Leonie. *That Was the Wild East: Film Culture, Unification, and the "New" Germany*. Ann Arbor, MI: University of Michigan Press, 2002.

Pinkert, Anke. *Film and Memory in East Germany*. Bloomington: Indiana University Press, 2008.

Reimer, Robert, and Reinhard Zachau. *German Culture through Film: An Introduction to German Cinema*. Newburyport, MA: Focus, 2005.

Rinke, Andrea. *Images of Women in East German Cinema. 1972–1982: Socialist Models, Private Dreamers and Rebels*. Lewiston, NY: Edwin Mellen Press, 2006.

———. "Models or Misfits? The Role of Screen Heroines in GDR Cinema." In *Triangulated Visions: Women in Recent German Cinema*, edited by Ingeborg Majer O'Sickey and Ingeborg von Zadow, 207–218. Albany: State University of New York Press, 1998.

———. "Sex and Subversion in GDR Cinema: '*The Legend of Paul and Paula*' (1973)." In *100 Years of European Cinema: Entertainment or Ideology?*, edited by Diana Holmes and Alison Smith, 52–63. Manchester: Manchester University Press, 2001.

DEFA AND THE HOLOCAUST, THE ANTIFASCIST LEGACY, AND INTERNATIONAL ACCLAIM: *JAKOB DER LÜGNER*

German-Language Resources

Al-Zubaidi, Kais. *Faschismus im deutschen Kino-Spielfilm*. Berlin: DEFA-Stiftung, 2003.

Beutelschmidt, Thomas. *Kooperation oder Konkurrenz? Das Verhältnis zwischen Film und Fernsehen in der DDR*. Berlin: DEFA-Stiftung, 2009.

Beyer, Frank. *Wenn der Wind sich dreht*. Munich: Econ, 2001.

Davidowicz, Klaus. "Frank Beyers 'Nackt Unter Wölfen' (DDR 1962) Und Die Darstellung Der Shoah Im Deutschen Spielfilm Der Frühen 60er Jahre." In *Film Im Sozialismus—Die DEFA*, edited by Barbara Eichinger and Frank Stern, 125–146. Vienna, Austria: Mandelbaum, 2009.

Heimann, Thomas. *Bilder von Buchenwald. Die Visualisierung des Antifaschismus in der DDR (1945–1990)*. Cologne: Böhlau, 2005.

Jordan, Günther. "Davidstern und roter Winkel: Das jüdische Thema in DEFA-Wochenschau und –Dokumentarfilm 1946–48." In *Apropos: Film 2002*, edited by Ralf Schenk and Erika Richter, 24–43. Bertz: Berlin, 2002.

———. "DEFA und Holocaust. Drei Dokumente und ein P.S." In *Apropos: Film 2002*, edited by Ralf Schenk and Erika Richter, 44–49. Bertz: Berlin, 2002.

Kannapin, Detlef. *Antifaschismus und Film in der DDR: Die DEFA-Spielfilme 1945–1955/1956.* Cologne: Papyrossa, 1997.

Kober, Anne. *Die Antifaschismusthematik der DEFA—eine Kultur- und Filmhistorische Analyse.* Marburg, Germany: Schüren 2008

Stern, Frank. "Ein Kino subversiver Widersprüche. Juden im Spielfilm der DDR." In *Apropos: Film 2002*, edited by Ralf Schenk and Erika Richter, 8–23. Berlin: Bertz, 2002.

Wischnewski, Klaus. "Über Jakob und andere." *Film und Fernsehen* 2 (February 1975): 18–24.

Yamane, Keiko. "Jakob und andere. Zur Rezeption von DEFA-Filmen in Japan," in *Apropos: Film 2005*, edited by Ralf Schenk, Erika Richter, and Claus Löser, 314–315. Berlin: Bertz, 2005.

English-Language Resources

Berghahn, Daniela: "Liars and Traitors: Unheroic Resistance in Antifascist DEFA films." In *Millennial Essays on Film and Other German Studies*, edited by Daniela Berghahn and Alan Bance, 23–39. Oxford: Peter Lang, 2002.

Byg, Barton. "The Antifascist Tradition and GDR Film." In *Proceedings, Purdue University Fifth Annual Conference on Film*, 115–124. West Lafayette, IN: Purdue University Press, 1980.

Fox, Thomas. *East Germany and the Holocaust.* Rochester, NY: Camden House, 1999.

Hake, Sabine. "Political Affects: Antifascism and the Second World War in Frank Beyer and Konrad Wolf." In *Screening War: Perspectives on German Suffering*, edited by Paul Cooke and Marc Silberman, 102–122. Rochester, NY: Camden House, 2010.

Powell, Larson. "*Mama, ich lebe*: Konrad Wolf's Intermedial Parable of Antifascism." In *Contested Legacies: Constructions of Cultural Heritage in the GDR*, edited by Matthew Philpotts and Sabine Rolle, 63–75. Rochester, NY: Camden House, 2009.

Reimer, Robert. *Nazi-Retro Film: How German Narrative Cinema Remembers the Past.* Woodbridge, CT: Twayne, 1992.

THE WOMEN'S FILM, KONRAD WOLF, AND DEFA AFTER THE "BIERMANN AFFAIR": *SOLO SUNNY*

German-Language Resources

Allan, Seán. "Frauen, Stars und Arbeitswelten. DEFA-Forschung in Großbritannien 1996–2005," in *Apropos: Film 2005*, edited by Ralf Schenk, Erika Richter, and Claus Löser, 308–313. Berlin: Bertz, 2005.

———. "'Ich denke, sie machen meistens nackte Weiber': Kunst und Künstler in Konrad Wolf's *Goya* (1971) und *Der nackte Mann auf dem Sportplatz* (1974)."

In *Von der Vision zur Realität: Film im Sozialismus—die DEFA*, edited by Frank Stern and Barbara Eichinger, 342–367. Vienna: Mandelbaum, 2009.

Bundeszentrale für politische Bildung, ed. *Frauenbilder in den DDR Medien*. Bonn: Bundeszentrale für politische Bildung, 1996.

Ferchland, Rainer, Renate Ullrich, and Ursula von Schroeter. *Patriarchat in der DDR: Nachträgliche Entdeckungen in DFD-Dokumenten, DEFA-Dokumentarfilmen und soziologischen Befragungen*. Berlin: Dietz, 2009.

Holland-Cunz, Barbara. *Die alte neue Frauenfrage*. Frankfurt am Main: Suhrkamp, 2003.

Jacobsen, Wolfgang, and Rolf Aurich. *Der Sonnensucher—Konrad Wolf: Biographie*. Berlin: Aufbau, 2005.

Kramer, Thomas. "Kunst und Auftrag: Der Regisseur Konrad Wolf." In *Film im Lauf der Zeit. 100 Jahre Kino im Deutschland, Österreich und der Schweiz*, edited by Thomas Kramer and Martin Pucha, 225–231. Vienna: Überreuter, 1994.

Rauhut, Michael. *Rock in der DDR*. Bonn: Bundeszentrale für politische Bildung, 2002.

Salow, Friedrich. *Der DEFA-Spielfilm in den 80er Jahren—Chancen für die 90er?* Berlin: Vistas, 1992.

Schieber, Elke, and Michael Wedel, eds. *Konrad Wolf: Werk und Wirkung*. Berlin: Vistas, 2009.

Sell, Katrin. *Frauenbilder im DEFA-Gegenwartskino: Exemplarische Untersuchungen zur Filmischen Darstellung der Figur der Frau im DEFA-Film der Jahre 1949–1970*. Marburg, Germany: Tectum, 2009.

Wedel, Michael, and Thomas Elsaesser. "Einblicke von außen? Die DEFA, Konrad Wolf und die internationale Geschichte." In *Filmgeschichte als Krisengeschichte—Schnitte und Spuren durch den deutschen Film*, edited by Michael Wedel, 327–362. Bielefeld: Transcript, 2010.

Zahlmann, Stefan. "Geregelte Identität. Männlichkeitskonzepte Und Partnerschaft Im Spielfilm Der DDR." In *Mann Bilder: Ein Lese-Und Quellenbuch Zur Historischen Männerforschung*, edited by Wolfgang Schmale, 221–266. Berlin: Arno Spitz, 1998.

Zahlmann, Stefan. "Vom Wir zum Ich: Körper und Konfliktkultur im Spielfilm der DDR seit den 1960er Jahren." In *Körper mit Geschichte: Der menschliche Körper als Ort der Selbst—und Weltdeutung*, edited by Clemens Wischermann and Stefan Haas, 309–336. Stuttgart: Franz Steiner, 2000.

English-Language Resources

Bahr, Gisela. "Film and Consciousness: The Depiction of Women in East German Movies." In *Gender and German Cinema: Feminist Interventions. Volume. I: Gender and Representation in New German Cinema*, edited by Sandra Frieden, Richard W. McCormick, Vibeke R. Peterson, and Laurie Melissa Vogelsang, 125–140. Providence, RI: Berg, 1993.

Brockmann, Stephen. *A Critical History of German Film*. Rochester, NY: Camden House, 2010.

Coulson, Anthony. "Paths of Discovery: The Films of Konrad Wolf." In *DEFA: East German Cinema, 1946–1992*, edited by Seán Allan and John Sandford, 164–182. New York: Berghahn, 1999.

Elsaesser, Thomas, and Michael Wedel. "Defining DEFA's Historical Imaginary: The Films of Konrad Wolf." *New German Critique* 82 (Winter 2001): 3–24.

Hansen, Miriam. "*Frauen und Film* and Feminist Film Culture in West Germany." In *Gender and German Cinema: Feminist Interventions. Volume II; German Film History/ German History on Film*, edited by Sandra Frieden et al., 293–298. Oxford: Berg, 1993.

Koch, Gertrud. "On the Disappearance of the Dead among the Living: The Holocaust and the Confusion of Identities in the Films of Konrad Wolf." *New German Critique* 60, Special Issue (1993): 57–75.

Meurer, Hans Joachim. *Cinema and National Identity in a Divided Germany, 1979–1989: The Split Screen* Lewiston, NY: Edwin Mellen Press, 2000.

Reimer, Robert. *Nazi-Retro Film: How German Narrative Cinema Remembers the Past.* Woodbridge, CT: Twayne, 1992.

Rinke, Andrea. "From Models to Misfits: Women in DEFA Films of the 1970s and 1980s." In *DEFA: East German Cinema, 1946–1992*, edited by Seán Allan and John Sandford, 183–203. New York: Berghahn, 1999.

———. *Images of Women in East German Cinema. 1972–1982: Socialist Models, Private Dreamers and Rebels.* Lewiston, NY: Edwin Mellen Press, 2006.

———. "Models or Misfits? The Role of Screen Heroines in GDR Cinema." In *Triangulated Visions: Women in Recent German Cinema*, edited by Ingeborg Majer O'Sickey and Ingeborg von Zadow, 207–218. Albany: State University of New York Press, 1998.

Silberman, Marc. "Remembering History: The Filmmaker Konrad Wolf." *New German Critique* 49 (Winter 1990): 163–191.

Soldovieri, Stefan. "Managing Stars: Manfred Krug and the Politics of Entertainment in GDR Cinema" In *Moving Images of East Germany: Past and Future of DEFA Film*, edited by Baron Byg and Betheny Moore, 56–71. Washington, DC: AICGS (American Institute for Contemporary German Studies), 2002.

Stott, Rosemary. " 'Letting the Genie out the Bottle': DEFA Film-Makers and *Film und Fernseh.*" In *DEFA: East German Cinema, 1946–1992*, edited by Seán Allan and John Sandford, 42–57. Oxford: Berghahn, 1999.

PASSED BY HISTORY: DYSTOPIA, PARABLE, AND BOOKEND: *DIE ARCHITEKTEN*

German-Language Resources

Decker, Kerstin "Neben der Zeit. Die Filme von Andreas Dresen und Andreas Kleinert." In *Apropos: Film 2001*, edited by Ralf Schenk and Erika Richter, 328–343. Berlin: Das Neue Berlin, 2001.

Foth, Jörg. "Forever Young." In *Filmland DDR*, edited by Harry Blunck and Dirk Jungnickel, 95–105. Cologne: Wissenschaft und Politik, 1990.

Grunenberg, Antonia. *Aufbruch der inneren Mauer. Politik und Kultur in der DDR 1971–1989.* Bremen: Temmen, 1990.

Kahane, Peter. "Interview 1993." In *DEFA NOVA: Nach wie vor? Versuch einer Spurensicherung*, edited by Dietmar Hochmuth, 115. Berlin: Freunde der deutschen Kinemathek, 1993.

Lode, David. *Abenteuer Wirklichkeit—Die Filme von Andreas Dresen.* Marburg, Germany: Schüren, 2009.

Wolf, Dieter. "Die DEFA-Spielfilmproduktion Unter Den Bedingungen Staatlicher Finanzierung Und Kontrolle. Zur Arbeit Und Organisation Der DEFA-Dramaturgie." In *Politik Und Mythos—Kader, Arbeiter Und Aktivisten Im DEFA-Film*, edited by Klaus Finke, 112–138. Oldenburg: BIS, 2002.

English-Language Resources

Allan, Seán. "1989 and the *Wende* in East German Cinema: Peter Kahane's *Die Architekten* (1990), Egon Günther's *Stein* (1991) and Jörg Foth's *Letztes aus der Da Da eR'* (1990)." In *1949/1989: Cultural Perspectives on Divisions in East and West*, edited by Clare Flanagan and Stuart Taberner, 231–244. Amsterdam: Rodopi, 2000.

McGee, Laura, "'Ich wollte ewig einen richtigen Film machen! Und als es soweit war, konnte ich's nicht!' The End Phase of the GDR in Films by DEFA Nachwuchsregisseure." *German Studies Review* 26, no. 2 (May 2003): 315–332.

———. "Revolution in the Studio? The DEFA's Fourth Generation of Film Directors and Their Reform Efforts in the Last Decade of the GDR." *Film History* 15 (2003): 444–464.

Mueller, Gabriele. "Going East, Looking West: Border Crossings in Recent German Cinema." *Seminar: A Journal of Germanic Studies* 44, no. 4 (2008): 453–469.

THE *WENDEFLICKS*, JÖRG FOTH, AND DEFA AFTER CENSORSHIP: *LETZTES AUS DER DA-DA-ER*

German-Language Resources

Dell, Matthias. "Der filmische Osten. Das Bild der DDR im deutschen Kino nach ihrem Ende." In *Apropos: Film 2005*, edited by Ralf Schenk, Erika Richter, and Claus Löser, 140–151. Berlin: Bertz, 2005.

Foth, Jörg. "Forever Young." In *Filmland DDR*, edited by Harry Blunck and Dirk Jungnickel, 95–105. Cologne: Wissenschaft und Politik, 1990.

Hanisch, Michael. "Auf Dem Weg Zur Markwirtschaft: Das Kino Der DDR Im Letzten Jahr Der Existenz." In *Film-Jahrbuch 1991*, edited by Lothar Just, 13–16. Munich: Heyne, 1991.

Haucke, Lutz. "Das Theater der Clowns: Jörg Foths Versuche mit dem Liedtheater der DDR." In *Film-Künste-TV-Shows: Film-und fernsehwissenschaftliche Studien: Auswahl 1978–2004*, edited by Lutz Haucke, 423–434. Berlin: Rhombos, 2005.

Hochmuth, Dietmar, ed. *DEFA NOVA: Nach wie vor? Versuch einer Spurensicherung.* Berlin: Freunde der deutschen Kinemathek, 1993.

Robb, David. *Zwei Clowns im Lande des verlorenen Lachens: Das Liedertheater Wenzel & Mensching.* Berlin: Links, 1998.

Steingröver, Reinhild. "Narren und Clowns. Abschied von der DDR in zwei späten DEFA-Filmen: Egon Günthers *Stein* und Jörg Foths *Letztes aus der DaDaeR*." In *Apropos: Film 2005*, edited by Ralf Schenk, Erika Richter, and Claus Löser, 119–139. Berlin: Bertz, 2005.

English-Language Resources

Allan, Seán. "1989 and the *Wende* in East German Cinema: Peter Kahane's '*Die Architekten*' (1990), Egon Günther's '*Stein*' (1991) and Jörg Foth's '*Letztes aus der Da Da eR*' (1990)." In *1949/1989: Cultural Perspectives on Divisions in East and West*, edited by Clare Flanagan and Stuart Taberner, 231–244. Amsterdam: Rodopi, 2000.

Dennis, David Brandon. "*Coming Out* into Socialism: Heiner Carow's Third Way." In *A Companion to German Cinema*, edited by Terri Ginsberg, and Andrea Mensch, 55–81. Chichester: Wiley-Blackwell, 2012.

McGee, Laura, "'Ich wollte ewig einen richtigen Film machen! Und als es soweit war, konnte ich's nicht!' The End Phase of the GDR in Films by DEFA Nachwuchsregisseure." *German Studies Review* 26, no. 2 (May 2003): 315–332.

———. "Revolution in the Studio? The DEFA's Fourth Generation of Film Directors and Their Reform Efforts in the Last Decade of the GDR." *Film History* 15 (2003): 444–464.

Robb, David. "Wenzel, Mensching and the *Latest from the Da-Da-R.*" In *Latest from the Da-Da-eR*. Amherst: DEFA Film Library, 2009. Essay as part of DVD bonus material.

Rottman, Gordon. *The Berlin Wall and the Intra-German Border 1961–89*. New York: Osprey, 2008.

Steingröver, Reinhild. "2 February 1988: Last Generation of DEFA Directors Calls in Vain for Reform." In *A New History of German Cinema*, edited by Jennifer M. Kapczynski and Michael E. Richardson, 497–501. Rochester, NY: Camden House, 2012.

———. "On Fools and Clowns: Generational Farewell in Two Final DEFA Films: Egon Günther's *Stein* and Jörg Foth's *Letztes aus der DaDaeR*." *German Quarterly* 78, no. 4 (2005): 441–460.

FILMOGRAPHY

The following filmography lists detailed information about the 12 films discussed in this book to facilitate access. The second part catalogues all DEFA films with English subtitles currently available for purchase at the DEFA Film Library. The third part contains a list of films mentioned in this book.

For a complete list of feature films produced by DEFA see Susanne Brömsel and Renate Biehl, "Die Spielfilme der DEFA: 1946 bis 1993." In *Das zweite Leben der Filmstadt Babelsberg: DEFA–1992*, edited by Ralf Schenk, 356–543. Berlin: Henschel, 1994.

I. THE 12 FILMS

These films can be purchased individually and also in a special box set at the DEFA Film Library.

Apachen (*Apaches*). Directed by Gottfried Kolditz. 1973. Berlin: Icestorm, 2006. DVD. Color. 94 minutes.

Die Architekten (*The Architects*). Directed by Peter Kahane. 1990. Northampton, MA: Icestorm International, 2004. DVD. Color. 97 minutes.

Berlin—Ecke Schönhauser (*Berlin Schönhauser Corner*). Directed by Gerhard Klein. 1957. Berlin: Icestorm, 2007. DVD. B&W. 82 minutes.

Die Geschichte vom Kleinen Muck (*The Story of Little Mook*). Directed by Wolfgang Staudte. 1953. Northampton, MA: Icestorm International, 2000. DVD. Color. 96 minutes.

Heißer Sommer (*Hot Summer*). Directed by Joachim Hasler. 1968. Northampton, MA: Icestorm International, 2001. DVD. Color. 91 minutes.

Jakob der Lügner (*Jacob the Liar*). Directed by Frank Beyer. 1974. Northampton, MA: Icestorm International, 1999. DVD. Color. 101 minutes.

Das Kaninchen bin ich (*The Rabbit Is Me*). Film. Directed by Kurt Maetzig. 1965. Northampton, MA: Icestorm, 2007. DVD. Color. 109 minutes.

Die Legende von Paul und Paula (*The Legend of Paul and Paula*). Film. Directed by Heiner Carow. 1973. Northampton, MA: Icestorm International, 1999. DVD. Color. 106 minutes.

Letztes aus der Da-Da-eR (*Latest from the Da-Da-eR*). Film. Directed by Jörg Foth. 1990. Babelsberg: Medien Bildungsgesellschaft, 2009. DVD. Color. 86 minutes.

Die Mörder sind unter uns (*The Murderers Are among Us*). Film. Directed by Wolfgang Staudte. 1946. Northampton, MA: Icestorm International, 2002. DVD. B&W. 81 minutes.

Der schweigende Stern (Silent Star). Film. Directed by Kurt Maetzig. 1960. Amherst, MA: DEFA Film Library, 2004. DVD. Color. 95 minutes.

Solo Sunny. Film. Directed by Konrad Wolf. 1980. Berlin: Icestorm, 2007. DVD. Color. 102 minutes.

II. OTHER DEFA FILMS AVAILABLE WITH ENGLISH SUBTITLES

All films are available for purchase on DVD at the DEFA Film Library.

Die Abenteuer des Werner Holt (The Adventures of Werner Holt). Directed by Joachim Kunert. 1964.

Affaire Blum (The Blum Affair). Directed by Erich Engel. 1948.

Alle meine Mädchen (All My Girls). Directed by Iris Gusner. 1979.

Art/Work: Six Shorts. Directed by Jürgen Böttcher. 1961.

Das Beil von Wandsbek (The Axe of Wandsbek). Directed by Falk Harnack. 1951.

Bis daß der Tod euch scheidet (Until Death Do Us Part). Directed by Heiner Carow. 1979.

Chingachgook, die Große Schlange (Chingachgook, the Great Snake). Directed by Richard Groschopp. 1967.

Coming Out. Directed by Heiner Carow. 1989.

DEFA Animation Nr. 1/ Ohne Worte (Animation before Unification: 16 Shorts from East Germany). Various directors. 1975.

Denk bloß nicht, ich heule (Just Don't Think I'll Cry). Directed by Frank Vogel. 1965.

Der Dritte (Her Third). Directed by Egon Günther. 1972.

Ehe im Schatten (Marriage in the Shadows). Directed by Kurt Maetzig. 1947.

Eine Berliner Romanze (A Berlin Romance). Directed by Gerhard Klein. 1956.

Einer trage des Anderen Last (Bear Ye One Another's Burden). Lothar Warneke, 1981.

Eolomea. Directed by Hermann Zschoche. 1972.

Das Fahrrad (The Bicycle). Directed by Evelyn Schmidt. 1982.

Der Fall Gleiwitz (The Gleiwitz Affair). Directed by Gerhard Klein. 1961.

Der fliegende Holländer (The Flying Dutchman). Directed by Joachim Herz. 1964.

Die Flucht (The Flight). Directed by Roland Gräf. 1977.

Flüstern und Schreien (Whisper and Shout). Directed by Dieter Schumann. 1988.

For Eyes Only-Streng geheim (For Eyes Only-Top Secret). Directed by János Veizci. 1964.

Frauenschicksale (Destinies of Women). Directed by Slatan Dudow. 1952.

Die Frau und der Fremde (The Woman and the Stranger). Directed by Rainer Simon. 1984.

Fünf Patronenhülsen (Five Cartridges). Directed by Frank Beyer. 1960.

Gegenbilder (Counter Images: GDR Underground Images 1983–1989). Various directors. 1983.

Der geteilte Himmel (The Divided Heaven). Directed by Konrad Wolf. 1964.

Die goldene Gans (The Golden Goose). Directed by Siegfried Hartmann. 1964.

Goya. Directed by Konrad Wolf. 1971.

Ich war neunzehn (I Was Nineteen). Directed by Konrad Wolf. 1968.

Im Staub der Sterne (In the Dust of the Stars). Directed by Gottfried Kolditz. 1976.

Irgendwo in Berlin (Somewhere in Berlin). Directed by Gerhard Lamprecht. 1946.

Jadup und Boel (*Jadup and Boel*). Directed by Rainer Simon. 1980.

Jahrgang 45 (*Born in '45*). Directed by Jürgen Böttcher. 1966.

Jana und Jan (*Jana and Jan*). Directed by Helmut Dziuba. 1992.

Karbid und Sauerampfer (*Carbide and Sorrel*). Directed by Frank Beyer. 1963.

Karla (*Carla*). Directed by Hermann Zschoche. 1965.

Das Land hinter dem Regenbogen (*The Land beyond the Rainbow*). Directed by Herwig Kipping. 1991.

La Villette. Directed by Gert Kroske. 1990.

Leipzig im Herbst (*Leipzig in the Fall*). Directed by Gert Kroske and Andreas Voigt. 1989.

Die Mauer (*The Wall*). Directed by Jürgen Böttcher. 1989/90.

Miraculi. Directed by Ulrich Weiß. 1991.

Nackt unter Wölfen (*Naked among Wolves*). Directed by Frank Beyer. 1963.

Professor Mamlock. Directed by Konrad Wolf. 1961.

Rat der Götter (*Council of the Gods*). Directed by Kurt Maetzig. 1950.

Red Cartoons—Animated Films from East Germany. (Also known as *DEFA Animation Nr. 1*). Various Directors. 1975.

Roman einer jungen Ehe (*The Story of a Young Couple*). Directed by Kurt Maetzig. 1952.

Rotation. Directed by Wolfgang Staudte. 1949.

Schaut auf diese Stadt (*Look at This City*). Directed by Karl Gass. 1962.

Schlösser und Katen (*Castles and Cottages*). Directed by Kurt Maetzig. 1957.

Das singende, klingende Bäumchen (*The Singing, Ringing Tree*). Directed by Francesco Stefani. 1957.

Die Söhne der Großen Bärin (*Sons of the Great Mother Bear*). Directed by Joseph Mach. 1966.

Sonnensucher (*Sun Seekers*). Directed by Konrad Wolf. 1958.

Spur der Steine (*Trace of Stones*). Directed by Frank Beyer. 1966.

Sterne (*Stars*). Directed by Konrad Wolf. 1959.

Stilles Land (*Silent Country*). Directed by Andreas Dresen. 1992.

Die Taube auf dem Dach (*The Dove on the Roof*). Directed by Iris Gusner. 1973.

Der Tangospieler (*The Tango Player*). Directed by Roland Gräf. 1990.

Dein unbekannter Bruder (*Your Unknown Brother*). Directed by Ulrich Weiß. 1982.

Und deine Liebe auch (*And Your Love Too*). Directed by Frank Vogel. 1962.

Der Untertan (*The Kaiser's Lackey*). Directed by Wolfgang Staudte. 1951.

Die Verfehlung (*The Mistake*). Directed by Heiner Carow. 1991.

Wer reißt denn gleich vor'm Teufel aus (*The Devil's Three Golden Hairs*). Directed by Egon Schlegel. 1977.

Winter Adé (*After Winter Comes Spring*). Directed by Helke Misselwitz. 1988.

Wozzeck. Directed by Georg Klaren. 1947.

Das zweite Gleis (*The Second Track*). Directed by Joachim Kunert. 1962.

III. DEFA FILMS NOT AVAILABLE WITH ENGLISH SUBTITLES

Some films may be available on the German website of Icestorm.

1–2–3 Corona. Directed by Hans Müller. 1948.

Alarm im Zirkus (*Alarm at the Circus*). Directed by Gerhard Klein. 1954.

Der Aufenthalt (*The Turning Point*). Directed by Frank Beyer. 1983.

Berlin um die Ecke (*Berlin around the Corner*). Directed by Gerhard Klein. 1965.

Chronik eines Mordes (*The Story of a Murder*). Directed by Joachim Hasler.1965.

Drei Haselnüsse für Aschenbrödel (*Three Nuts for Cinderella*). Directed by Václav Vorlíček. 1973.

Einheit SPD-KPD (*Unity SPD-KPD*). Directed by Kurt Maetzig. 1946.

Ernst Thälmann—Führer seiner Klasse (*Leader of His Class*). Directed by Kurt Maetzig. 1955.

Ernst Thälmann—Sohn seiner Klasse (*Son of His Class*). Directed by Kurt Maetzig. 1954.

Ete und Ali (*Ete and Ali*). Directed by Peter Kahane. 1985.

Feuer unter Deck (*Fire Below Deck*). Directed by Hermann Zschoche. 1977.

Figaros Hochzeit (*Figaro's Wedding*). Directed by Georg Wildhagen. 1949.

Die Fledermaus (*The Bat*). Directed by Géza von Bolváry. 1946.

Fräulein Schmetterling (*Miss Butterfly*). Directed by Kurt Barthel. 1965.

Freies Land (*A Free Country*). Directed by Milo Harbich. 1946.

Der Frühling braucht Zeit (*Spring Takes Its Time*). Directed by Günter Stahnke. 1965.

Geliebte weiße Maus (*Beloved White Mouse*). Directed by Gottfried Kolditz. 1964.

Die goldene Jurte (*The Golden Tent*). Directed by Gottfried Kolditz and Rabschaa Dordschpalam. 1961.

Hände hoch, oder ich schieße (*Hands Up, or I'll Shoot*). Directed by Hans-Joachim Kasprzik. 1966.

Die Hexen von Salem (*The Witches of Salem*). Directed by Raymond Rouleau. 1957.

Insel der Schwäne (*Island of Swans*). Directed by Hermann Zschoche. 1983.

Der Kahn der fröhlichen Leute (*The Happy Barge Crew*). Directed by Hans Heinrich. 1950.

Das kalte Herz (*Heart of Stone*). Directed by Paul Verhoeven. 1950.

Das Kleid (*The Dress*). Directed by Konrad Petzold. 1961.

KLK an PTX—Die rote Kapelle (*KLK Calling PTX—The Red Orchestra*). Directed by Horst Brandt. 1971.

Die lustigen Weiber von Windsor (*The Merry Wives of Windsor*). Directed by Georg Wildhagen. 1950.

Mama, ich lebe (*Mama, I'm Alive*). Directed by Konrad Wolf. 1976.

Meine Frau macht Musik (*My Wife Makes Music*). Directed by Hans Heinrich. 1958.

Der Mann mit dem Objektiv (*Man with the Objective*). Directed by Frank Vogel. 1961.

Der nackte Mann auf dem Sportplatz (*The Naked Man in the Stadium*). Directed by Konrad Wolf. 1974.

Nicht schummeln, Liebling! (*Don't Cheat, Darling*). Directed by Joachim Hasler. 1972.

Novalis-Die blaue Blume (*Novalis—The Blue Flower*). Directed by Herwig Kipping. 1994.

Orpheus in der Unterwelt (*Orpheus in the Underworld*). Directed by Horst Bonnet, 1973.

Rauschende Melodien (*Sweeping Melodies*). Directed by Erich Wilhelm Fiedler. 1955.

Die Reise nach Kosmatom (*The Journey to Kosmatom*). Directed by Manfred Gußmann and Janusz Star. 1961.

Revue um Mitternacht (Midnight Revue). Directed by Gottfried Kolditz. 1962.

Die Russen kommen (The Russians are Coming). Directed by Heiner Carow. 1968.

Die Schlüssel (The Keys). Directed by Egon Günther. 1974.

Die Schönste (The Most Beautiful). Directed by Ernesto Remani. 1958.

Die Schönste (The Most Beautiful). Directed by Walter Beck. 1959.

Signale (Signals—An Adventure in Space). Directed by Gottfried Kolditz. 1970.

Die Spielbank-Affäre (The Casino-Affair). Directed by Arthur Pohl. 1957.

Das tapfere Schneiderlein (The Brave Little Tailor). Directed by Helmut Spieß. 1956.

Ulzana. Directed by Gottfried Kolditz. 1974.

Unser kurzes Leben (Our Short Life). Directed by Lothar Warneke. 1981.

Der verlorene Engel (The Lost Angel). Directed by Ralf Kirsten. 1966.

Wenn du groß bist, lieber Adam (When You're Older, Adam). Directed by Egon Günther. 1965.

Zar und Zimmermann (Czar and Carpenter). Directed by Hans Müller. 1956.

Zille und Ick (Zille and Me). Directed by Werner Wallroth. 1983.

Das zweite Leben des Friedrich Wilhelm Georg Platow (The Second Life of Friedrich Wilhelm Georg Platow). Directed by Siegfried Kühn. 1973.

INDEX

Film titles are indexed under their original German title. The definite articles der, die, and das are not considered part of the title and therefore not indexed. For example, *Die Spielbankaffäre* is listed under the letter S as *Spielbankaffäre, Die*. The English film titles are taken from the website of the German distributor Progress Filmverleih.

Printed in the United States of America